BLUE ICE

TRAVELS IN ANTARCTICA

DON PINNOCK

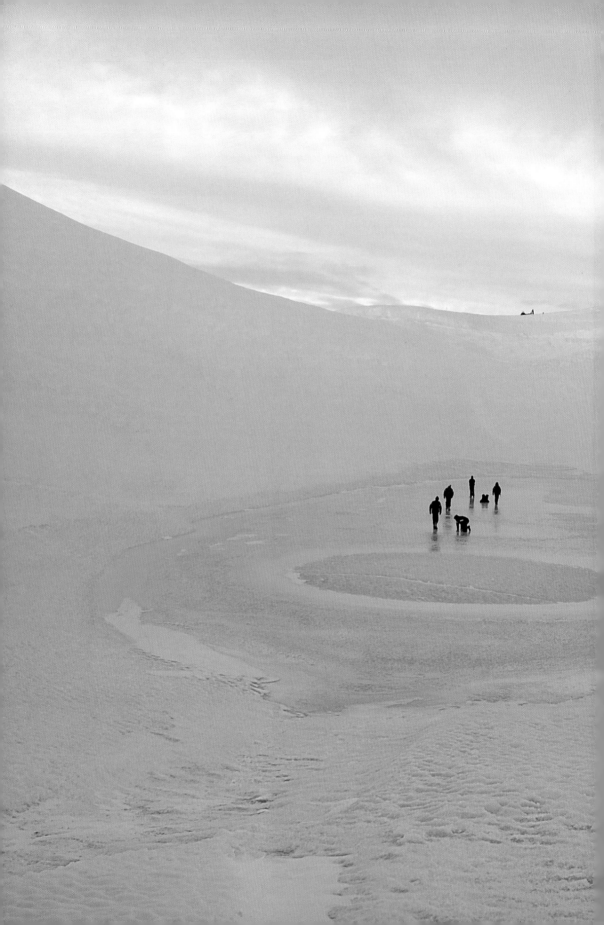

BLUE ICE

TRAVELS IN ANTARCTICA

DON PINNOCK

DOUBLE
STOREY
a juta company

First published 2005
by Double Storey Books,
a division of Juta & Co. Ltd,
Mercury Crescent, Wetton, Cape Town
in association with *Getaway* magazine

ISBN 1-77013-013-6

Design and layout by Jenny Young
Printing by CTP Book Printers, Cape

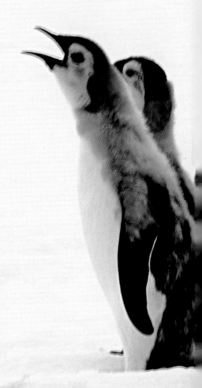

When you look upon such things, there comes surging through the confusion of
the mind, an awareness of the dignity of the earth, of the unaccountable importance
of being alive, and the thought comes out of nowhere that unhappiness rises not so
much from lacking as from having too much … And you guess the end of the world
will probably look like that, and the last men retreating from the cliffs will look out
on some such horizon, with all things at last in equilibrium, the winds quiet,
the sea frozen, the sky composed and the earth in glacial quietude.

Richard Byrd, *Discovery*

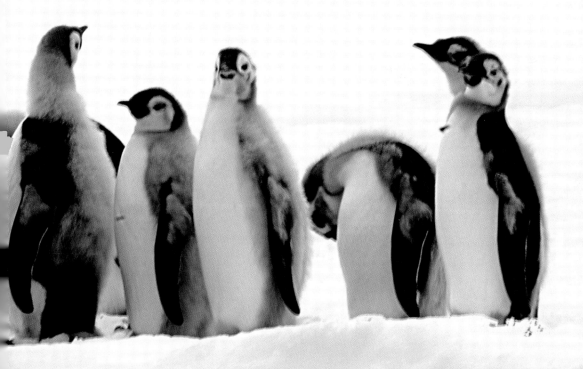

Contents

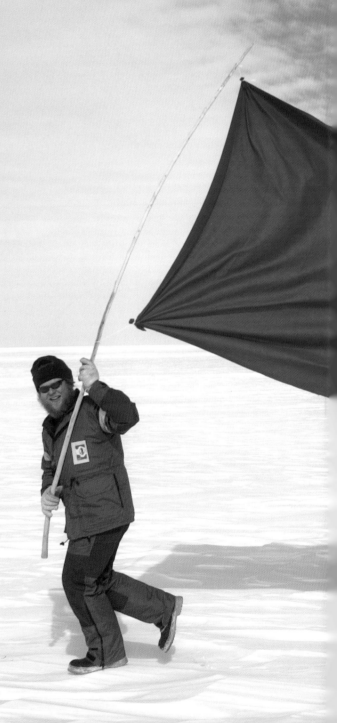

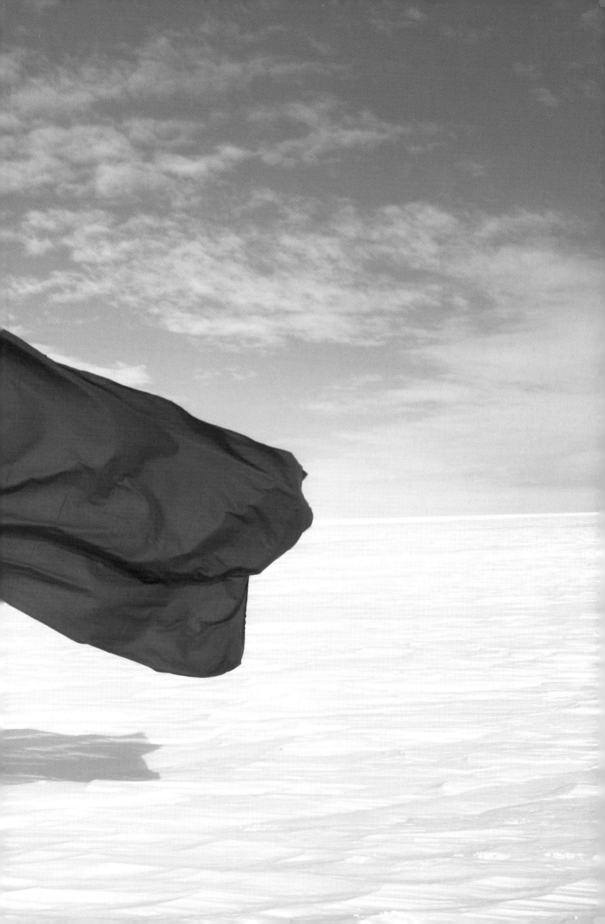

Preface

South Africa has been intimately involved with the exploration and exploitation of Antarctica for hundreds of years, but nobody seems to have written much about this fact. Von Bellingshausen, Scott, Amundsen, Shackleton and many more all refitted and replenished their ships beneath the ramparts of Table Mountain. Sealers set out from the great bay at the tip of Africa each year and returned with their bloody plunder. And when there were no more seals, they were replaced by whalers. These days the traffic is almost exclusively research ships, probing the high southern latitudes for information about our planet. Each year the SA *Agulhas* joins them and, one summer, I hitched a ride.

I returned overawed, thrilled, bursting to say something – but stalled. How does one write about a landscape that has become coated with layers of lyrical language of the countless explorers who ventured there? They had sailed before the wind, stayed there for years, mushed huskies, man-hauled heavy sledges, and some even wrote as they died. It was intimidating. In the end, though, I pushed away their books, opened my diary and typed it out, stitching in the bits of history, natural science and reminiscences that fascinated me at the time. So this is a personal adventure, a view from the deck in an environment that is both alien and very South African.

No book of this nature is a solo effort, especially one that requires me to travel to the planet's antipodes. The people at the South African Department of Environmental Affairs and Tourism, who made the trip possible, are a great team and I'm especially indebted to the head of its division on Antarctica and the Islands, Henry Valentine, who pressed the 'go' button and supported my work all the way. Caltex assisted in the publication of this book by providing funds to supply free copies to school libraries. This fine offer was made by Denzyl O'Donoghue before a single word had been written.

Other team members are my colleagues at *Getaway* magazine who made space for the trip and waved me off on the quay. I cannot forget the day editor David Bristow called me into his office and said: 'I think it's time you went to Antarctica.' My publishers, Double Storey, took the risk with good grace and a few memorable parties. Then there were the men and women who brave the wild southern oceans and the harsh Antarctic weather to maintain South Africa's presence on the seventh continent. They are true adventurers and also excellent company.

A rather unexpected and extraordinary source of information was the Raymond Danowski Antarctica Collection of books in the AH Molteno Library at Diocesan College (Bishops) in Cape Town. For access to this considerable resource, I am indebted to librarians Janet van Tonder and Judy Hildon-Green.

Special thanks, as always, goes to the author and poet Patricia Schonstein – my wife, first editor and best friend – who was sensitive to the earth's subtle rhythms long before I was and is my eyes and ears on the state of the environment. She's also quick to spot a poor sentence or a tacky sentiment. And our children, Gaelen and Romaney Rose, who put up with my absences and welcome me back with love – thanks, guys. It's an amazing world and what's so heart-warming is that you know it.

Don Pinnock

Cape Town, 2005

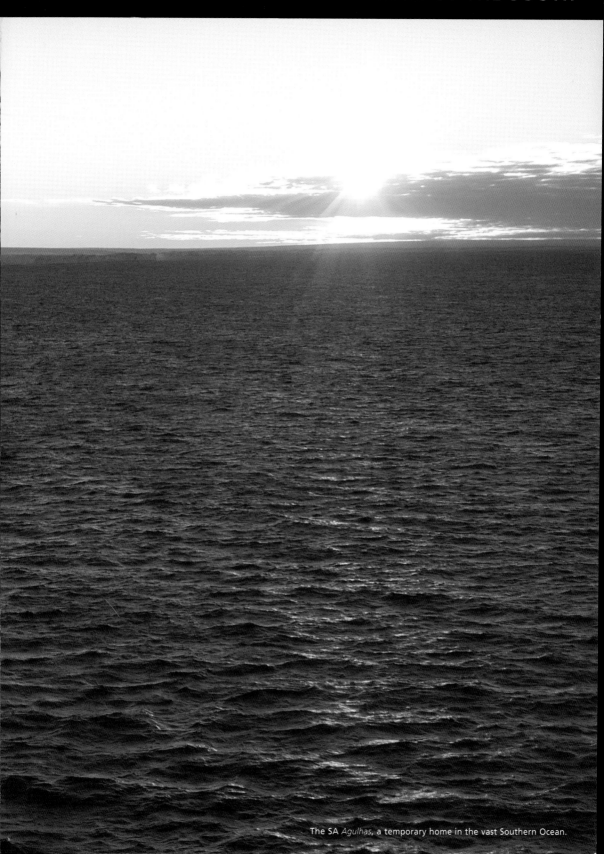

The SA *Agulhas*, a temporary home in the vast Southern Ocean.

Lure of the south

To anyone who goes to the Antarctic, there is a tremendous appeal, an unparalleled combination of grandeur, beauty, vastness, loneliness and malevolence – but which truthfully convey the actual feeling of Antarctica.

Captain LM Sunter, *The Antarctic Century*

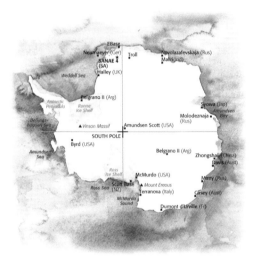

It takes a while to find the kit store, despite what seemed to be precise instructions from Zaid, the storeman. A small side road passes through a tunnel under red-brick warehouses so typical of Cape Town's older industrial areas. My son, Gaelen, and I drive through it as instructed and end up beside railway tracks next to which is a flat, orange contraption that looks like a mobile stage with no evidence of an entrance. Half a year later I will identify the object as an ice sled, but now it gives no clues. We back-track and find a small door in the tunnel. A plastic sign reads 'Department of Environment and Tourism, Directorate of Antarctic and Islands'. I ring the bell and, after a long pause, the door opens to reveal a bleak foyer with some offices leading off it.

'Kit?' the door-opener enquires. I nod.

'In there.'

The room we enter is no less bare but has a hatch behind which are countless shelves stacked and waiting for adventurers. Zaid checks my name on a list marked 'Takeover Personnel', asks my shirt, trouser and shoe size, then starts dropping kit on the hatch shelf: three sets of thermal underwear, nine pairs of woolly socks, warm shirts, bright blue industrial trousers, Polartec zip-up tops, a pair of padded dungarees, a heavy weather jacket with a badge showing a map of Antarctica, a penguin and the letters SANAP plus a South African flag on the sleeve (should someone find my body down a crevasse years later), a pair of sky-blue winter sheets, a pile of inner and outer gloves, a balaclava with a cute pompom, a pair of felt boot-liners and the largest boots I've ever seen.

'Whew,' exclaims Gaelen, eyeing the growing pile. 'That's some serious kit you've got there.'

'I guess it's seriously cold in Antarctica,' I mutter, bemused, as I try to stuff the gear into the two duffel bags Zaid hands me.

Before leaving we poke around the offices for a bit and find a gate that opens to reveal a huge warehouse packed with all manner of things. It has a whiff of expedition and makes me think of Livingstone and Stanley packing for their African exploration, the difference being that everything here is outsize and clearly not for human portage. We wander past crates of red cherries, curried carrots, marshmallows, butter beans, coriander, smoked mussels, boxes of Funky Fruit Bars, a pile of chocolate vermicelli, a box of Golden Smackeroos (what are they?), rows of skidoos – which look like jet skis with rubber tracks below the waterline – flasks of ethanol, a crate of magnetometers, mountains of boxes mysteriously marked 'Contents on attached form', and towers of orange containers into which all of this obviously has to fit. Expedition chief Frans Hoffman appears from behind a pile of containers, an ear glued to his cellphone. He waves, finally finishes the call, and confesses he has a migraine. Looking around, I can see why. Getting these supplies across the ice to the base is clearly going to be a major operation.

::

Several days before our departure the Department of Environmental Affairs and Tourism (DEAT) team – me included – are called to a meeting. When I walk into the Antarctic and Islands offices there's a group of people sitting round a table. They're a tough-looking bunch, even the two women.

'Are you guys from DEAT?' I enquire. There's a brief, puzzled silence.

'No. We're from the Defence Force.'

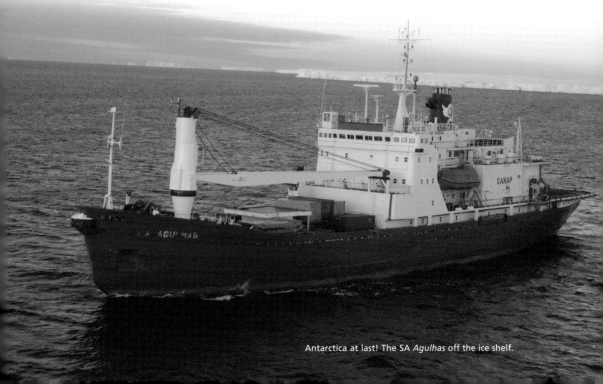

Antarctica at last! The SA *Agulhas* off the ice shelf.

'I'm from Armscor.'

'I'm Navy.'

'Oops, sorry, wrong meeting,' I say and am about to back out when a tall man in blue overalls with faraway eyes strolls in, introduces himself as transport manager Jeremy Pietersen. He starts talking about ice logistics, so I sit down. The Antarctic Programme, I discover, advertises mainly within the government services, and most volunteers come from the armed forces. Programme director Henry Valentine appears soon afterwards, introduces himself, and takes pole position.

I've met him before. He's a quietly spoken oceanographer with a wry sense of humour who runs South Africa's only out-of-Africa territories. It was to Henry that I'd sent a speculative e-mail almost a year earlier asking how I could get to Antarctica. He'd invited me to his office, spent half an hour showing me around and telling me about Antarctica's bases and his charges on the southern-ocean islands of Marion, Gough and Prince Edward. Then he decanted two cups of strong tea, sat back and said: 'There, now you understand more about what we do.'

I knew many writers had asked to be included on the three-month summer replenishment trip without success. Was he about to turn me down?

'Er, about my going …' I began.

'Oh, yes, about that, you've got a berth.'

'You mean I can go?' I couldn't believe what I was hearing. 'Just like that?'

'Well, if you're prepared to be part of the DEAT team, muck in where work is needed – sure, you're welcome.'

I did a little dance round my chair and sat down again. The tea tasted delicious. A week later he faxed me a letter confirming the offer. I'd been appointed Writer in Residence. I felt like wearing the fax on my chest as if it were a badge: 'Look here, I'm going to Antarctica!'

Henry opens the meeting with a caution. 'There will be no ranks, no special treatment. You'll all have to work long hours when the weather opens. Look after your vehicles – they're your life-support systems – and obey the rules because Antarctica can be a dangerous place and they're there for your protection.' The old hands settle back in their chairs and stare at the ceiling. The rookies lean forward on their elbows, drinking in every word. He surveys the circle of muscular characters and skinny me for a moment, then says: 'Be considerate. Minor irritations can become big issues at the base. It's all about how you deal with them. Listen to the old-timers: there's no substitute for experience.'

Frans takes over and lists the rules: 'No visitors aboard the SA *Agulhas* before sailing. No private alcohol on board. No smoking within the ship and don't throw anything overboard

– it's a violation of Antarctica's environmental code. Oh, and clean up behind you. The *Agulhas* is at Quay Five and the gangplank goes up at 13h45 on Tuesday. See you're on board. We'll be back in about 73 days, but there might be a delay returning because the Queen of Norway will be visiting the base.'

And that's it. For several weeks my kit lies in our hall at home, impressing visitors. Just before the departure date we hold a farewell dinner and I put a snow boot in the middle of the table as a conversation piece. It provokes much comment.

'This isn't a boot, it's a mobile platform.'

'How will you lift your feet up with this on?'

'Do your feet swell that much in Antarctica?'

Someone asks me why, really, I'm going to Antarctica. I think about it – the thrill of adventuring into the unknown, the chance of some great photos, penguins, icebergs, the midnight sun … Then I consider the possibility of nearly a month of seasickness, bitter cold, the dangers of extreme weather and terrain. Also about leaving home for so long.

'I don't know why I'm going,' I tell my questioner. 'I think it has something to do with my great-grandmother. But ask me again when I come back. I may have figured it out by then.'

Why *do* we hanker to travel? The philosopher Blaise Pascal was of the opinion that all our miseries stem from a single cause: our inability to remain quietly in a room. 'Why', he asked, 'must a man with sufficient means to live on feel drawn to direct himself on long sea voyages? To dwell in another town? To go off in search of a peppercorn? Or to go off to war and break skulls?' We travel, he decided, to distract ourselves from our weak moral condition. It prevents us from thinking about ourselves.

That inveterate traveller Bruce Chatwyn, on the other hand, insisted that we are rootless wanderers, nomads by nature. 'Could it be', he asked, 'that our need for distraction, our mania for the new, is in essence an instinctive migratory urge akin to that of birds in autumn?'

The Australian Antarctic explorer Douglas Mawson had a less practical answer. 'Tramping over the plateau where reigns the desolation of the outer worlds, in solitude at once ominous and weird, one is free to roam in imagination through the wide realm of human experience to the bounds of the great Beyond. One is in the midst of infinities … of the dazzling white plateau, of the dome above, time past and time to come.'

::

In the days that follow, a strange, unreal calm settles round me. I've packed and have only a few things to add. My wife, Patricia, and I hang around each other anticipating my leaving, intentionally avoiding too much discussion. The night before the ship sails, we

snuggle up. How many others are experiencing similar sensations? How many, throughout history, on the eve of a long, potentially dangerous journey, have felt the same confusion of anticipation, the thrill of adventure, pain of separation, maybe fear? It's disorienting. Antarctica is so far away. So alien.

'To anyone who goes to the Antarctica,' I read in the book *Wild Ice*, 'there is a tremendous appeal, an unparalleled combination of grandeur, beauty, vastness, loneliness and malevolence …' The quote provokes decidedly mixed feelings.

On the day of departure my six pieces of luggage seem outrageous for someone who usually travels with one or two items – especially since I'd delivered a trunkful of extras to the warehouse a week earlier. One duffel is stuffed with cold-weather gear for my arrival on the ice, another holds my huge snow boots, a third is full of cameras. I hope I'm not going to look like some pampered voyager beside Koos Cronje, the dozer driver who, according to the passenger list, is my cabin mate and an old Antarctic hand. He probably has only a single bag.

The weather is Cape perfect: clear blue skies and a light breeze dragging a cloth of cloud over the lip of Table Mountain. Here and there, hadeda ibises are tugging reluctant invertebrates out of lawns and seagulls are bombing tourists along the beachfront. When we arrive mid-morning, Quay Five is crowded with stevedores, officials, families, lovers and friends. We, the chosen few going south, are checked off a list, allowed to duck under a taped-off barrier and clamber up the *Agulhas*'s swaying gangplank. I needn't have worried

Cape Town, the haven of so many Antarctic travellers.

about my excess baggage: people are ferrying mountains of it aboard. Bags, bulging suitcases, scientific equipment, PCs, a keyboard, a running machine … all are being negotiated up the gangplank.

Koos has three bags, big ones, which together are considerably larger than he is. I drop mine and head back ashore. There I sit with my family, dangling our legs over the quayside, munching sandwiches.

'So I'm only going to see you again next February?' my daughter asks. I nod, feeling like a traitor.

At the appointed hour I say my goodbyes and board. Some *Getaway* colleagues turn up to wave and everyone stands around waiting for the ship to depart. Word gets about that sailing has been delayed and the crowd thins, then trickles back to the car park. I wander inside to survey my new shipmates. They're a cross-section of South Africa: weathered crewmen and women in orange overalls, officers in neat whites with shoulder braids, tough-looking heavies, delicate young women, bearded ice-men and we timid rookies.

The *Agulhas* sails eventually, around sunset, nosing out of Table Bay. Lights twinkle along the foot of the Peninsula's spectacular mountains. Cape Town is a city best appreciated from the sea, the way Portuguese and Dutch mariners first saw it. Dinner is solid English fare – roast beef, roast potatoes and Yorkshire pudding, followed by jelly and custard. I decide I can survive a day before telling them I don't eat meat. Experience has taught me to never irritate a chef.

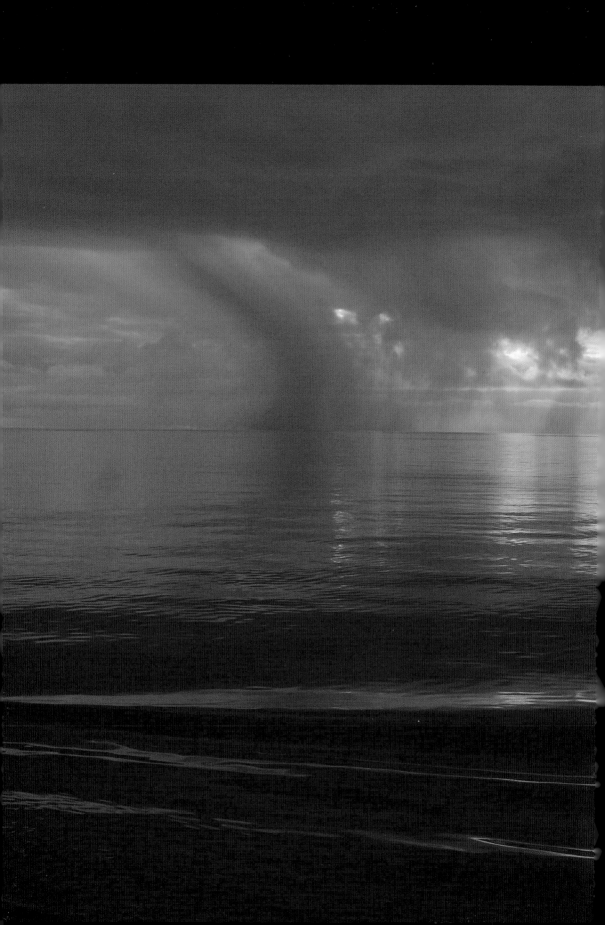

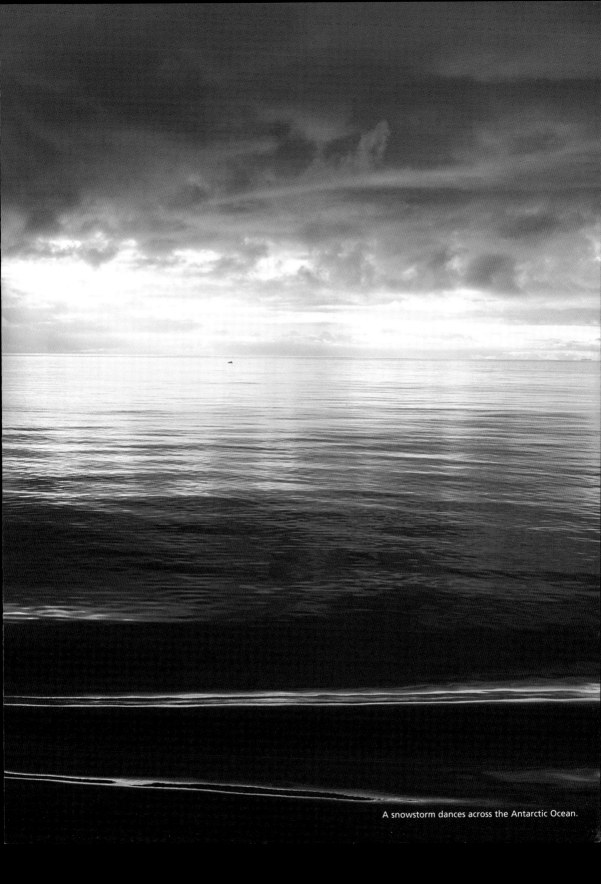

A snowstorm dances across the Antarctic Ocean.

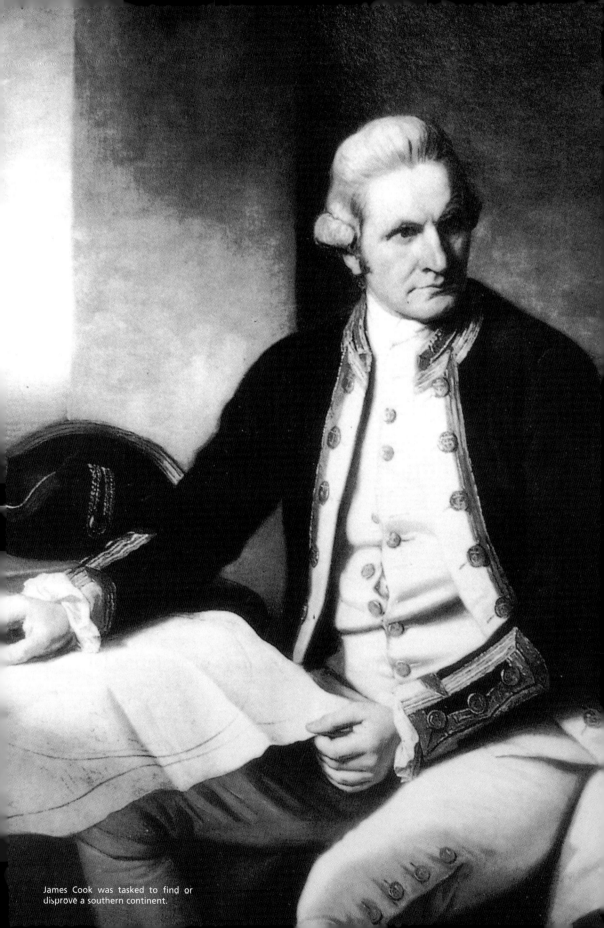

James Cook was tasked to find or disprove a southern continent.

Cook's tour

That there may be a Continent or large tract of land near the Pole, I will not deny, on the contrary I am of opinion there is …

Captain James Cook, *Journals*

For hundreds of years, expeditions to the white south have stopped at Cape Town for replenishment and their last taste of civilisation. On 22 November 1772, exactly 232 years and 24 days before the SA *Agulhas* cast off her moorings, cleared the breakwater and set a course into the Southern Ocean, two very different vessels had weighed anchor and done the same.

The 462-ton *Resolution* and the 340-ton *Adventure*, which nosed out of Table Bay that day, had been built as coal-hauling square-riggers by the Fishburn yard at Whitby on the east coast of England. Their commander was the son of a day labourer who had been born dirt-poor in a clay-walled, thatched cottage in north Yorkshire. In his youth he had worked the 'sea-coal' trade, carrying coal from the northern coalfields to an ever-growing London, and he knew the value of these tough little barques. His name was James Cook.

When he gave orders to sail from Africa's southernmost city on this, his second great voyage of discovery, there would have been many among his crews who looked wistfully at the receding profile of Table Mountain as they headed into the unknown. They'd spent a month at the Cape and, according to Cook's diary, 'they were given fresh-baked bread every day, with fresh beef or mutton and as much greens as they could eat.' The ships had been caulked and painted, and fresh provisions, wine and brandy were taken on board. A young Swedish naturalist, Anders Sparrman, was persuaded to join the expedition. He was described as a 'clever, steady man' but was easily shocked by the oaths, blasphemy and boisterous behaviour of the British seamen. Two days before leaving, Cook wrote a letter to John Walker, a friend of his collier days, in which he revealed an anxiety he never showed his men:

> 'I should hardly have troubled you with a letter was it not customary for men
> to take leave of their friends before they go out of the World … When I think
> of the Inhospitable parts I am going to, I think the Voyage dangerous.'

Cook was one of those men who spent well the span of his days. If you measured his life by his achievements rather than by the 51 years he lived, you would be forced to conclude that he lived a life far longer than most. His voyages were to change utterly the way Europeans viewed the world.

Cook's orders were to find the southern lands which had never been seen but about which there had been much speculation – or testify to their non-existence. Ever since the fourth

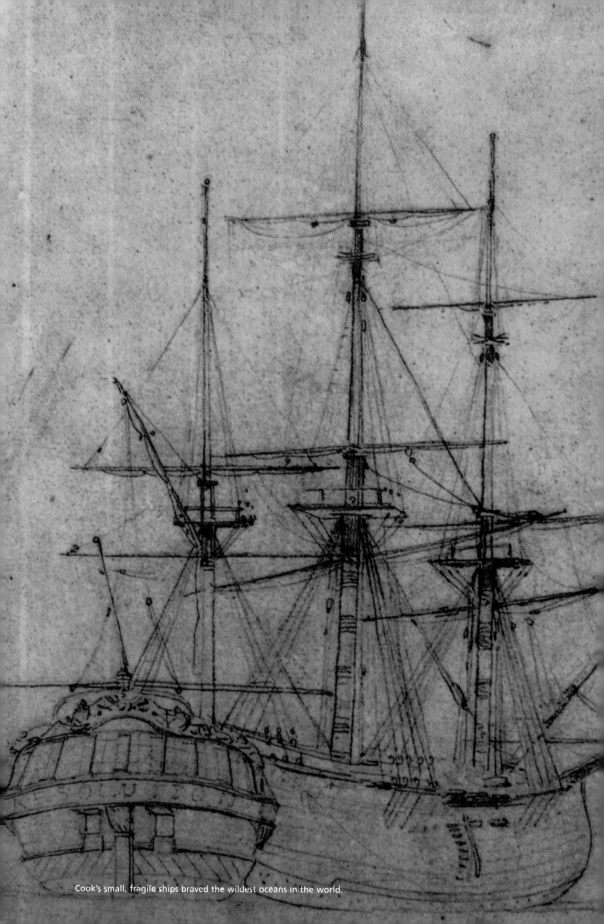

Cook's small, fragile ships braved the wildest oceans in the world.

century BC, when Aristotle insisted that the earth was not flat but a sphere, there had been much debate about the nature of 'southern lands'. For the Homeric Greeks, balance was the order of the world. If the earth was a spinning sphere, there had to be two points around which it pivoted. The northern pivot they named Arktos – the Bear – after the constellation in that region of the sky. And if there was an Arktos, they reasoned, there had to be an Ant-arktos. As it turned out, they were correct in two respects: there is a northern and southern region around which the planet spins, and while the north has bears, the south has none.

In that year of 1772, when Cook sailed out of Cape Town, the possibility of a southern continent was mere speculation. But the known world had been creeping steadily south since 1520 when the Spaniard Ferdinand Magellan discovered the stormy strait at the southern tip of America which now bears his name. It had taken Magellan's three ships 37 days to thread their way through the strait. Their crews looked south, saw a shadowy land in the mists and named it Tierra del Fuego, not sure whether it was part of a great land mass or yet another island.

More than half a century later, in 1578, an Elizabethan captain – or pirate, depending on whose history you read – named Francis Drake made a landing even further south on what was to be named Cape Horn. He carried Admiralty instructions to investigate Terra Australis Incognita (or the Southern Unknown Land), but a bit of plunder along the way wasn't out of the question. He jumped ashore and, throwing his arms wide, he proclaimed, 'I am the southernmost man in the world!'

To the south he saw only glittering sea, and felt confident to record that 'there is no maine or lland to be seen to the Southwards, but that the Atlanticke Ocean and South Sea [Pacific] meete in a most large and free scope.'

After that he sailed north to attack the Spanish viceroyalties in Chile and Peru, bagging a phenomenal haul of treasure, before proceeding across the Pacific and then back home via the Cape of Good Hope, where he was royally wined and dined.

A Dutch mapmaker named Abraham Ortelius disagreed with Drake's assertion that there was 'no maine or lland to be seen to the Southwards'. In 1570 he published a collection of 70 maps, *Theatrum Orbis Terrarum* (Theatre of the World) on which Tierra del Fuego is shown as part of a vast southern continent with a coastline sweeping round the earth, complete with capes, headlands, rivers, bays and inlets. Its name was cumbersome: *Terra Australis Nondum Cognita*, which was later simplified to *Terra Incognita*. The collection ran to 40 editions and influenced a fellow countryman, Gerhardus Mercator, who produced a new type of map projection and published it as *A New and Improved Description of the World*.

Yet another Dutchman, Wilhelm Schouten, rounded Cape Horn in 1616 and sailed into the Pacific. Not to be outdone, a Spanish expedition under the command of two brothers,

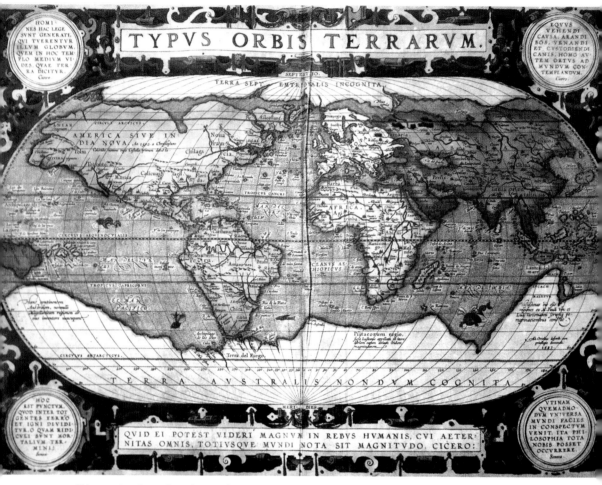

TYPVS ORBIS TERRARVM.

Old mapmakers dreamed up a huge southern continent. This one is dated 1570.

Bartolomé and Gonzalo Garcia de Nodal, negotiated the Horn two years later and were blown south to an island they named Islas Diego Ramirez after their cartographer. Drake was clearly wrong, and the presumed shores of Terra Incognita were pushed ever further southwards. Twenty-six years after the Horn was rounded, two Dutch ships under Abel Janszoon Tasman, discovered an island they named Tasmania and sailed on to New Zealand, where several of the crew were murdered by Maoris.

Not to be caught lagging, Britain sent south one John Clapperton in the square-rigger *Success*. He was driven south to 61° 30'S and this vessel was later wrecked, but he managed to make his way back home where he published his adventures. Clapperton's journey was to inspire the poet Samuel Taylor Coleridge to write *Rime of the Ancient Mariner*, using sinister imagery by which, even today, the southern latitudes are still often viewed.

The greatest – though misled – enthusiast of a southern paradise was undoubtedly the British Admiralty's first hydrographer, Alexander Dalrymple. He'd served with the British East India Company in Madras and developed a zeal for collecting maps, charts and accounts of the southern oceans. Borrowing from every conceivable source, he published a two-volume account of his findings in 1770, called *A Historical Collection of Voyages in the South Pacific Ocean*. In it he was precise about his southern continent. Its coastline lay between 28°S and 40°S and stretched from east to west 'to a greater extent than the whole civilised part of Asia, from Turkey eastward to the extremity of China'.

This continent, he argued, might contain at least 50 million inhabitants and have raw materials that could replace the trade of 'those two million ungrateful wretches' Britain had just lost control of in her former American colonies. The reason this prosperous land had not been discovered, he reasoned, was that previous explorers had simply been too timid. He, Dalrymple, if given a ship, would not be daunted. His ideas interested the Admiralty, but the terms he demanded for such an expedition were deemed so outrageous – absolute command of one of His Majesty's ships plus immediate replacement if it sank – that the expedition was entrusted to the then relatively unknown James Cook.

On his voyages Cook carried with him an instrument that was to change the nature of nautical exploration: a Harrison timepiece. In those days, to find latitude was relatively easy – you could work it out from the relationship between the date and the angle of the sun at midday. But longitude was another matter. Sea captains had been struggling with the problem (and wrecking ships) for years with little success in fixing it accurately. Longitude was a human invention and only when you found both latitude and longitude could you know where you were with any precision. The best way to do this was to find the difference between local time and the time at some fixed point, such as Greenwich. But until John Harrison created his extraordinarily accurate, portable timepiece, this was impossible.

In 1714 the British Government had offered a large reward to any person who could manufacture such a chronometer. Harrison's first instrument could barely fit into a room, but by 1761 he had honed it down to the size of a large pocket watch. He received his award (£20 000), after a good deal of haggling and petty jealousy from rivals. Cook took with him on its first trials an instrument named K1, built by Harrison's partner, Larcum Kendall. It worked perfectly, making voyages into unknown waters safer and more predictable, enabling Cook to draft accurate charts of his explorations so others could follow.

Cook's first expedition, three years earlier, had been an enormous success. He returned with a wealth of specimens, 'insects innumerable', charts of the coastlines of New Zealand and Australia and tales of romantic islands, perils and a near shipwreck. But of a southern continent he found nothing. Dalrymple was incensed, accusing Cook of ignorance.

Cook, however, was not going to let these matters lie. 'Whether the unexplored part of the Southern Hemisphere be only an immense mass of water', he wrote, 'or contain another continent, as speculative geology seemed to suggest, was a question which engaged the

attention, not only of learned men, but most of the maritime powers of Europe.' Unbeknown to Dalrymple, after Cook had put in order and documented the mountains of information he'd gathered on the first voyage, he began planning an exploration which would either find a seventh continent or dispose of the theory forever. When he sailed from Cape Town in November 1772, this was his sole aim. It was to be the first systematic scientific exploration of the Antarctic Ocean.

::

During her first night at sea, the *Agulhas* begins to pitch and roll and, next morning, there are not many at breakfast and even fewer at lunch. Walking down the passages is a strange experience. They look like solid fixtures but seem to have somehow come unstuck from their foundations. As the ship's bow is heaved upwards by a roller, my knees buckle under the extra gravity. Then, as it falls off the back of the receding wave, I have a sense of weightlessness. All the while I'm being catapulted from one side of the passage to the other from handrail to handrail or, if I miss a hold, bounce off the walls with my shoulders. In the dining room the tables are covered with an adhesive plastic net to prevent plates crashing to the floor and the chairs are tethered below their seats by steel cables. I don't get seasick easily, but the fried breakfast is a stern test. Outside the sea is wild, windswept and gorgeous, with spume flying off the crests and lace traceries streaming down the wave backs. It's the sort of sea that in films is always accompanied by brassy trumpets and crashing cymbals.

Cape Town is 34° South and within two days we're in the legendary Roaring Forties, the southern trade winds of the old square-riggers. People appear in the lounge, their faces blank and clammy, staring vacantly around, then stagger back to their cabins. Koos and I have another sort of problem: the toilet won't flush and, with no porthole, we are without natural ventilation. Our mutual pursuit of a solution becomes a good bonding exercise. Someone arrives and unscrews bits of the flusher but fails to solve the problem.

'Fokken ship's too old,' is Koos's analysis. 'Should be pensioned off.' Koos is short – his nickname is Klein Koos (Small Koos) – but he's built like a wrestler. His bristling black beard has touches of grey and his eyes are wrinkled with laughter lines. Back home he has a business fixing diesel vehicles. 'Also this is a crap cabin,' he informs me. 'No window! I mean how the hell are we going to tell if it's night or day?'

'Pretty soon it's going to be all day outside so we may be happy with a cabin that's all night,' I suggest. He gives me a long, speculative look.

'So now you think you know all about Antarctica? Just you wait. You're going to get a serious shock. But if you're clever, maybe you can fix the shithouse.' Then he hoots with laughter, and slaps me on the back. 'I think we'll get along all right. Would you like a brandy and Coke?'

'But it's only ten o'clock.'

'Ja, well, what's that got to do with brandy and Coke? It's going to get so rough you're gonna need it.'

In a way Koos is right about the *Agulhas*. She was built by Mitsubishi Heavy Industries in Shimonoseki, Japan, in 1977, which certainly makes her pensionable. She's a Polar Class 4, not an icebreaker, but has an ice-strengthened hull which can chew through pack ice of up to about a metre. She's a little over 100 metres long and 18 wide, and has a range of around 15 000 nautical miles. But this is her 121st voyage down south – a veritable old lady – and she's soon to be retired from Antarctic service.

Next morning I explore. The lounge is rather gloomy with long tables and fixed swivel chairs that swing this way and that as the ship pitches and rolls. The colour scheme is dark blue and brown – nondescript seventies décor enlivened somewhat by paintings of old Antarctic explorers and their masted ships in a white wasteland. Under the large-screen TV monitor is a pile of dog-eared car and computer magazines. There I meet Andrew Collier, with whom I'll be sharing a room at Sanae 4. He's a scientist, and when I ask him what he does he replies in Advanced Electronicese. From my blank expression he probably figures he'll have a dumb ass for a room mate.

Also sitting around drinking coffee are Lindsay Magnus who monitors geospace; Sharon du Plessis, the environmental officer; Joseph Nhlapo, who'll be overwintering as the communication man; engineers Martin Slabber and Chris van der Merwe; and Sybrand van Niekerk, a man of the cloth who declares he isn't planning on doing any weddings or funerals down south. His passion is birds. Others in the science team I meet later, after they've finished being seasick. Pretty soon a debate is in full swing ranging over evolution, the dimensions of space, killer particles from the sun, religion and the possibilities of human governance beyond dictatorship and democracy. I can't decide whether the idealists or the pragmatists win, so I take a walk.

Many steep metal stairways later, I find myself on the monkey deck, probably so named because it requires a lot of climbing to get there. Perched on a fairly protected seat above the bridge, I stare at the vast expanse of the sea. It gives an alarming new meaning to being in the middle of nowhere and leaves me in no doubt that the earth is round. The nearest land is more than five kilometres away and straight down.

Nearly three-quarters of the planet is covered by water, and because most of the earth's landmass is north of the equator, the Southern Ocean is enormous. If you left Cape Horn astern and set your bow towards the rising sun, you could sail round the globe along the 56° latitude and arrive back at Cape Horn, tanned by wind and sun, having sailed more than 12 000 nautical miles of ocean without sighting land, your only companions being seabirds, whales, dolphins and some drifting icebergs. To the south, for our entire trip, will be the shores of Antarctica. No other continent is surrounded by so much water.

The bridge, below the monkey deck, is a mass of knobs, dials and screens, all under the control, when I visit, of Second Officer Anne Myers. Not wanting to disturb, I wander around looking at the signage. 'White Gill Bow Thruster' advises one panel. 'To dump roll damp tank activate this switch' insists another. Then some very practical advice in case of fire: 'Run either supply or exhaust fan, not both together.' There's a stout cord hanging from the ceiling which activates the ship's horn. Beside it is an orange tape label which reads: 'Ring for Service.' Another sign is in Japanese and has been translated: 'Made in

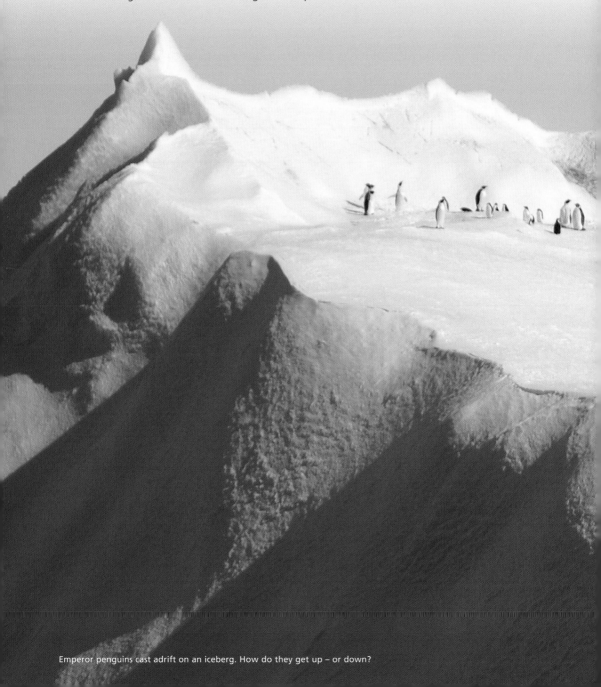

Emperor penguins cast adrift on an iceberg. How do they get up – or down?

Japan,' it proclaims. Another warns: 'Look out for Pedestrians.' I gaze out of the window at the endless sea but can't see any jaywalkers.

Back in my cabin Koos is disappointed. 'It's bloody unusual,' he tells me.

'What is?'

'The sea. It's too smooth. But okay, we're going to be in the Fifties soon. There you'll see rough.'

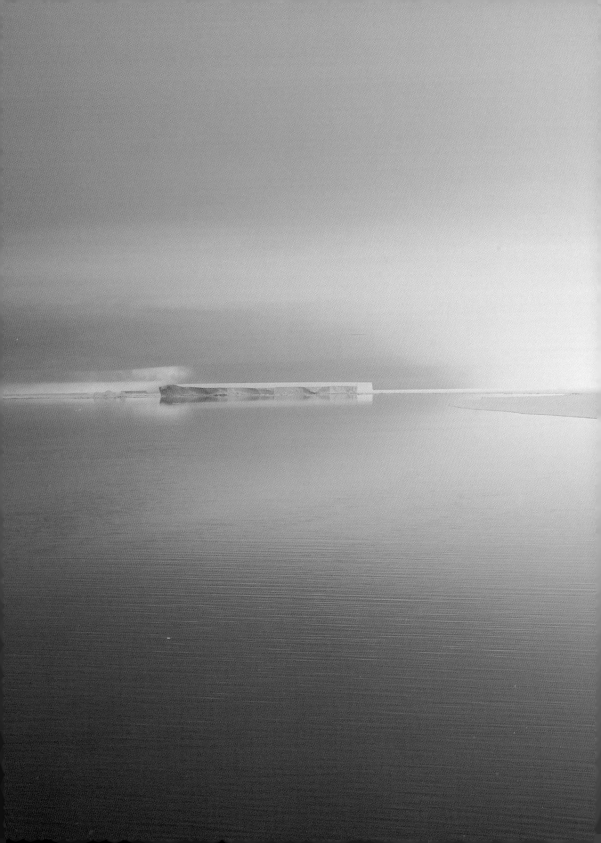

The crystal edge of Antarctica.

The Southern Ocean

It is a reproach to every civilized country, that the people of this enlightened age possess so little accurate knowledge of the seas, islands and perhaps continents which exist in the polar regions of the southern hemisphere.

Benjamin Morrell, *A Narrative of Four Voyages*, 1832

Sailing south, the days follow each other with a disorienting sameness that transforms mealtimes into highlights. Somehow the Public Works Department team always gets to the dining room first and sits at the same table. To one side of them, beneath a bad picture of seals on an ice shelf, are the chopper pilots and support crew. On the other side are the SnoCat and 'dozer drivers, and beyond them the scientists. Top table, at the far end from the door, is for officers in their neat whites and shiny epaulettes. Being non-aligned, I make a point of table-hopping, but I never manage to penetrate the PWD circle. They were such a tight-knit group that it would have seemed like trespassing.

Koos and I have another problem. It seems our cabin is against the engine-room bulkhead and at around 06h00 every morning, without fail, a motor on the other side of the wall is switched on with devastating effect. The bulb rattles out of the reading light and anything on the table tends to wander around and finally fall off. I place my camera bag on several layers of jackets in the cupboard to stop everything in it from shaking to bits. The cabin is uninhabitable until 16h00, when the motor finally falls silent.

With a choice between the crowded lounge and the freezing deck, I go hunting for a refuge and find a small unoccupied geological office with a window opening onto the stern winch and the departing sea. I get tenancy permission from the captain, borrow a battered old swivel chair from the purser, and settle down in my private haven with a desk and a view of following albatrosses. Koos's solution, he says, is to blot out the noise with anything at hand. I think he means brandy and Coke, but when I walk into the cabin one afternoon he's asleep with a pillow jammed over his head.

Somewhere between 50° and 60° latitude, south of Bouvetøya, the temperature dives suddenly towards freezing and I figure summer's over for us. We've crossed the Antarctic Convergence. Here the low-saline summer melt-water from the pack ice and bergs slides over the warmer Atlantic water, which plunges beneath the surface but continues southwards until it hits Antarctica's continental shelf. There, some of this warm water wells up, giving birth to rich blooms of phytoplankton. The rest mixes with high-saline water from beneath the ice shelf, then sinks and heads northwards again as Antarctic bottom water which feeds the world's ocean currents. The Convergence is a globe-encircling temperature curtain, arresting the dispersion of southern birds, fish, squid, krill and algae, all of which could not survive in warmer, nutrient-poor waters. Biologist David Campbell, writing

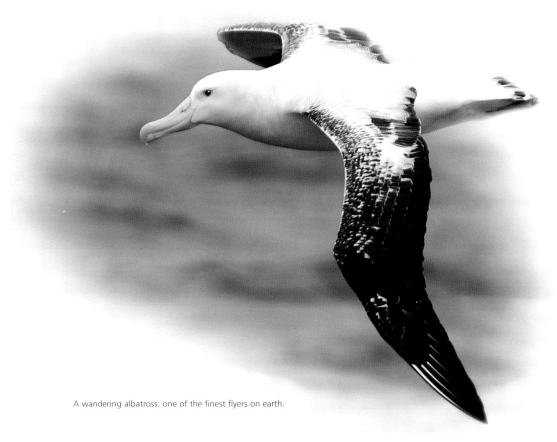

A wandering albatross: one of the finest flyers on earth.

in *The Crystal Desert*, calls the Convergence 'perhaps the longest and most important biological barrier on earth, as formidable as any mountain range or desert'.

Cook's daily record of his passage through these latitudes was a litany of 'very high swell', 'great swell', 'prodigious swell', 'sea ran prodigious high'. Ten-metre rollers are common and 30-metre breaking waves have been recorded. It's the very stuff of a seaman's worst nightmare.

The continent – alone at the bottom of the world and wrapped around by this wild ocean – has even more implacable defences than mere wind and waves. During winter, about half the ocean below the Convergence gradually freezes and locks the continent in an iron grip. At its peak, the pack ice covers an area the size of South America. In summer this breaks up into a maze of floes and drifting bergs.

Together, the North and South Poles are the engines of the world's ocean currents and weather, elements so intertwined that they're considered by meteorologists to be a single system. Wind pushes the upper layers of the sea, which flow as currents. This is happening, however, on a spinning sphere which, at the equator, is travelling at 1675 kilometres an hour. The earth goes one way and – rather like pulling the carpet out from under

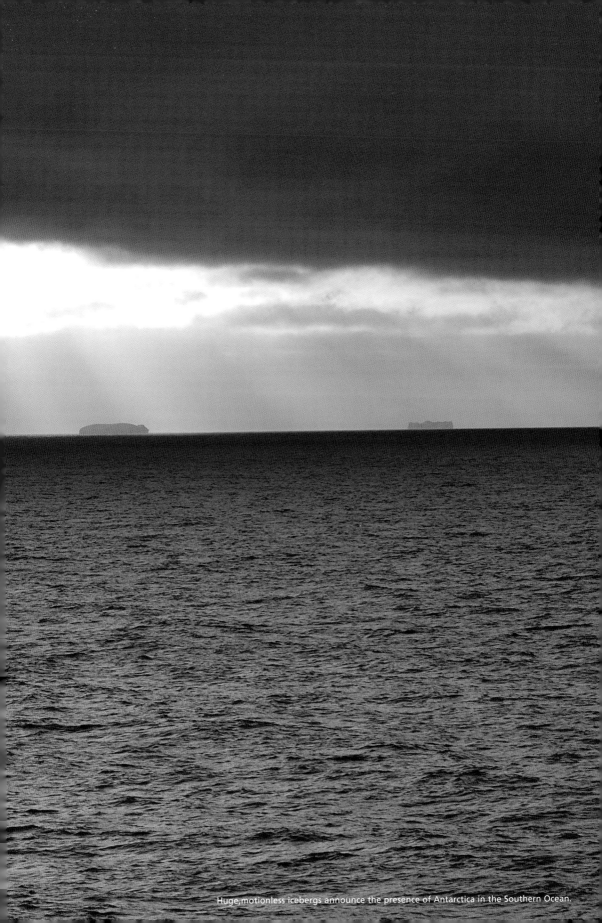

Huge, motionless icebergs announce the presence of Antarctica in the Southern Ocean.

someone's feet – the main streams of wind and water go the other. Oceans slop west and pile up against the eastern shores of continents. Sea level is a relative term.

Because water flows downhill, these piled waters create currents along eastern Asia, the Atlantic coast of the Americas, and East Africa which push north or south at really impressive speeds, seeking equilibrium. The Agulhas Current, after which our ship is named, is one of them.

Unaffected by wind, other currents also prowl the abyssal plains at depths of up to 10 kilometres (deeper than Mount Everest is high). By a process known as thermohaline circulation (or, more commonly, the global conveyor belt) cool, salt-saturated and therefore heavy waters of the Gulf Stream cascade to the bed of the North Atlantic between Norway and Greenland. Down south they do this at the edge of the Convergence.

The currents get saltier as they head away from the equator, for a number of reasons. Evaporation is one. Then, as the surface currents become super-cooled and eventually freeze around the Poles, salinity in the water rises because salt is excluded from ice when it freezes. This produces cold 'heavy' water which sinks to the bottom, pushing the water already there towards the equator through the ocean's depths. This occurs only in the North Atlantic and around Antarctica, because water in the northernmost limits of the Indian and Pacific oceans is too warm to sink.

The volume driven by this global pump is enormous. It's been estimated that in the North Atlantic, the salinated water mass plunges at a rate of 17 million cubic metres a second – more water than all the rivers in the world combined. Around Antarctica the volume is far higher, and there it supplies the world's great oceans with cold, deep water.

These ever-moving waters distribute heat around the globe – ensuring, for example, that Europe is warmer than Siberia. Ocean currents soak up tremendous volumes of carbon and provide a means for it to be safely locked away. Zillions of little marine creatures with unpronounceable names such as *foraminiferans*, *coccoliths* and *calcareous algae* capture atmospheric carbon to make their shells. When they die, thermohaline circulation drags them to the ocean floor where they eventually become limestone, preventing oxygen from combining with the carbon to create the greenhouse gas, carbon dioxide. (A 10-centimetre cube of limestone – chalk – contains more than a thousand litres of compressed CO_2.)

For life to continue as we know it, the planet needs to get rid of airborne carbon dioxide. It has been estimated that since 1850, when the Industrial Revolution began in earnest, humans have lofted an average of seven billion tons of greenhouse gases a year, including CO_2 and, more recently, chlorofluorocarbons (CFCs). Volcanoes and decaying plants put out nearly twice as much, but it may not take much to tip the balance. It's rather like shoving one of those old light switches: it takes a few pushes but the mechanism will finally snap.

An increase of a mere 6°C could cause the Arctic ice cap and Greenland's vast glaciers to melt, pouring fresh water into the North Atlantic. Even a modest amount of ice melt could

desalinate the Gulf Stream, preventing its waters from sinking. This would stop it in its tracks. As the global conveyor belt halts, it could eventually liberate all the suspended CO_2 and possibly huge beds of methane hydrate, an even more damaging greenhouse gas present in vast quantities around the fringes of the northern polar seas.

Without the Gulf Stream, much of the North Sea would eventually freeze over, bouncing back the heat of the sun and kicking off an ice age. Before then, as the temperature rose elsewhere, the boundless Antarctic ice deserts would begin to melt. Such a runaway greenhouse effect could destabilise the atmosphere to the point where little would survive. Greenhouse events appear to have happened in the past and life has bounced back. The carbon cycle reasserts itself and the situation re-stabilises. The problem, for us, is the time scale. Last time it happened the recovery took a mere 60 000 years. Recovery from the Permian collapse took a bit longer … about 150 million.

The signs are not encouraging. Carbon dioxide in the atmosphere is now 375 parts per million, the highest level for at least half a million years. Europe's winters are 11 days shorter than they were 35 years ago and Iceland's biggest glacier, the Breidamerkurjokull, is expected to slide into the Atlantic within five years – right into the teeth of the Gulf Stream.

I stare out over the vast, rolling waters and find it hard to believe small creatures like us could have any effect on them. Are the planet's systems really that fragile? Puzzling over this, I wander up to the seeming stability of the bridge to check our progress. According to the *Agulhas's* captain, Frikkie Viljoen, we are having an exceptionally easy time of it. The swells are only about five metres and the fine weather is holding. Frikkie says he considers the sea to be 'kicking up a bit' when the bridge kettle falls out of its mountings and the helmsman spills his coffee.

'You want to see this place after a Force 12 gale with 12-metre seas,' he says, indicating his office. 'Everything's on the floor. We just heave to, keep the bow into the wind and hang on.'

For Cook, on his journey out, it was far worse – sailing ships can't head upwind, so in a storm they roll. A day out of Cape Town the weather became vile. Sparrman took to his bed suffering from seasickness. As the two small vessels plunged south, their decks were swept by mountainous seas. The weather, according to Cook's journal, was 'pinchingly cold', with temperatures at night falling below freezing. On 10 December, close to 51°S and within the Antarctic Convergence, they came upon their first iceberg. The next day they thought they had sighted land, but it turned out to be another, immense berg. Water froze on deck, the sails and rigging grew icicles, ropes froze in the blocks and Cook issued an extra tot of rum.

One morning the *Agulhas's* horn rings for service incessantly and we are hauled out for lifeboat drill. We all muster on the heli-deck in ridiculously over-sized lifejackets with lights and whistles attached. We're counted, then troop off into crowded orange lifeboats with tiny, unpadded seats.

'These things drop with a bang, so you're advised to sit on your lifejackets,' we're told.

'How long can a person last floating in Antarctic waters?' someone asks.

'Oh, about three minutes, if you don't have a heart attack when you hit the water.'

Each boat holds 80 people, has some water and food but no toilet and no deck. Waiting to be rescued could be challenging.

::

Beyond the lounge, with its seemingly non-stop videos, bored passengers and dog-eared magazines, the changes are exciting. Off our stern, pelagic birds are massing: fulmars, shearwaters, skuas, Wilson's storm-petrels, pigeon-like Cape petrels and huge, soaring albatrosses. Most of these are tubenoses, so named because of raised, salt-excreting glands on their beaks. South of the Convergence there are fewer species of nesting bird than you'd find in a Cape Town park – just 39: eighteen petrels, six albatrosses, seven penguins, two skuas and a cormorant, a gull, a tern, a sheathbill, a pintail and a pipit. But what they lack in variety they make up in numbers – in total, around 70 million individuals, which together eat an estimated 7.8 million tons of krill and other zooplankton a year.[1]

These nutrient-rich, ice-sprinkled seas below the Antarctic Convergence are the pastures of the ocean, supporting vast numbers of creatures, from tiny diatoms to the largest ocean predators. Here the smallest flora and fauna on the planet feed the largest mammal ever to live, the blue whale, and countless other creatures. Huge blooms of phytoplankton – minute sea plants – are grazed by zooplankton and, particularly, by a shrimp-like crustacean commonly known as krill. These breed in vast numbers: one swarm tracked off Elephant Island in 1981 was estimated to exceed 2.5 million tons. Krill feed the fin, sei, bride, mike, humpback and blue whales as well as crabeater and leopard seals and Antarctic fish. Ever in their wake are killer whales – misnamed *Delphinus orca* (demon dolphin) by Linnaeus – which have managed to collect for themselves a fearsome reputation.

Wilson's storm petrels are astounding flyers: tiny scraps of black and white feathers that flit and swoop like swallows and so close to the mountainous waves it seems impossible to avoid plunging into them. How do they manage what David Campbell describes as their 'shuttlecock navigations and magical weavings'?

The masters of the wind, though, are the albatrosses – just now sooties, black-browed and wanderers. Their great wings scooped and seemingly locked in position, they slide up to the *Agulhas*, watching the waves, glancing at the ship, turning their heads to regard me standing on the heli-deck, only a few arm's lengths away. They radiate intelligence and presence, more than our equals in these storm-lashed oceans. Their huge wings are not rigid, as I had first thought, but seem to undulate, making constant micro-adjustments,

altering their geometry and exhibiting an incomparable, gravity-defying knowledge of wind and flight. They almost never deign to flap – when you're in the air for most of your life, flapping is uneconomical. They swoop down into the wave troughs, then up at right angles to the wind, using the different wind velocities and wave updrafts to propel themselves, effortlessly matching the speed of the ship.

Wandering albatrosses can live as long as we do and will circumnavigate the planet for years without touching land. One was radio-tracked across 25 000 kilometres over nine months, at times flying at speeds above 80 km/h. I spend hours on the pitching rear deck of the *Agulhas* photographing the companionable birds, aware of the privilege. Recording their magnificent presence fills me both with joy and, because they are so endangered, with sadness.

::

Each year in the heat of summer, around 10 000 icebergs are plucked from the ice shelf and spin in the circumpolar current like the rings of Saturn. Our first berg south of Bouvetøya is a shock. The massive iceberg is glowing, unmoving, defying the waves which thunder up against its weathered sides and fall back in haloes of foam. Its towering spires gleam white in a low Antarctic sun which is leaking beneath grey snowclouds. From every crack and cavity the berg radiates an intense indigo glow, as though it's being lit from within. The deep blues – as I recalled from what I'd read – are old burdened ice, the air

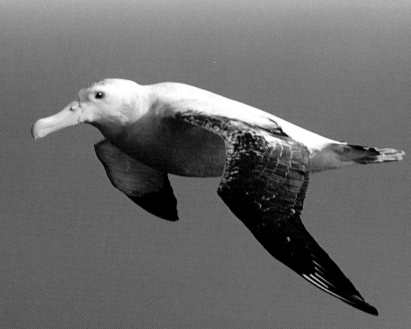

Wandering albatrosses can spend years without ever touching land.

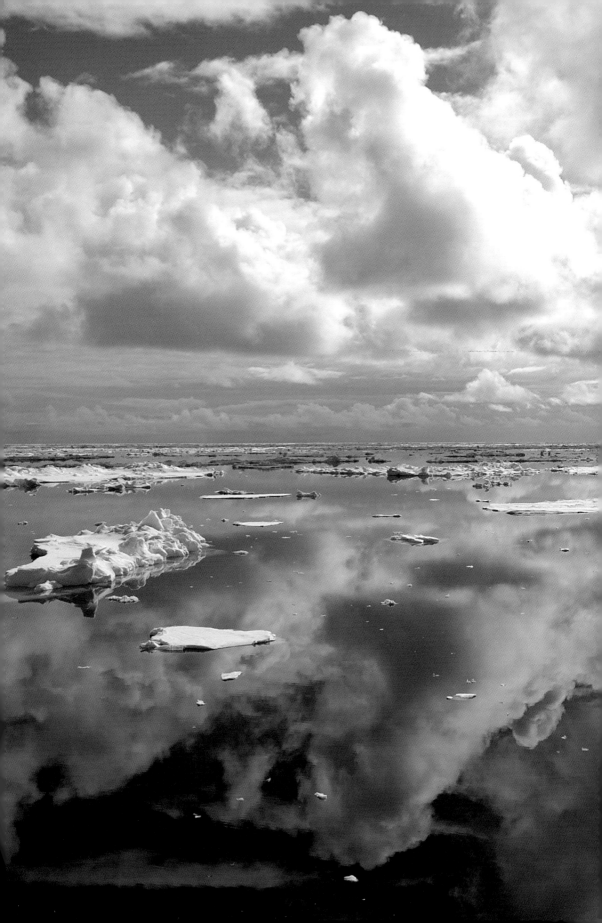

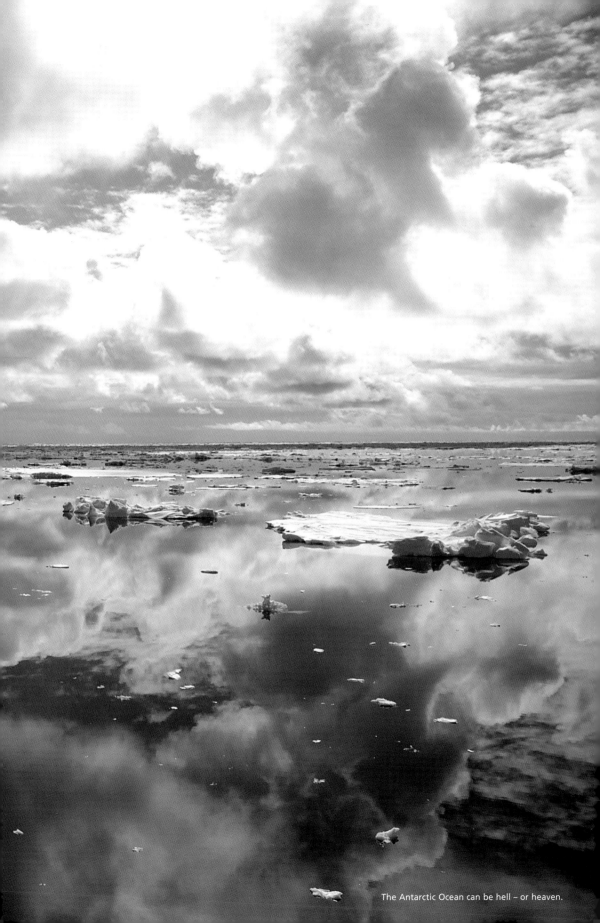

The Antarctic Ocean can be hell – or heaven.

squeezed out by the weight of vast layers and fathomless time. Another berg which appears is tipped precariously, showing a green underside, its angled tabletop reflecting the sun like a huge mirror. A humpback whale slices its fin through the midnight-blue surface and huffs, then dives, leaving a widening circle of ripples. To the east there's a brooding snowstorm, its vertical legs giving it the appearance of a gigantic floor brush. With *Titanic* in mind, I ask Captain Viljoen how he avoids colliding with them at night.

'We slow down and look out for them. The nasty ones are the growlers. They're dense blue ice with very little above the water. Hard as concrete.'

That isn't too reassuring. A week after our departure I wake early to scraping sounds. The ship is shuddering.

'Pack ice,' says Koos.

I go out on deck, shivering. Snow has cloaked the vessel and, beyond it, to the horizon, is ice – cracked, jumbled, some pieces like pancakes, others tipped as though a giant egg-beater has been at work. The pack seems to hang together in long, jumbled streamers. The air is freezing with snow falling in solid clumps of clustered flakes. Several large penguins are perched on an ice flow, discussing our presence. I'm chilled in seconds, my skin screaming for more layers, and I scamper back to bed. By breakfast time it's all gone and we're surrounded by nothing but a gently rippling ocean.

Come Christmas Day we're deep within the Antarctic Circle. I wake up confused by the stillness of the ship. Out on deck the scene is ethereal. Not a breath of wind disturbs a cobalt-blue sea so flat it appears to be colour without substance. Floating, to the horizon and seemingly suspended, are ice floes, sky-blue below and with surfaces like whipped meringue, looking like white holes of pure light. On one floe, an emperor penguin struts importantly, on another a leopard seal lounges, indifferent to 7500 tons of red research ship nudging its way through the pack ice. Apart from the soft throb of the *Agulhas*'s engines, it's a world of utter silence. Then we hit a floe with a scrunch and it either rolls to one side or splinters with a crusty, cracking sound. Despite the below-zero temperature, I stand at the bow, transfixed. Today we bid farewell to night. The sun rises, describes a lazy arc across the sky, then hovers low in the west and stays there past midnight without setting.

The next day it begins snowing big fat flakes. Like Christmas-card images they're beautiful, six-sided crystal stars. I bound round on deck catching them on my sleeve, hoping nobody is watching. Later that day we have a chopper briefing. Both pilots are named André, one tall and laid-back, the other short and intense. Short André Stroebel instructs us on how to crash, how we can get chopped up by the props, how to inflate a lifejacket, and he tells us to wear heavy weather gear while flying in case we come down. There is, he says, only enough food supply in the choppers for the crew, so we must fill our pockets with chocolate bars while flying. That explains the large packet of chocolates we'd been issued at the start of the voyage. Luckily I resisted the temptation to wolf them down.

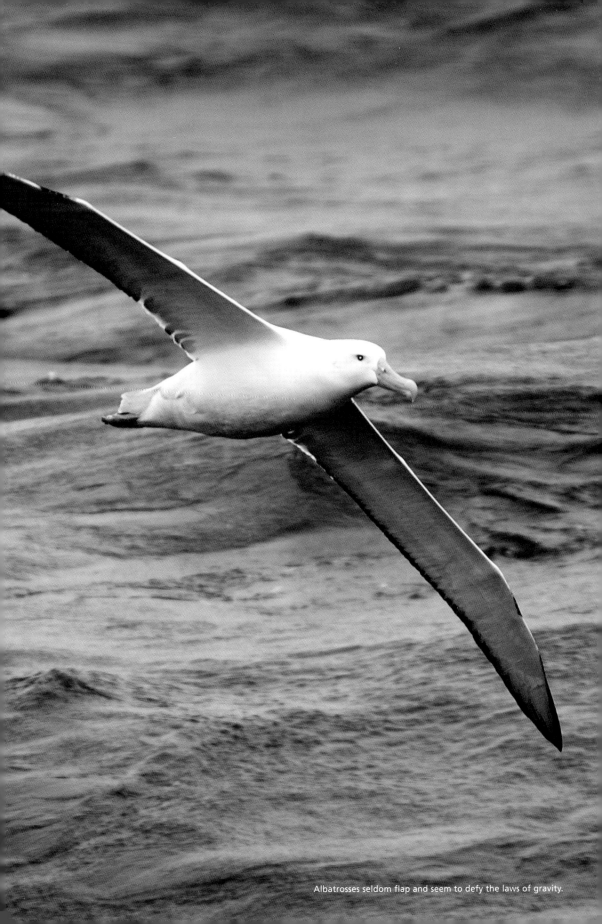

Albatrosses seldom flap and seem to defy the laws of gravity.

BIRDS ON THE HOOK

Once, deep in the South Atlantic aboard the RMS *St Helena* bound for Tristan da Cunha, I watched a wandering albatross tracking us like some anti-gravity fighter from *Star Wars*. 'That thing's incredible!' I exclaimed to ornithologist Warham Searle, who was sharing my perch at the stern as the ship pitched through the rollers.

'What's incredible is that it's still here,' he replied, gloomily. 'Seven years ago the waters around here were full of them. Each year I come here there are fewer and fewer.'

'Where have they gone to?' I asked.

'I think it's longline fishing,' said Warham. 'They're ripping the guts out of the oceans. Albatrosses and many other birds go for the baits and get hooked and drowned.'

Back in Cape Town I started investigating his remark. He was right. The numbers of wanderers, the largest flying creatures on earth, were dropping, and so were those of the other 23 albatross species. In their last three generations, wanderer populations have gone down by 20 per cent, and 21 species are considered endangered. The cause was, indeed, longlining.

Longlining is a relatively new fishing technique which boomed following the international ban on 'wall-of-death' drift nets. Lines of up to 130 kilometres with baited hooks every few metres are spooled or 'shot' overboard and then reeled in several hours later. Current targets include tuna, hake, swordfish and Patagonian toothfish. Because the line is generally shot from deck height, it's suspended in the air for some metres, then floats on the surface briefly before, hopefully, sinking. In the southern oceans hundreds of petrels and albatrosses will hang round a single boat. If they grab a bait, they can get hooked, pulled under and drowned.

I asked Basil Lucas of the Tuna Longline Association whether he was catching birds as well as fish.

'We catch maybe one or two birds on a trip,' he insisted, 'but that's it. We drop lines at night, we use bird-scaring *tori* lines and we don't throw offal overboard when we're shooting line.'

When I asked Barrie Rose, the fishing-quota director of South Africa's biggest fishing outfit, Irvin & Johnson, he said they mostly took hake, with one boat shooting for Patagonian toothfish. These, he pointed out, were both bottom fish and the longline technique – using fast-sinking line – reduced bird bycatch to a handful. The real problem, he'd said, were the Oriental fishing fleets and IUUs (illegal, unregulated and unreported fishing vessels). The Orientals – Japan, Taiwan, Korea and China – paid little heed to bycatches, he insisted, and IUUs – flag-of-convenience pirates registered in nondescript countries – obeyed no rules.

But at the tail end of a discussion about longlining at Marine and Coastal Management, researcher Barry Watkins slipped me a paper headed *Seabird Bycatch by Tuna Longline Fisheries off Southern Africa* by the Percy FitzPatrick Institute for birds and Marine and Coastal Management.

'I guess its okay to give it to you,' he said. 'But you're not going to like it. Actually, it's frightening . . . '

It was. The report was on the estimated mortality of seabirds within South Africa's 200-kilometre 'exclusive economic zone' (EEZ). It was compiled from observers on 13 commercial fishing boats, two being Japanese and the rest South African. Multiplying the average bycatch for each 1000 hooks by the 11 million hooks known to be shot in South African waters each year, the researchers had estimated the annual bycatch in local waters to be between 19 000 and 30 000 birds a year – 70 per cent of them albatrosses. Even though lines on the boats observed were shot at night, and despite the obvious fact that skippers with observers on board would tend to be more cautious, these numbers were scandalous. The locals were being less than truthful.

Beyond South Africa's territorial waters the situation turned out to be much worse. There are around 3.5 million fishing vessels operating globally. These catch about 94 million tons of fish a year of which an estimated 27 million tons is discarded as 'bycatch'. Not all of these boats are longliners. Not all the bycatch is birds – sharks, dolphins and turtles are also being dragged out – but a large proportion of it is. Around 100 million longline hooks hit the water annually. In blunt terms it is an ecological disaster.

For every ton of fish caught by a registered fishing vessel, it has been estimated that an IUU pirate lands 10 tons – and they don't care what else they kill. They fish in daylight when birds abound, they dump offal while shooting line, they use huge lights at night which attract both fish and seabirds, and they're mowing down southern-ocean pelagic birds like aquatic chainsaws. BirdLife International has reported that between legal and pirate boats, the Patagonian toothfish industry in the southern oceans kills around 145 000 seabirds a year, most of them white-chin petrels. But the tuna boats probably kill far more birds.

There are an estimated 15 000 sooty albatross pairs on Earth; royal albatross, perhaps 13 000; wandering albatross, a mere 8500 pairs. At present bird-catch rates, the end might come shockingly soon. Will our generation be the last to see these magnificent birds?

::

On 17 January 1772, Cook's two ships crossed the Antarctic Circle, the first men in recorded history to do so. They were escorted across the line by snow petrels. A few hours later, after sailing in comparatively clear water, their passage was blocked by a great mass of pack ice. Cook would have no way of knowing that the timing of his voyage coincided with the tail end of what would become known as the Little Ice Age, a century of low temperatures, advancing glaciers, freezing storms and undoubtedly more southern pack ice than we were experiencing. His ship's log for the summer of 1772/3 documented only three per cent of days as 'clear' or 'fine'. Cook reluctantly gave the order to steer northeast. A mere 80 miles to the south lay the unseen coast of Antarctica.

'The risque one runs in exploring a coast, in these unknown and icy seas,' he complained, 'is so very great, that I can be bold enough to say that no man will ever venture farther than I have done; and the lands which may lie to the South will never be explored.'

The commander decided to winter in New Zealand and set a course east within the Convergence. They encountered penguins and shot a sooty albatross. On 24 February Cook tried again to steer south, but was driven back by icebergs and growlers. His descriptions of the ice were later to influence Gustav Doré's frightening woodcuts for Dante's *Inferno*, a depiction of a descent into Hell. In thick mist the two ships were separated and Cook resolved to run for Tasmania and then northward into the Pacific, hoping to rendezvous with the *Adventure* as had been planned if the ships were to lose contact.

Nearly a year later, still having not sighted the *Adventure*, he tried for south a third time and nearly lost the *Resolution* against a huge iceberg. Sails froze into curved, metal-like sheets. This time the ship reached 71° 54'S in calm, clear weather, surrounded by hundreds of icebergs. Except for the hushed voices of the sailors, the only sound was the croak of penguins. To the south lay almost solid pack ice. Cook had no option but to turn north again.

> That there may be a Continent or large tract of land near the Pole, I will not deny. On the contrary, I am of the opinion there is, and it is probable that we have seen part of it ... Lands doomed by nature to everlasting frigidness and never once to feel the warmth of the Sun's rays, whose horrible and savage aspect I have no words to describe; such are the lands we have discovered.

As the *Resolution* came about, she backed up before the wind, and Sparrman, in the aft cabin, would also note that he had come closer to the South Pole than any other man. In 22 March 1775 – two years and four months after leaving Cape Town – the *Resolution* anchored in Table Bay. There Cook discovered that his lost ship, *Adventure*, had passed the Cape nearly a year earlier. *Resolution* spent five months beneath Table Mountain being refitted before sailing home.

Cook's discoveries had demolished the idea of a huge, inhabited southern continent. He'd redrawn the map of the Pacific and had laid the foundation for the coming age of scientific navigation. He would return home to fame, another voyage of discovery and his untimely death in Hawaii by a native spear. Sparrman remained in the Cape, where he became one of the foremost naturalist explorers of the day. Dalrymple and his southern paradise faded from history.

::

We, unlike Cook and his fragile vessels, make it through the ice floes and are about to venture to the lands he predicted would never be explored. Up on the bridge, with the *Agulhas* nosing ahead at three knots, concentration is intense. I turn on my voice recorder:

Captain: 'Just cut the edge off that floe, then go hard to port.'

Second mate Anne: 'Right, Captain.'

We bump the floe. The ship shudders and is deflected to starboard, the ice screeching its way protestingly down the side of the vessel.

Captain: 'Okay, hard to port now. Then straight through that lane. What you steering?'

Anne: 'Two ten. I'll take her in just to the right of that iceberg.'

Captain: 'Fine. Maybe ram that floe. We can break it.'

Anne: 'This is like dodgem cars. I wonder how those old sailing ships managed. Just look at that beautiful iceberg! Such deep blue – it's indescribable.'

The *Agulhas*'s bow rises up over the floe and stops, its prop churning. Then the ice breaks with a crumbly sound and we push forward again. On a CD player in the background Schubert's Unfinished Symphony is rising and falling with the floes drifting past. As we draw level with the blue iceberg, another appears off to starboard, pinky-grey and cloaked in mist.

Anne: I just love this place.

Here and there Weddell and crab-eater seals are lazing – dark slugs in a white-and-blue world. Emperor penguins toboggan on their stomachs across the floes or waddle and sway in the manner of fussy old men. Great tabular bergs lord over the floes like white mesas in a white Karoo. Through this fantasy we sail further and further south, as if in a dream.

The albatrosses leave, but we're joined by the white angels of the south: snow petrels. They seem to be scraps of flying ice, soaring and chasing one another across the ship's bow, their coal-black eyes startlingly out of place in their milk-white faces. They whirl

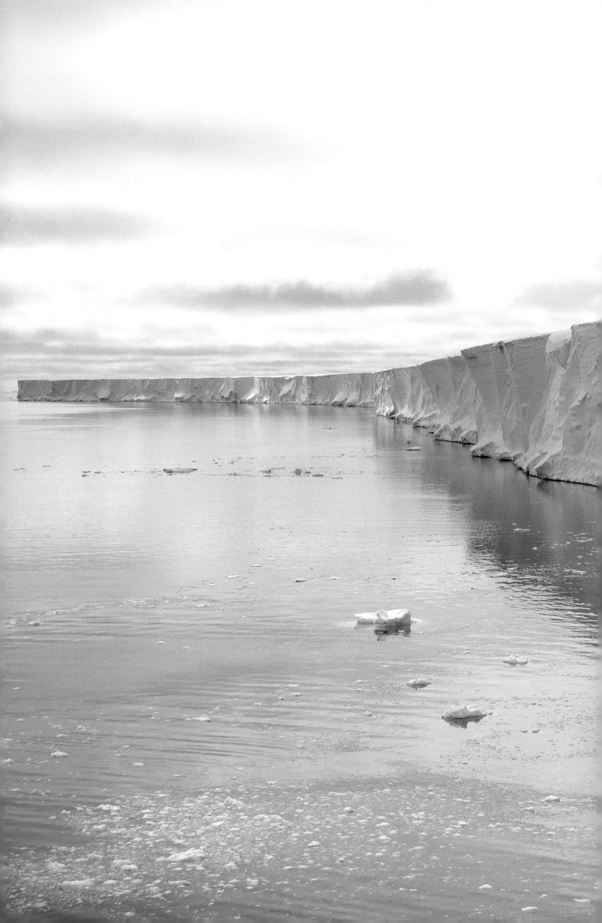

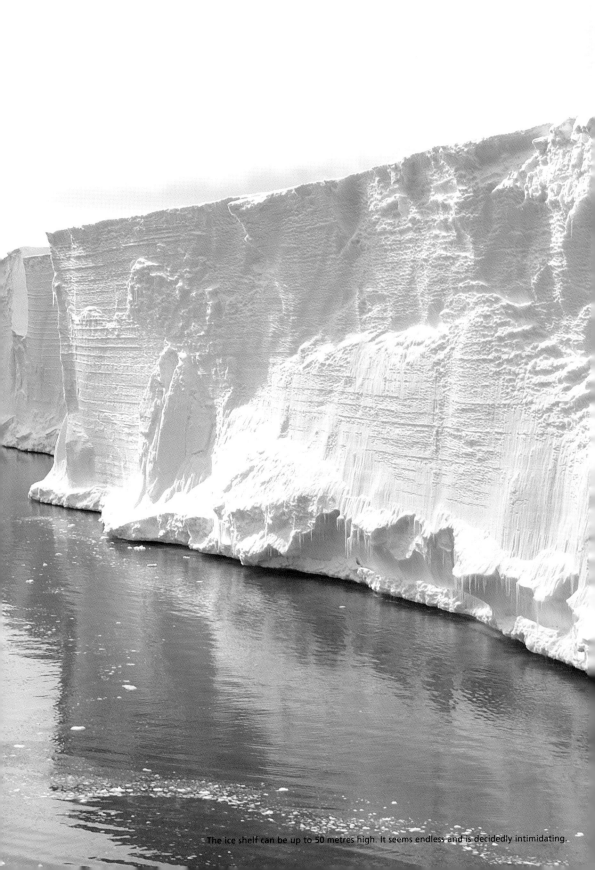

The ice shelf can be up to 50 metres high. It seems endless and is decidedly intimidating.

upwards, higher and higher, then dive down almost vertically and whiz across the ship's bow, playing with the wind and each other. I'll be sorry to leave these waters of wonder.

The day after Christmas, Antarctica's massive ice skirt appears. It's a stupendous sight: a wall of ice maybe thirty metres high stretching across our bows from east to west. It glitters in the sharp sunlight. When we nose up to it, the shelf is higher than our foredeck. It has annual stripes the way a tree has rings: I count fifty years sticking out of the water, with several hundred more below.

When Robert Falcon Scott first encountered the edge of the ice shelf on the *Discovery* expedition in 1905, he was floored by its implications. 'It is not what we see that inspires awe,' he wrote, 'but the knowledge of what lies beyond our view. We see only a few miles of ruffled snow bounded by a vague wavy horizon, but we know that beyond that horizon are hundreds, even thousands of miles which can offer no change to the weary eye, while on the vast expanse that one's mind conceives, one knows there is nothing but this terrible, limitless expanse of snow …'

The skipper wedges the *Agulhas*'s bow against the shelf and holds her there with the prop slowly turning. Then the crew begins offloading the first cargo: huge Challenger SnoCats, a bulldozer, several skidoos, large cargo sleds and many containers. While this is happening, the Cat train from South Africa's inland Sanae 4 base arrives. They've been travelling almost non-stop for 35 hours.

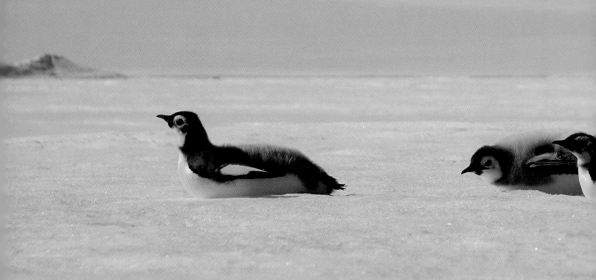

Young emperors have no fear of humans and are insatiably curious.

From the top deck I look across the ice fields. My first impression of Antarctica is its clean, unbroken, eye-searing whiteness and the clarity of every line. Each edge – the shelf, surrounding icebergs and the long scythe of bay ice – seems sharp, crystal, mathematically precise. Then the emperor penguins arrive. They stand out from their snowy background like exclamation marks on a blank page. These are youngsters, not yet fully fledged and obviously in need of entertainment. A welcoming party to the white continent.

After the Cat train is loaded and departs, I kit up with everything I've got and hitch a ride ashore on a chopper, which deposits me near the penguins and flies off on some mission. I'm all alone on the ice with the birds. They look more interested than scared, but I don't want to frighten them so I sit down. *I'm sitting on Antarctica!* I pat the ice in disbelief and have the oddest sensation: I'm home. Being here fulfils a longing I didn't know I had until then: to be in a place without humans, without roads or noise. Somewhere unowned. Between me and the other side of the continent, thousands of kilometres away, there may be only one or two footprints – probably none.

After a bit of skraaking, flipper flapping and shuffling, the emperors waddle over to see if I'm worthy entertainment. They give me a thorough inspection from about three metres, then decide the ship is more fun and make their way over to the edge of the shelf. There they line up to watch operations, an intrigued audience.

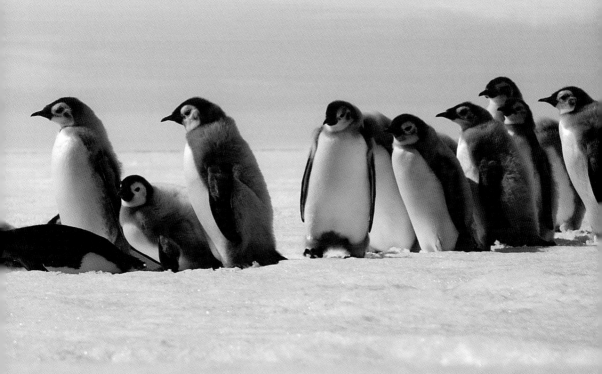

I stand up to discover a group of around twenty more heading my way. I walk slowly towards them, then lie on my back, in the belief that if I'm not higher than them I won't appear threatening. Strangely, it doesn't feel cold lying there, probably because it's too cold for the ice to melt, leaving my clothes desert dry. What follows is pure theatre. A penguin steps forward, then looks back to see if it's being followed. If not, it stops. But if another steps forward, the leader keeps moving and draws the whole group along. After a metre or so they all stop and discuss their progress with much flapping and self-congratulation.

Birds at the back, however, shuffle forward to get a better view, at which point a front runner interprets this as 'being followed' and the group advances again, frustrating the attempts of those at the back. Then they all stop and the process begins over again. In this way they approach to within a few metres of my boots, curious, cautious but unafraid. When nothing but my camera moves, they give up on me and shuffle or toboggan towards the other group. These they meet in the most formal and, dare I say, human manner. The two groups face each other, bow, skraak, whistle and flap. After about a minute or two of this, they all join together and become a single group. Awfully formal, emperor penguins are.

::

We're ferried to South Africa's Sanae 4 base in a bright, Vietnam-style Huey chopper. I stare down at the unspooling ice shelf that looks like a rough-plastered white pavement and then at the dark mountainous edge of Queen Maud Land. 'Glittering white, shining blue, raven black in the light of the sun, the land looks like a fairy tale,' the Norwegian explorer Roald Amundsen wrote. 'Pinnacle after pinnacle, peak after peak – crevassed, wild as any on our globe, it lies unseen and untrodden.' He would have loved to see it from the air.

The base is perched on bright blue legs atop Vesleskarvet (Little Barren Mountain), a rocky nunatak on west side of Ahlmann Ridge, protruding from the ice about 200 kilometres inland from the edge of the shelf. The round-edged building in bright orange, white and blue consists of three double-storey units on stilts joined by interleading passageways – links – that also serve as access points to the outside. I'm bemused by such practical comfort in such a hostile environment. It has a heli-deck, several generators, living quarters, labs, offices, a games room, lounges, a large dining room, a gym and a pub. A few weeks later I will find the sauna tucked behind the engineering offices. It's a veritable Holiday Inn on ice. Even with the temperature outside about –40°, people are walking around inside in T-shirts and jeans.

Top: Without choppers, Antarctica would be a much tougher place to visit.
Bottom: From the air Sanae 4 seems remote and lonely atop its nunatak in Queen Maud Land.

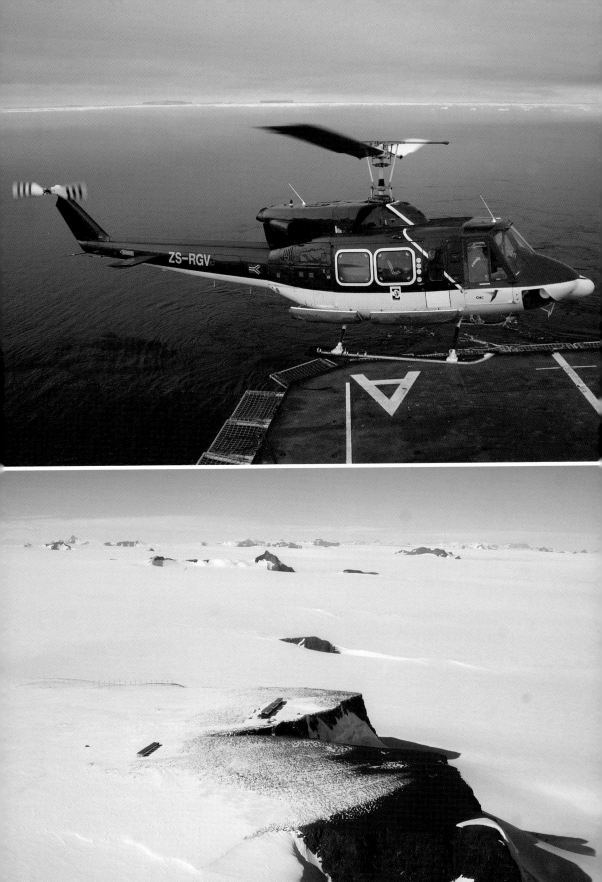

I wonder how the nine over-wintering team members must be feeling about this sudden influx of strangers to their icy fastness and how they have coped with the dark isolation of winter. I figure – lonely as life must have become – they must have dreaded it.

As the sun dips towards the west but refuses to set, I peer out of one of the double-glazed windows at the cliff edge. Antarctica beckons. So I head for the link – which is like an airlock in a spacecraft – where the outside gear is stored in locker baskets. This room is where you transform yourself from a human into a polar bear. I kit up – for the third time that day – in thermal underwear, polar fleece zip-up, down jacket, snow pants, weather-proof jacket, snow boots with thick felt inners, two pairs of gloves, a balaclava, a woolly hat with ear muffs and finally snow goggles. I'm not taking any chances. Then I step out of the door.

The cold is shocking. Breathing through my nose causes the cloth of the balaclava to ice up almost immediately, limiting the airflow. But if I breathe through my mouth, my lungs feel as though they're filling up thorns. Clouds seem to be exploding out of the low sun and shooting over my head. I trudge towards the edge of the nunatak over dry snow. It's

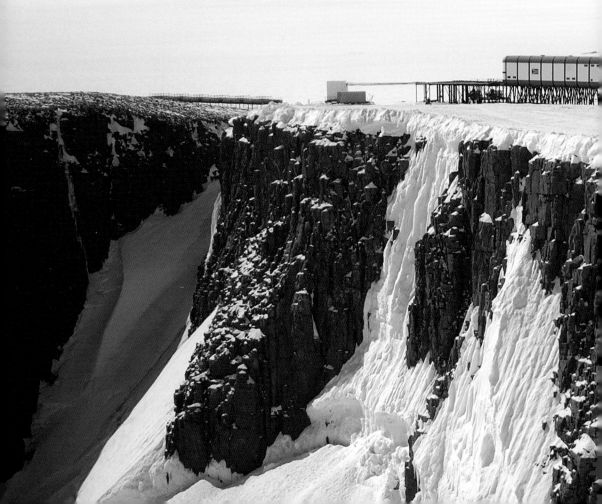

like walking on squeaky polystyrene balls. Up a slight rise are brown rocks smashed by constant freeze and thaw. Because they're dark, these rocks absorb the thin summer sun which melts the ice between them. When this re-freezes it's hard and slippery, as I discover when I step onto it and come crashing down. A second good reason for thick clothing becomes clear: in Antarctica you fall over a lot.

I sit on a flat rock at the cliff edge. Near my perch, a couple of snow petrels chase each other in tight arcs, their wings flashing, transparent scimitars as they cross the sun. I notice, for the first time, the spectral quality of the light: the air is invisible. In temperate zones air contains water vapour, dust, pollen and pollution. You judge distance by the purpling of the atmosphere. Here I seem to have X-ray eyes. To the east, west and north the ice desert disappears into the cloud-smudged horizon, perhaps fifty kilometres away. But to the south are the sharply angled, ice-cloaked mountains of Queen Maud Land, so close in the crystal air I seem to be able to reach out and touch them. The ice fields, covered in drift snow, look like undulating silk. Everything seems to shimmer. I decide then that Antarctica is the most beautiful, heavenly place I've ever seen.

The South African base looks like several giant millipedes in convoy.

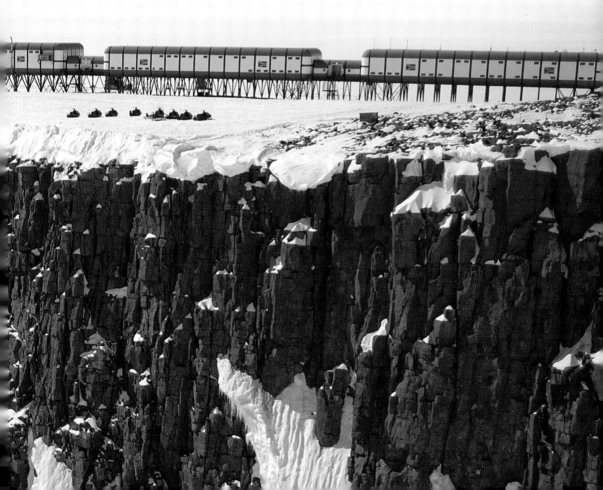

Blood and discovery

A new land has been discovered off Cape Horn lat. 61 long. 55 by the ship *William* on a voyage from Montevideo to Valparaiso. The fact is susceptible of no doubt – the same ship was again dispatched there by Capt. Sherriff, of the *Andromache* frigate, to survey the coast, which the *William* explored for 200 miles. The captain landed, found it covered with snow, an abundance of seals and whales – no inhabitants.

New York Mercantile Advertiser, 1820

Until 1820 no human had stepped ashore on the ice shelf of Antarctica, although it had been sighted. It was generally accepted, though, that what lay to the south was, in Cook's words, 'doomed by nature'. His charts and diaries, though, had alerted others to certain possibilities down south. One group was sealers who, by the late eighteenth century, had discovered a profitable and insatiable market for fur seal pelts in China. Seal skins – mistakenly described as sea otter pelts – are covered in stiff guard hairs, but the Chinese had discovered a method of removing these, leaving only the soft under-down. In 1786 a single load of skins aboard a United States ship earned $65 000 in Canton, a huge sum in those days.

With such returns, southern fur seals were doomed. American and British sealers pushed ever further south, clearing the swarming beaches of seals in South Georgia, South Sandwich, Crozet, Marion, Prince Edward, Macquarie and the Kerguelen islands. Sealers would work an island until the beaches were empty, then move on. Realising their plunder would afford them only a few seasons, they kept their discoveries secret. When others invaded 'their' beaches, wars were fought with fleshing knives and guns. One sealing skipper gave the following advice to a friend about to set sail on a sealing trip:

> If you got out there early and saw a great show of seals, I should get as many on board as I could without running any risk of not getting back in time. I would leave on the rocks all the men that I thought would blab; go to the most convenient port, ship my skins, get what I needed and go back to the rocks … and I should expect to have another season without company.[2]

The plunder of southern fur and elephant seals began around 1775 when a British sealing fleet of 16 vessels based itself in the Falkland Islands, and ended only around 1930. Beach after beach was picked clean and left, blood-stained and empty of mammals. The last expedition netted a mere 785 and failed to pay the costs of the expedition.

Killing was a bloody business. Elephant seals were not valued for their pelts but for the large amounts of oil that their blubber contained. Young males and pups were clubbed on the snout, then lanced to make them bleed. The larger bulls were prodded to rear up, shot in the mouth, then lanced. A chronicler of one expedition recorded that when bulls tried to defend their harems, they were blinded in one eye and 'it was laughable to see these old goats planted along the beach keeping there [sic] remaining peeper fixed in their

seraglio of Clapmatches [females] while the sailors passed … unheeded between their blind side and the water's edge'.[3] This way females were easier to kill, and their bodies were carted away while their mewling pups were left to starve.

Blubber was cut away, minced into smaller chunks and boiled in a cauldron-like tri-pot. It produced an oil equal in quality to the best whale oil and, in the late eighteenth and early nineteenth centuries, lubricated the machinery and lit the street and home lamps of much of the civilised world. After the 1820 season hunt, around half a million seal skins were traded on the London market alone. This excludes all those killed for their oil and boiled on the spot.

It is difficult to assess the true numbers of seals killed. A meticulously researched book by Robert Headland with the rather laborious title of *Chronological List of Antarctic Expeditions and Related Historical Events* records many sealing expeditions where numbers caught were not given, but those that were listed are startling enough.[4] In the heady early days of newly discovered islands, a single ship could return with 60 000 fur seal-skins and several thousand barrels of elephant-seal oil. Sometimes the catch could be much higher. A United States sealing expedition to the Antipodes Islands bagged 400 000. From one island alone, San Ambrosia, 3.5 million seal skins were taken in 14 years.

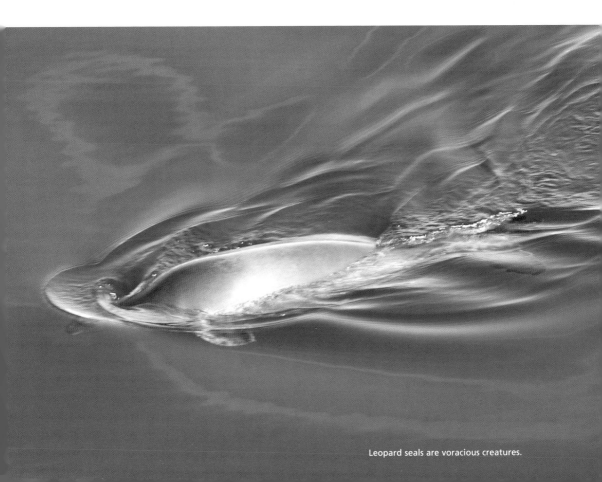

Leopard seals are voracious creatures.

Around 1800 a base for southern ocean sealing was established in Cape Town and, for the next 130 years ships set out almost annually to scour the islands of South Georgia, Tristan da Cunha, Prince Edward, Crozet, Saint Paul, Heard, Gough, Marion and Kerguelen for their prey. There may have been a number of South Africans among their crews who sighted the Antarctic shelf and even walked upon it, but if they did they left no records.

This lucrative hunting bred risk-takers who drove their ships and their crews south through huge seas, looming icebergs and bitter cold. Each season greed and plunder pushed them further and further towards the unknown continent. Most captains cared for little beyond a seal-covered beach or a profitable cargo. But there were a few, like 28-year-old William Smith – part owner and skipper of a converted North Sea collier from Blythe, England, that went under the odd name of *Williams* – upon whom the south exerted a magnetic attraction.

Smith hailed from Northumberland and, like Cook, had earned his ticket in the coal-hauling business. His enterprise was neither coaling nor sealing, but shipping merchandise to Valparaiso in Chile. Rounding the Horn in 1819, a southwest gale blew him south and he sighted land, an island later to be named Livingstone, part of the South Shetland group. His interest piqued, he pushed south to 62°, where he found the sea alive with seals and whales. The terms of his insurance, however, precluded exploration, so he came about and sped to Valparaiso.

The news of his find soon got out but was treated with contempt by officials and Royal Navy officers, who thought he was lying. Perhaps spurred by this slight on his character, Smith steered on his return journey to 62°S but, being east of his previous position, saw no land. On rounding the Horn on another trip three months later, he sailed south again and found himself two degrees further south than Cook had been. This time the Royal Navy was interested and promptly commissioned his vessel for a return to his discovered islands, appointing Edward Bransfield as master and Smith as pilot.

They sailed south and claimed King George Island for Britain by planting a Union Jack and a bottle of coins. From there, the *Williams* continued along the southern shores of the South Shetland Islands, rounded an island peak they named Tower Island and then continued to Trinity Island. From there, they found themselves staring at the mountain ranges of the Antarctic Peninsula. It was, as a midshipman recorded in his journal, 'a prospect the most gloomy that can be imagined, and the only cheer the sight afforded was the idea that this might be the long-sought Southern Continent'. In that, he was correct.

Smith, relieved of the charter, later fitted out the *Williams* as a sealer and returned to the South Shetlands. But word of his southern exploration had leaked out and he was appalled to find 15 to 20 British and 30 American sealing ships in the vicinity. The slaughter of the South Shetland seals had begun.

It would be the fate of history that the crew of the *Williams* were not the first to confirm a sighting of Antarctica (Cook's had been speculative). That honour is accorded to two Russian navy ships, under the command of Fabian Gottlieb Thaddeus von Bellingshausen, which had sailed up to the ice shelf of Queen Maud Land two days before Smith. At 69° 21'S they encountered 'continental ice of exceptional height and on that magnificent evening, looking from the cross-trees, it extended as far as the eye could see'. He didn't claim it was a continent, but history would give him the benefit of the doubt.

In its scope and achievements, the journey of the *Vostok* and *Mirnyi* equals that of Cook. Indeed Von Bellingshausen was a great admirer – a virtual disciple – of the British captain and he saw his journey as a continuation of Cook's search for a southern continent. The voyage was undertaken at the behest of Tsar Alexander in order to 'train a cadre of seamen and to discover lands for establishing future permanent sea communications or places for the repair of ships'. Von Bellingshausen was given 190 men, including an astronomer, an artist and a priest.

The Russians spent three weeks in Rio de Janeiro, a town which Von Bellingshausen found disgustingly dirty. Then, in January 1820, he set a course for South Georgia. From there he

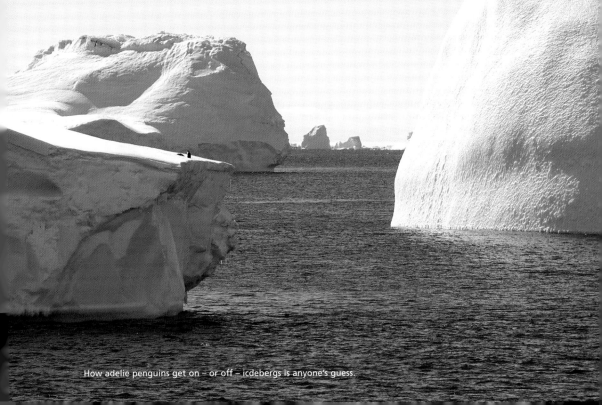

How adelie penguins get on – or off – icdebergs is anyone's guess.

surveyed the Sandwich Islands – charted earlier by Cook – and discovered an island volcano with stinking fumes rising out of its caldera which he named Zavodovski (its highest point is today named Mount Asphyxia). Just west of the Greenwich meridian, Von Bellingshausen turned south, crossing the Antarctic Circle. A day later his ships were within sight of huge ice cliffs, two days ahead of Smith. They were most probably the continent's shelf, but Von Bellingshausen wasn't absolutely sure:

> We observed a great many large high flat-topped icebergs, surrounded by small broken ice, in places piled up high. The ice towards the south-south-west adjoined the high icebergs which were stationary. Its edge was perpendicular and formed into little coves, whilst the surface sloped upwards towards the south to a distance so far that its end was out of sight even from the mast-head.[5]

There is a sad irony about both these discoveries. The journal of the *Williams* exploration was sent to the Hydrographic Office in England where it was lost. And William Smith slid into poverty. He became master of a whaling ship in 1827 but was fired three years later. A year after this, his pilot's licence was revoked due to 'reduced skills'. He petitioned the British Admiralty to be remunerated for discovering Antarctica but it was refused and he died in an almshouse, poverty-stricken and forgotten.

Von Bellingshausen – who sailed on into the Pacific as Cook had done, circumnavigated Antarctica and clocked up 57 073 nautical miles – arrived home in Kronstadt to no official Russian reception. Reports of his voyage were treated with indifference, the more pressing problems being the Russo-Turkish War. His comprehensive charts were studied then shelved. The explorer's findings were not published for another 10 years and created a sensation only when they were translated into English in 1945. Von Bellingshausen, however, became military commander of Kronstadt and eventually attained the rank of Admiral. It took the Russian government more than a hundred years to lay claim to the first discovery of Antarctica.

As to who first jumped ashore on the Antarctic continent, nobody is sure, but it also occurred in 1820, an auspicious year for polar firsts. *Cecilia*, a small, schooner-rigged tender to the New Haven-based sealer *Huron*, was sent ahead of its mother ship in the South Shetlands to spy out a route south. The small boat nosed her way into a large bay with the land 'high and covered entirely with snow'. The crew scrambled onto the beach, but the weather closed in and, after an hour, they boarded the *Cecilia* and headed back. The area is Hughes Bay and the unnamed men were the first humans known to have walked on the shores of Antarctica.

The first circumnavigation of Antarctica was accomplished by two sealing vessels, the *Tula* and *Lively* captained by John Biscoe and George Avery from the sealing firm Enderby Brothers. They hunted and charted their way through storms and freezing conditions, inscribing finally as they did the extremities of Terra Incognita.

LEVIATHANS ON THE EDGE

There is a footnote to the sealing debacle. Long before the crash, another lucrative reason to take risks in the southern oceans had been found: whaling. Hunting these huge mammals had begun in the 19th century in the northern hemisphere and by 1846 there were nearly a thousand whaling ships in the world's oceans. But by the end of the century whales in these latitudes had been hunted to near extinction and the catchers turned south. By 1902 the Norwegians were using steam power and would develop factory ships to process whale blubber, from which oil was extracted.

By 1910 – when whale catches began to be systematically recorded – there were 48 whale catching ships in the southern ocean which took 10 230 whales. Bow-mounted cannons with exploding-tip harpoons had been developed and began taking their toll. Twelve years later there were 60 catchers and 13 factory ships operating in the region, and six years along there were 111 whaling ships, which accounted for more than 20 000 whales. In the freezing seas, conditions for the crews and those who sliced up the great beasts were terrible. It was said among whalers that beyond 40° South there was no law, beyond 50° no God. In 1920 some deeply discontented men – described as 'Bolsheviks' in a colonial report – called a strike in a South Georgia whaling station, intending to create the first Marxist state outside of Russia, but the strike collapsed when a British warship entered the harbour.

In 1929 an International Whaling Commission was established and declared the creatures in need of protection. Its recommendations were ignored: that year 30 000 whales were caught, the following year 50 000. In 1931 the International Convention for the Regulation of Whaling was signed by 26 nations, effective from 1932. But whaling continued unabated, with 24 000 creatures killed in that year, then 26 000 and 31 000 in the years that followed. The season of 1937/8 bagged 46 039 whales. In 1930 signatories to the Whaling Convention met in London and promised to enforce agreements through their governments. A whaling sanctuary was established from 40°S. This, too, was ignored. Eight years after the sanctuary was established, southern whalers hauled in 38 000 carcasses.

When World War Two ended, the International Convention for the Regulation of Whaling was signed by most whaling countries and again ignored. Ten years later the catch was still 36 000. In 1965 the Whaling Commission imposed quotas to no avail. There was clearly only one thing which would stop whaling: population collapse. That began in 1975. Two years later whalers began catching previously ignored and smaller minkes. Then in 1979, with virtually no whales to warrant the cost of an expedition, the Whaling Commission banned all whaling in the southern ocean. That didn't deter the catchers, particularly Norway and Japan, but by 1988 only 273 whales were caught. The party was over.

In 1990 the International Whaling Commission made an estimate of the southern whale stocks. It makes sad reading.

Humpbacks, 3000 left of an estimated original 100 000.

Blue whales, 500 of an original 180 000.

Fin whales, 2000 of an original 400 000.

Sei whales, 1500 of an original 150 000.

Right whales, only a few hundred.

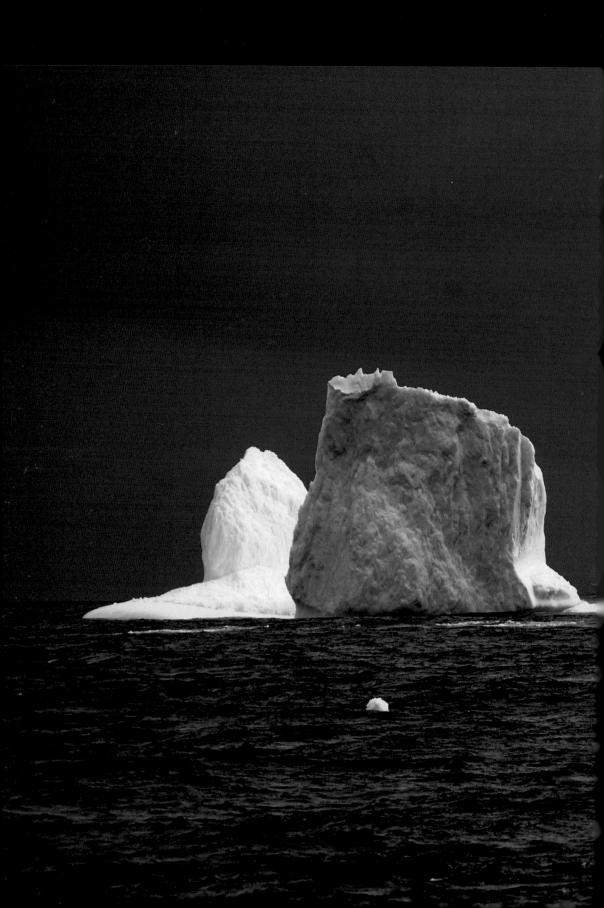

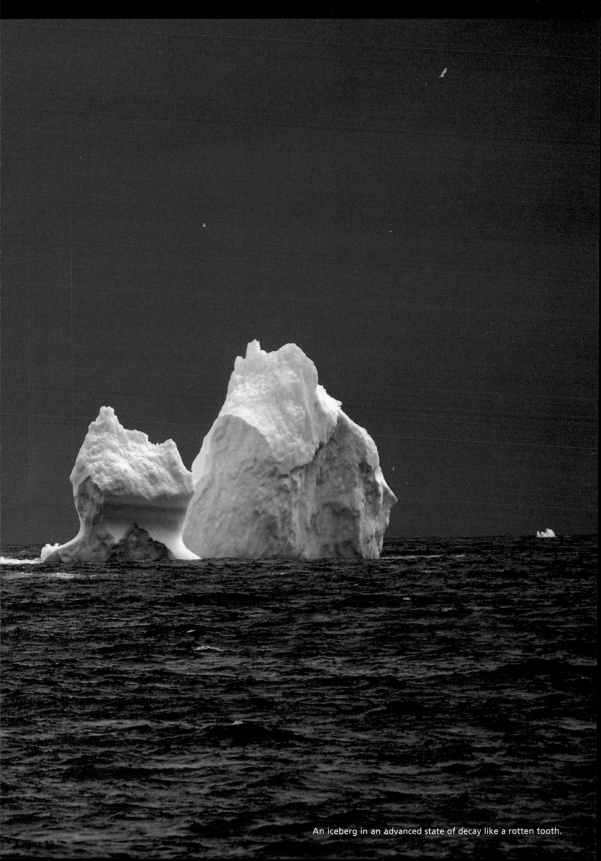

An iceberg in an advanced state of decay like a rotten tooth.

Onto the ice desert

Ice is the beginning of Antarctica and ice is its end. As one moves from perimeter to interior, the proportion of ice relentlessly increases. Ice creates more ice, and ice defines ice.

Stephen Pyne, *The Ice*

I wake up on my second day at Sanae to find the temperature outside way down with a wind-chill of –25, so exploring the base seems a better option than taking a walk. All along the passages hang old photographs of previous bases, sledging expeditions and the much-beloved huskies. There is a nostalgic black-and-white shot of Sanae 2 looking half swallowed by ice and one of Sanae 3 looking much the same. No wonder the present base is built on stilts atop a mountain: you don't have to keep digging it out or having it crushed by ice.

In each of the links between the base's two pods are Perspex-fronted cabinets which contain a mixed collection of objects: a cracked emperor penguin's egg; a glass polar bear in a case presented in 2001 by the Antarctic Treaty inspectors (a polar bear?); a plastic snowman; an aeroplane in a glass dome that snows when you shake it; a tattered book entitled *Don't Panic!!* full of mainly scatological scribblings; a rusted tin of Pure Danish Plum Butter and another of MacConochie's Scotch Smoked Kippered Herrings; a silver Russian tea samovar; 13 ancient Bachelors Beef and Pork Bars; various weathered pieces of clothing and pairs of boots (one labelled Canadian Bush Boots); a packet of Forget-Me-Nots issued by Amnesty International; various rocks found on geological expeditions; two lethal-looking flare guns and a stack of old documents. Among this memorabilia I find a photocopied report on the origins of South Africa's relationship with Antarctica. I borrow it for later reading.

After my foraging, I walk through the dining room and find the Public Works Department guys, all in blue overalls, taking their tea break very seriously. Their department owns the building and, year after year, these men endure the long sea voyage and Christmas away from home to repair, rebuild and paint the base. Many are experienced ice-men and they establish comfortable routines which include strict teatimes with sandwiches, cakes and the occasional pizza. I decide they may have hogged the table on the ship, but here they're a good crowd to get to know. The building inspector, Kim Gierdien, turns out to be something of a Renaissance man, with interests ranging from practical construction through religion, photography, philosophy, politics and history.

'I saw a mountain move once,' he told me, staring over the ice fields. 'People may not believe me, but this storm was coming at it from behind and it sort of shrugged and shoved the storm off its side. I couldn't believe it. It may sound fantastic, but once you've been here a while you'll see. This place is different. Things happen here you don't see anywhere else.'

Kim had been a gangster ('out of necessity – it was the only way to get to school unhurt'), a political activist in South Africa's stormy 1980s and a rugby player with provincial-level potential ('I got the cap and the jersey, then figured there were other things I had to do'). These days he makes sure people have good houses 'because they deserve them'.

'I came to Antarctica ten years ago as a nobody without the vote,' he tells me. 'Now I'm back for the anniversary of my freedom. I didn't plan it that way, but I can tell you it feels good.'

::

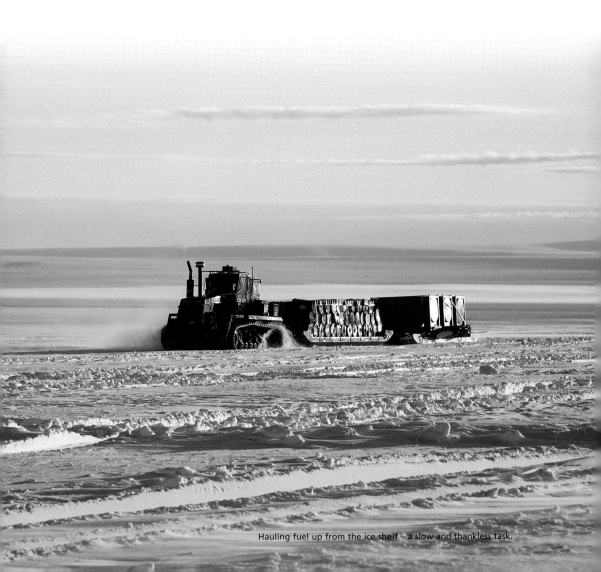

Hauling fuel up from the ice shelf – a slow and thankless task.

After a few days I've explored the base and start planning how to get beyond it, remembering Sarah Wheeler's comment in her book *Terra Incognita* that big bases are places you need to get out of in order to really experience Antarctica. That gets me thinking about E-Base, a satellite outfit down on the shelf ice. It had been an emergency retreat for Sanae 3 before the latter was swallowed by ice, and was still being used as a stopover for the transport drivers ferrying goods and fuel from the ship up to Sanae 4. I nag and finally get the go-ahead to travel with the drivers, but am warned that the trip isn't going to be comfortable. This will prove an understatement.

I am duly assigned to Gary Harper and John Skelete, who are, just then, running polar diesel up from the shelf in 25-ton tanks on the type of sleds I'd failed to recognise back in Cape Town. Their vehicle is a Caterpillar Challenger – a yellow, rubber-tracked monster topping nearly four metres at its cab roof and powered by 10 000 cc straight six diesel motors each delivering a massive 300 horsepower.

We leave Sanae early one morning. The sky is blue and the temperature an uncommonly warm -1°C. Without polaroids or snow goggles the searingly white ice will blind you in half an hour. We thud down the nunatak over several crevasses and onto the ice field. It's nearly midnight and the sun is ambling along the western horizon. High overhead, dishevelled cirrus clouds are dancing across a high blue heaven, but lower down the horizon is laminated by clouds and ice. We could be in for nasty weather. There's no road to E-Base, just a string of upright gum poles.

'The poles are a kilometre apart,' shouts Gary above the thumping Weskus *boeremusiek* beat of *Ouma se Pot*.

'They can't be,' I yell back. 'They look about 200 metres.'

'They're a kilometre. Here,' he says, shoving a GPS into my hand, 'see for yourself.'

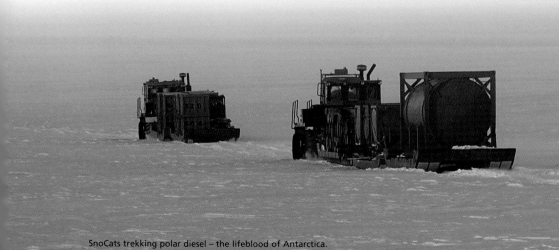

SnoCats trekking polar diesel – the lifeblood of Antarctica.

SLOW SLIDE INTO THE FREEZER

Antarctica was not always frozen. A hundred million years ago it was covered in lush, temperate forests inhabited by all manner of creatures. In the few areas not covered by ice, the fossilised bones of dinosaurs, crocodiles, plants and prehistoric birds have been found.

The evolutionary changes which were forced on plants and animals as Antarctica was driven south by continental drift are among the most spectacular and poorly understood palaeontological events in the earth's natural history. Today the sole survivors are lichens, a few mosses and some primitive grasses, most of which are clustered on the slightly warmer Antarctic Peninsula.

As the continent slid south, monumental tears and collisions between landmasses took place. East Antarctica was once joined to Africa, India and Australia. West Antarctica is made up from pieces of South America. Areas of Queen Maud Land were once linked to the Karoo in South Africa and to the Eastern Ghat Mountains of India. Without its ice mantle, the continent would consist of the great eastern shield and a cluster of islands. Between them would be the towering Trans-Antarctic Mountains, one of the greatest ranges on the planet.

The last land bridge to the north was between the Antarctic Peninsula and the tip of South America. This barrier allowed subtropical ocean currents to reach much further south. When the bridge was severed, Antarctica's thermal isolation was complete. It became surrounded by the icy Circumpolar Current and consigned to the bane of permanent ice.

The coast of Antarctica is not land but a ring of floating land-ice. It is a kind of crystalline exoskeleton that binds and protects the inner ice fields, being constantly replenished from behind and forever sloughing off from the sea cliffs at its extremity. The shelf engulfs innumerable off-shore islands and its sheer magnitude shrinks an observer from privileged viewer to nothingness. 'One's dear self', wrote Lieutenant Prestrud of Roald Amundsen's party as he gazed over the shelf, 'becomes so miserably small in these mighty surroundings.'

They are exactly a kilometre.

'Look back at Vesleskarvet,' Gary insists. 'How far away do you think the mountain is?'

'Maybe five kilometres. Okay, say six.'

'Naah, it's 40. Just checked on the speedo. You can't tell how far things are in this place. There's nothing to measure against. No trees or houses or anything. Stuff that's not white looks close just because it's there. Your eyes want it to be.'

With an empty sledge we are moving fast – around 30 km/h – behind two other Challengers, but it isn't comfortable. SnoCats don't have suspension and this one weighs 23 tons.

Wind does to snow what it does to the sea: it makes waves; except that here they freeze hard, creating sastrugi.[6] These can be almost any height, depending on the amount of snow and the length of the blow that created them. Running parallel is easy. Our route crosses them. If you fail to angle the Challenger just right, it crashes over the sastrugi with a clatter like a shaken bag of loose spare parts.

We pass a black nunatak named Robertskollen (all names in Queen Maud Land are Norwegian – they got there first), after which the ice becomes flat and featureless. About 60 kilometres from Sanae, we roll past a wooden sign that isn't a flag with FLAG written on it.

'What's that?' I want to know.

'The end of the continent,' says John, who's resting on the small bunk behind our seats. 'It's the grounding line of the ice shelf. From here there's sea below us.' After that everyone lapses into silence, mesmerised by the nothingness.

::

Staring at the vastness, I'm invaded by a sense of unreality. We temperate-zone creatures are brief visitors here – only extremely sophisticated arrangements allow us to survive these ruthless conditions. While our ancestors were peopling the rest of the globe for millions of years, Antarctica lay in pristine isolation: unknown, unimaginable and huge. The continent is far larger than you realise from its insignificant position at the bottom of maps: more than 14 million square kilometres. That's about the size of all of Africa north of the equator. In winter its frozen skirt effectively doubles its size.

Apart from Antarctica's ice-free mountains – a mere five per cent of its surface – almost the entire continent is made from a single substance (water), in a single state (ice). This frozen blanket, together with its glaciers and shelf, consists of around 30 million cubic kilometres of ice – making up 80 per cent of the earth's supply. In some places it's nearly five kilometres thick and the continent's average height above sea level is a heady 2500

metres. If it were to melt, the world's oceans would rise between 60 and 65 metres. This icy vortex absorbs heat, water, and solar and cosmic radiation, and its sole output is giant glaciers – the largest in the world.

The shelf, across which our Challengers are seemingly making negligible progress, is made up of glacial drainage from the higher plateau or extensions of marine ice shelves. These shelves are inconceivably huge, many more than a kilometre thick. The largest are the Ronne, Filchner and Ross shelves, the last being about the size of France.

The process of ice deposition begins with tiny prisms of ice dust formed deep in Antarctica's interior. Nearer the coast, these link together to create crystalline snowflakes which fall, piling layer upon layer, at an average rate of about two metres a year. As snow builds up, the crystals are compressed into ice grains, trapping air bubbles. Relentlessly increasing pressure squeezes out much of the air and the grains become ice slates, then gneisses and finally glacial ice – hard, blue and translucent with a density one-third that of average rock. Much of it is constantly on the move from the interior to the coast. Sometimes blue and white ice contains black deposits gouged out of the valleys by glaciers – great ice rivers flowing off the Antarctic plateau. At other times, for reasons that are unclear, it can be jade green.

Hoar frost grows on exposed points, coastal fogs accumulate rime, wind redistributes snow and polishes surfaces to mirror intensity, or gouges the surface into wave-like sastrugi. Then a snowfall covers it again in a soft, seamless blanket all the way to the horizon. The whiteness reflects sunlight with gleaming intensity, causing temperature inversions that prevent surface melting and conjure up mirages. On windless days the surface is dusted with fine ice crystals – diamond dust – which simultaneously reflect and refract light, causing the surface to glitter. In *Moby Dick*, Herman Melville described this whiteness as 'not so much a colour as the absence of colour, and at the same time the concrete of all colours'.

Out of these simple ice prisms are structured a hierarchy of forms which, together, compose an entire continent. In his book *The Ice*, Stephen Pyne identifies a startling variety. On the polar plateau – the greatest desert on earth – are ice sheets, caps, domes, streams, saddles and ice rumples. In the mountains are glacial ice, valley, cirque and piedmont glaciers, ice fjords, faults, pinnacles, lenses, aprons, folds, falls, fronts and ice slush. Coastal areas generate fast ice, shore ice, ice tongues, cakes, foots, walls, floating ice, grounded ice, anchor ice, rime ice, ports, shelves, bastions, haycocks, lobes and streams.

Bergs, ringing the continent in a floating gallery of kinetic art, appear as tabular bergs, glacier bergs, ice islands, bergy bits, growlers, brash ice, and white, blue, green and dirty ice. Yapping at their heels are the sea ices: pack ice, ice floes, rinds, hummocks, ridges, flowers, stalactites, pancake ice, frazil ice, grease ice, infiltration ice, undersea ice, vuggy ice, new ice, old ice and rotten ice.

It's not only the number of forms frozen water can take that's unusual, but – in the southern regions – its astounding scale. Our water planet is also an ice planet, with more than 10 per cent under ice and another 14 per cent frozen in permafrost. Antarctica holds in its thrall more than six out of every ten litres of the world's fresh-water reserves. There's so much ice covering the continent that its weight depresses the south polar region, making the planet slightly pear-shaped. Each year 14 million square kilometres of sea ice freezes and then melts, girdling the continent in a heat sync which regulates the world's weather systems. The extent of the continent's perimeter ice is of vital interest to humans, even though it may seem remote and impossibly far away. The ice acts as a giant mirror, reflecting back into space excess heat from the sun. Without it the planet would overheat, with dire consequences.

Yet, for all that, what really marks Antarctica is its simplicity. All metaphors or analogies are trashed by the enormous singularity of its interconnected ice sheet. Driving over the flat white surface, everything outside the cab merges into a visual zero, a mind-blanking minimalism. In the deepest moments of meditation, Buddhists seek to enter the clear white light of the void, the ultimate state of nothingness. I'm driving through it. 'There is a great beauty here,' wrote the American explorer Richard Byrd, 'in a way that things which are also terrible can be beautiful.'

In all this visual simplicity the bergs are an exception, star performers in the gyre of the southern circumpolar current – groaning, rolling, shape-changing monsters. They're endlessly sculptural, some merely rectangular with flat tops, others eroded into fantastic forms. They piqued the imagination of Ernest Shackleton's navigator, Frank Worsley, while they were making their desperate attempt to reach South Georgia after their *Endurance* had been crushed by pack ice. He wrote later that he had found in their design all manner of strange things: 'Swans of weird shape pecked at our planks, a gondola steered by a giraffe ran foul of us, which much amused a duck sitting on a crocodile's head. Just then a bear, leaning over the top of a mosque, nearly clawed our sail …'

In sunshine icebergs dazzle, in cloud they glow white, in mist they're mysterious. Depending on the light, they vary from dead white through blues and greens to pearly translucency. Their sheer size can beggar belief. In 1965 a berg was measured at 7000 square kilometres. Another, named Trolltunga, was the size of Belgium and was tracked for eleven years, creeping along the coast of Queen Maud Land.

Larger bergs, pushed ever northwards by currents and the earth's Coriolis effect, are flung far and have even been sighted off the coasts of South Africa and Peru. But most are smaller and don't survive the summer season. They're bashed by other bergs, eroded by waves, melted from above and below.

As wear and tear modifies its profile, a berg can teeter and roll over. In a process of internal combustion, top ice melts and penetrates the berg through cracks, then refreezes, giving off heat. This melts ice around it and so the process continues. Such pressures create internal ruptures which split the berg into smaller bits.

Eventually bergs granulate, sometimes forming long filaments of white, rotten ice. Finally, all that's left are scraps of bobbing ice, perhaps thousands of years old, but soon to become simply water. Some of this will be drawn back into the polar vortex, into the heart of whiteness. Deep within Antarctica's interior, tiny ice prisms will be forming, beginning the process anew.

In this strange atmosphere, light doesn't act in the nice, disciplined way it does on the other six continents. Inversions, the ice dust and the snow's reflectiveness cause all manner of strange and often disturbing optical phenomena, turning the sky into a natural Hall of Mirrors. Oddest of all are false suns, parhelia, hovering beside the real one and commonly known as sun dogs. When the sun is low these can develop into spectacular sun pillars or multiply into a virtual pack of sub-suns. Apsley Cherry-Garrard, one of Scott's party in 1911, described a splendid parhelia 'with four mock suns in rainbow colours, and outside this another halo in complete rainbow colours. Above the sun were the arcs of two other circles touching these halos. Below was a dome-shaped glare of white which contained an exaggerated mock sun, which was as dazzling as the sun itself.'

Antarctica feels eternal but is not. Ice is hyper-sensitive to any rise in temperature, especially one which can transform it from a solid to a liquid state. And the earth is warming up. There is some doubt about whether global warming is being caused solely by the massive increase in greenhouse gases released by human industrial activity, or whether these emissions are simply adding to an existing trend. In the 1920s and 1930s, a Yugoslavian geophysicist, Milutin Milankovitch, demonstrated that glacial and interglacial stages correspond to variation in heat received by the earth from the sun because of changes in the earth's orbital variation. Global warming and cooling, he said, were part of natural cycles we can do nothing about.

But the appearance of a hole in the protective ozone layer above Antarctica and a demonstrable and rapid rise in levels of carbon dioxide in the 20th century have left us in no doubt that human actions can damage our fragile atmosphere. Only those who are guilty of emissions and their hired scientists still 'doubt' that global warming is actually occurring.

On a local level, temperature rise in the southern regions is causing problems for bases around Antarctica's perimeter. Those built on the shelf are in danger of finding themselves drifting out to sea as their platforms become icebergs. As the shelf breaks off further and further inland, it also becomes higher. The *Agulhas* first responded to this by installing a huge bow crane and using bulldozers to dig a ramp into the ice – an extremely dangerous exercise. But the shelf nearest Sanae is now so high that they have to load and offload against a lower shelf much further west, nearly doubling the travelling distance from ship to base.

During the 20th century, in just the Peninsula area, there was a significant reduction of the Larsen and George IV ice shelves while the Wordie and Müller shelves eroded away completely. Researchers now suggest that there is a dynamic link between the Arctic and Antarctic Poles. Any extensive melting of the Arctic ice sheet will increase sea levels. This

would raise the Antarctic's shelves, which would break off at their grounding lines, float free and melt in the warmer northern waters. With less reflective ice acting as a solar mirror, global warming would speed up. Without the continent's protective skirt, it is thought that the flow speed of the many ice streams would increase, thinning the central plateau. This would rapidly accelerate a sea-level rise.

::

After a few hours of bouncing along in the Challenger, the sameness out of the window is starting to make my eyes twitch. Gary has the fixed stare of a man seeing beyond sight.

'Hell, it's hot back here,' says John suddenly. 'I'm coming over.' He worms his way over onto the left-hand seat, opens the door and jams his foot in the gap to keep it open. A polar wind howls round the cab.

'Ah, that's better,' sighs Gary as I scramble for my cap and gloves. He stretches luxuriously, picks at a packet of jelly-babies then says: 'You want to drive?'

'You think I can? This is a big lorry.'

'Ja, sure. It's easy,' he says. 'She steers with servos. It's not like a car, so don't over-steer or she'll slew. Here's the hand accelerator – you go from this picture of a tortoise to the picture of a hare – that's fast. There are 10 gears. You start with a clutch, but after that just push it up, one at a time. Keep the revs in the green; if you drop, it strains the engine.'

He gets up, with the Challenger still bounding along, and ushers me into his seat. Ahead stretches an over-sized bonnet and beyond it is a squiggle of tracks that lead over the horizon. Given that I'm sitting about two and a half metres above the table-flat ice, that horizon is possibly a hundred kilometres away.

'When you see a sastrugi coming, don't slow down. Just head off to its lower side, then angle across it,' says Gary. 'That way you won't bang over it.'

When the next one appears, I slew out, over-steer, spin the wheel back frantically, dive over the sastrugi, then over-steer again. The Cat is side-sliding like a 4x4 on clay mud. I get her back on the track and glance at Gary.

'Bit heavy on the wheel,' he comments.

'Yeah, sorry.'

'Don't worry, you'll get it.'

Several sastrugis later I steer off the track, angle silently over the ice wave and plunk her right back on the track.

'Not bad,' Gary grins, which makes me feel like I've joined the select fraternity of ice-depot drivers. Humming a happy tune of all-conquering me, I fail to notice the next sastrugi and crash over it.

'Just angle it, okay?' Gary frowns, and bang goes my application to the club.

E-Base appears but doesn't arrive for an indecent length of time. When we finally drive up, it turns out to be a rather ramshackle affair which is still partly drowned, although two bulldozers have been digging it out for several days. I decide to rename it Sloping Base on account of the partial damage done by tons of snow. It's uphill from the toilets to the hand basins, and round objects roll off the tables. Several years ago the Public Works team gave up on it, considering it not worth repairing. Someone did careful estimates with a GPS and found it was moving seaward at around 25 metres a month.

A sign on a door jammed shut by two metres of ice reads: 'Please close the door gently, otherwise stay out.' A rather more cryptic one along the passage insists: 'No holes will be drilled through the outer wall panel, roof or floor.' You don't want heat leakages in this environment, even small ones.

Nineteen tons of brute force with no suspension.

E-Base was first described to me by my shipboard roommate, Koos, as the *Wit Plaas* (White Farm) and that's somehow appropriate. It consists of four boxy huts in the style of the original Antarctic explorers, supported on a gantry and surrounded by bulldozers, SnoCats and skidoos. There are fuel drums and pieces of equipment lying round, farm-style.

If you need to pee at night, you have to kit up and make a dash from the first hut to the last. The two loos are longdrops, the difference being you have to hook a plastic bag over nails on the edge of the hole to catch and store what you deposit: no pollution allowed in Antarctica. The nails are bent slightly outwards, but you can't help sitting on them.

Of course 'night' is a relative term. What happens is that you emerge in the small hours from your darkened hut into blinding sunlight. Fogged with sleep, the effect is disorienting. In a blizzard, I'm told, you have to radio ahead if you want to change huts. This is so that several strong men can shoulder the door open when you bang on it. Alone you'd never move it out of its frame. If you need a midnight pee, you're in trouble. I ask Koos what he'd do and he points at a plastic cooldrink bottle. 'You have to plan ahead,' he says.

The heart of E-Base is the sloping lounge which – with its heavy, hire-purchase-type suite, expansive coffee table, bookcase filled with trashy novels and some nostalgic pictures on

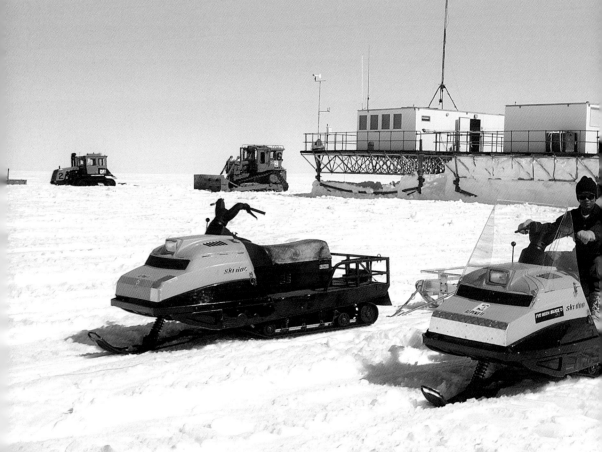

E-Base, known as the White Farm, is swallowed by ice and has to be dug out each year.

the wall – could be on any Karoo farm. If you ignore the slope. The only out-of-place item is a second bookcase stacked from floor to ceiling with shiny packets of crisps. In one corner, with pride of place, is Koos's CD player.

That evening the base's diminutive chef, Portia Maboa, cooks up a fine meal, after which we retire to the lounge to listen to more *Ouma se Pot* and drink copious amounts of hard liquor. The sounds of choice are thumping *boeremusiek*. After a few brandies and Coke (cooled by handfuls of snow), the party mood seems to be a compelling inducement for more B&C.

Koos does a side-splittingly funny number on the coffee table that cannot be decently described here, after which everyone becomes a bit maudlin because we realise we're the last people to party there. E-Base has been condemned and in a few weeks will be decommissioned, broken down and later shipped back to Cape Town as scrap.

'This is the best fokken place on the ice,' says Koos. 'Sanae's just a bloody hotel. This is the real experience. I'm going to miss it like hell.'

At one point I wander into the kitchen and stare out of the window. There are huge tabular icebergs floating above the shelf like quizzical grey eyebrows.

'Am I pissed or are those things really floating?' I ask Jeremy, the transport manager, who's walked in behind me.

'Mirages,' he says. 'Happens every evening. The old whalers used to call it "*the Looming*".'

That night I find a rather stained pamphlet in my room headed '*Fire Plan for E-Base*'. On discovering a fire, it reads, sound the alarm by shouting FIRE! FIRE! FIRE! Then try to put it out after first having read the instructions on the extinguisher. If you can't put it out, yell for the fire chief (who's he?), grab warm clothes and your sleeping bag, and hotfoot it to the skidoos. If, on the way, you find someone lying unconscious, you are required to 'tie his/her hands together, kneel over the supine patient, place the hands over your neck and crawl out, dragging the patient' – presumably down the two-metre, near-vertical ladder and 50 metres across ice to the skidoos. Good advice, maybe, but not for the faint-hearted.

Next morning we begin by digging ice – hacking it away from the buildings and between the base legs. After several hours I'm down to a T-shirt and jeans – and sweating. Several more hours later, lunch is declared and I'm in need of a shower. I soap myself under the steaming stream in the lop-sided cubicle and, with perfect timing, the generator dies and the pumps stop. I stand staring at the last few drops at the showerhead, thinking about clichéd situations. I'm damned if I'm going to rub off the soap on my only towel, so I unroll a wad of paper towels and do the best I can. I then get dressed, feeling sticky and, of course, as I am pulling on my boots, the generator fires up and water pours out of the shower once again. I dive in, rinse fast and am out in under a minute.

After lunch we kit up, mount skidoos and head off to see what Jeremy calls 'our little crevasse'. We're soon running beside a dent about ten centimetres wide and heading west. It widens gradually and holes begin to appear in the depression, leaving us in no doubt that the 'dent' is a thin filament of snow over a deep crack. After several more kilometres the crevasse is a yawning chasm. We stop and cautiously approach the edge. The ice below is deep blue and seems bottomless. The overhangs on the opposite side have stalactites hanging like transparent curtains. It suddenly dawns on me that we're probably standing on an overhang and I back away slowly, hardly daring to breathe. Ian Gouvais, coming up behind, asks who opened up the side crevasse. When we look blank, he says he saw a skidoo track crossing a place that is now a hole – one of us had obviously knocked out an ice bridge.

After about 14 kilometres we give up on the crevasse and turn back towards E-Base. There, safe and warm, I ask Jeremy what had caused the crevasse.

'It's where the shelf's breaking off. It will soon calve another iceberg.'

'And what about E-Base?'

'We could end up out to sea on our own private island.'

That night I'm awakened by a sharp crack that sounds like a rifle shot. I lie there, feeling

for movement, convinced we're departing Antarctica on an iceberg. We leave after six hours' sleep, towing huge tanks of polar diesel. Everything looks normal, but icebergs can be the size of small countries. I get a headache peering intently ahead at the blinding white non-road looking for the end of our berg, which I'm convinced is ahead. The trip takes ten and a half hours of non-stop driving and I only relax when we reach the grounding line with its FLAG board. For lunch the guys eat the leftover jelly-babies and a packet of crisps.

'What are you doing tomorrow?' I ask Gary.

'Driving to E-Base again,' he replies. 'Then back.' After that we backload to Neumayer, the German base 300 kilometres away. That'll take 36 hours straight if we don't hit a blizzard or a crevasse. We do that trip twice; maybe three times if there's too much stuff.'

'Good God! Don't you get exhausted?'

'Ja, sure. But at least we're outside, not sitting in that hotel on the hill. *This* is Antarctica.'

He's thoughtful for a while. Then he says: 'All those scientists and important guys who sit in the base and plan things, they'd be in deep shit without us.'

::

On the long trip back I think about what Gary said. Antarctica has its obvious heroes. They did brave deeds, wrote the books and became icons of polar history. But there are others who went with them, often mentioned only in passing. They built the huts, laid the depots for their leaders at great personal risk, hauled supplies and mushed the dogsleds to save the stranded and dying. Today they drive the supply trains, fly the choppers and build the bases. They're hard men and they drive hard vehicles. Without them – Gary's right – human occupation of the Antarctic would be impossible.

I look at my two travelling companions in the Challenger, noticing their broad shoulders and the ripple of muscles under their T-shirts. Back home you'd be awfully polite to such types in a bar because their irritation might cost you dearly. But here they're considerate and comfortingly able. I realise I'd far rather trust my life to a John or a Gary before a Robert Falcon Scott.

We get back in time for supper and I join a large table consisting mainly of geospace scientists. They're in heated conversation about the qualities of Tennis Biscuits. Evidently their imitator, Court Biscuits, doesn't use real butter and they can taste the difference. The base has been supplied with the latter and they are disappointed. I ask Lindsay what he's going to be working on in Antarctica. He gives me a thirty-second introduction to solar plasma emissions, then goes right back to the biscuit issue. It deviates slightly into the nature of taste buds, then to the objectivity of sensory organs followed by a quick survey of a billion years of organic development. Mealtimes, I decide, are going to be fun.

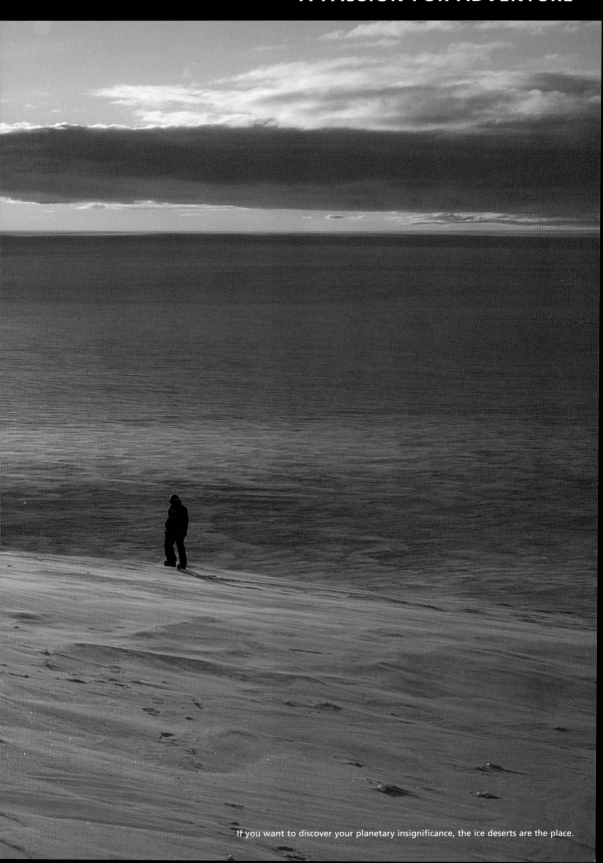

If you want to discover your planetary insignificance, the ice deserts are the place.

A passion for adventure

Great God, this is an awful place and terrible enough for us to have laboured to it without reward of priority … Now for the run home and a desperate struggle. I wonder if we can do it.

Captain Robert Falcon Scott, Final diary, 1912

Each morning, for the first week, I wake up and lie for a few minutes in complete disbelief at being in Antarctica. The desire to come here was insinuated into my life from the time I could first pronounce the word. As a youngster I used to roll it round my tongue: Antarctica. It had a beautiful ring about it, the sound of faraway adventure.

My abiding interest had to do with my great-grandmother, Bessie Smith Scott, who was evidently a lady of some standing. All the old, good furniture that has been handed down to me came from her, as well as a large picture in a gilt frame of the beheading of Mary Queen of Scots. There's a silver tea and coffee service in our cupboard that was a wedding present from the effete and controversial author of *Treasure Island*, Robert Louis Stevenson, though I can no longer prove this because many years ago someone lost the gift tag while polishing the silver. Though I never knew her, Bessie was the Gandalf of our family, a woman from another, far-off and romantic world with a whiff of magic about her. The projection, I later realised, came from my mother who was largely brought up by Bessie – her own mother, my grandmother, being perfectly characterised by the ferocious granny in Giles cartoons.

Exactly why Bessie ended up in South Africa is lost in history, but like many women she probably joined her husband who had been with the British forces fighting in the Anglo-Boer War. Many of these men saw, in the wide open spaces of Africa, limitless opportunities for making money and had developed a taste for unrestricted roaming. Not long after moving her household from Edinburgh, Bessie found herself a widow, well off but alone with three small children. How her husband died is another family mystery. With true Scottish grit she brought up her own brood alone and then the children of her daughter, one of them being my mother.

The presence of Antarctica in my childhood came from a family 'truth' which I cannot prove, but which was handed down and became generally accepted. This was that Bessie was related to Sir Robert Falcon Scott. Attempts to trace this link, admittedly not very thorough, came to nothing – there are as many Scotts in the world as thistles – but it ensured that I grew up knowing where Antarctica was and that heroes came from the continent. I had often gazed at the white smudge at the bottom of maps and wondered what went on in Antarctica. That led me, at a fairly young age, to an extraordinary book, *The Worst Journey in the World* by Apsley Cherry-Garrard, who was a member of Scott's fateful *Terra Nova* expedition. Sarah Wheeler, who wrote Cherry-Garrard's biography, described it as the greatest adventure book of all time. It's a gripping tale of raw-blooded

heroism written in accessible and at times lyrical prose. Who, with an eye for adventure, could fail to be intrigued by a book which begins: 'Polar exploration is at once the cleanest and most isolated way of having a bad time which has been devised'?

Many years ago, thus inspired, I applied to the Antarctic Programme for an over-wintering job but was not even short-listed. So I abandoned any hope of getting there until the day Henry Valentine offered me a berth. The first thing I grabbed to read after that was, of course, *The Worst Journey.* This was followed by others: *South* by Ernest Shackleton and *The South Pole* by Roald Amundsen. Quite by chance, on a street sale, I found both volumes of *Scott's Last Expedition.* They were first impressions, stained, perhaps, with seal blubber and wrinkled from the spray of the Ross Sea. I sniffed them appreciatively.

::

From a distance of about a hundred years after the age of heroic Antarctic exploration, it is possible to discern two motifs, which are surprising though obvious if you think about them. The first is the practical futility of Antarctic exploration. In *The Ice*, Stephen Pyne suggests that Antarctic discovery is best revealed by the things it lacked. Unlike the rich scenarios brought back by Marco Polo from the East, Cortez from South America, Richard Burton from Mecca or Livingstone from Africa, the Antarctic explorer brought back news of the great ice nothing.

Within the vast ice skirt there was no trade, no useful raw materials, no conquest of exotic races, no missionising among savage heathens, no pilgrimages to holy sites, no strange modes of travel or communities from which one could derive sustenance or new inspiration. It had no plants other than a few grasses, some lichens and mosses and a spider; no land-based mammals, no drinkable water, no indigenous cultures, no towns or villages. And it was bitingly cold. It was therefore necessary to invent reasons to go there. Adventurers made goals which were imaginary: the South Pole around which the planet spins but which has no physical existence; the Magnetic Pole which moves continuously and is invisible; or crossing great areas of emptiness for no reason other than for accomplishment.

The second motif is the esteem in which the British high-latitude explorers were held by the public, despite the fact that they were unqualified failures. They lost the race to both Poles, were unsuccessful in finding the Northwest Passage which they so diligently sought, and they died for refusing to make effective use of, or eat, their sledge dogs. 'I have always found the twilight-of-an-empire aspect of the Victorian age inexpressibly poignant,' British biologist Anne Fadiman wrote of the period, 'and no one could be more Victorian than the brave, earnest, optimistic, self-sacrificing, patriotic, honourable, high-minded and utterly inept men who left their names all over the maps of the Arctic and Antarctica.'[7]

::

Captain Scott – the jewel in the crown, the man whom almost anyone who has heard of Antarctica can name – was a poor organiser, bookish and an irrepressible romantic. After a few months of no contact with a razor, the men he chose to accompany him might have looked wild and uncivilised, but they were mostly a collection of artists, poets and men of letters.

In 1900 Scott was an obscure naval lieutenant, but through some fancy footwork and persuasion he was appointed to command a British Antarctic expedition with the blessings of the Royal Society, the Royal Geographical Society, the Royal Navy and Queen Victoria herself. Its patron was the Prince of Wales. In August 1901 expedition members – who included two Antarctic rookies, zoologist Edward Wilson and naval sub-lieutenant Ernest Shackleton – left the Isle of Wight in the new research vessel, *Discovery*. The ship was painfully slow and it leaked, but they patched it up as best they could in Cape Town. By mid-November, they'd reached pack ice, eventually establishing a base at McMurdo Sound at the edge of the Ross Ice Shelf. There they were frozen in, waiting – as all such expeditions did – through the long polar night for the onset of spring.

Shackleton, Scott and Wilson set off early for the Pole to make maximum use of the short polar summer. They had woefully little experience or knowledge of the conditions ahead. They got to 82° South – which is remarkable – but had to turn back, all showing signs of scurvy. By the time they returned to the hut, Scott and Wilson were 'nearly done'. The *Discovery* was iced in for a second winter and only managed to blast its way out and struggle back to Cape Town and then onwards to England in 1904. The English, who seem to prefer heroic failure over efficiency and success, hailed the men as heroes. Scott would heed the call and return south again.

::

Two years later there was another polar challenger camping on the edge of the Ross Ice Shelf. Shackleton had begged, borrowed and been granted sufficient top-up funds to buy an old sealer with decayed masts named *Nimrod*, and after a slow, precarious trip south it anchored at Cape Royds where he and his men built a sturdy hut. From there he and three companions as well as four ponies set off for the Pole. Their supplies soon proved inadequate and they shot the ponies to provide provisions for the return journey. The last pony, Socks, they saved for their final supplies. At the top of the huge Beardmore Glacier, which they were required to climb, she fell into a crevasse and disappeared down 'a black, bottomless pit'. Although confronted by possible starvation, Shackleton said he was pleased Socks had gone that way as he wouldn't have had the heart to shoot her. By Christmas Day they were at an altitude of around 3000 metres and short of breath, then found themselves confined to their tent by a blizzard.

'The end is in sight,' Shackleton wrote. 'We can only go for three more days at the most, for we are weakening rapidly.' At 88° 23' South, only 180 kilometres from the Pole, Shackleton decided to turn round in order to save his men. Using a sail, they made fast progress northwards, but when they reached the Cape Royds hut there was a note from the *Nimrod* saying the ship would wait until 26 February, then depart to avoid being iced in. They were three days too late. In a desperate bid to alert the departing ship, they set fire to a storage hut. The smoke was seen, miraculously, and the vessel returned to pick them up. Shackleton got back to London in 1909, having failed to reach the Pole, and was knighted, but had to work hard delivering lectures to pay off the huge debts which the trip had incurred.

::

The next Pole attempt was made by the super-efficient Norwegian, Roald Amundsen. He initially had his sights set elsewhere – the North Pole – and to this end he borrowed the *Fram*, a ship belonging to the revered Norwegian polar explorer Fridtjof Nansen. But, while preparations for the trip were taking place, he heard that the American Frederick Cook had reached the North Pole, followed shortly by Robert Peary. Amundsen was at first shattered by this news, then decided to go for the South Pole instead.

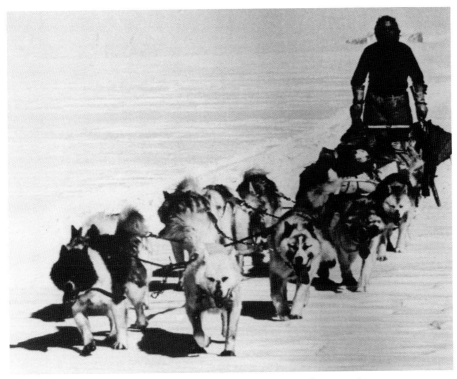

Huskies, beloved of all earlier explorers, are now banned from Antarctica.

He told few of his changed plans, and let the world know by telegram only when he had reached Madeira. His crew, who had also not been informed, were startled by the change of plans, but all agreed to continue south. In January 1910 the *Fram* tied up at the Bay of Whales on the Ross Ice Shelf. The men built a cabin and began ferrying ten tons of supplies. There they over-wintered and – at the start of the austral summer, in October 1911 – they headed south with five men, four dog sledges and 52 dogs.

The trip cannot be described as easy: they were tied down by blizzards, fell into crevasses and experienced debilitating temperatures. But Amundsen's meticulous planning, together with the use of dogs both as transport and as dog food (killing them according to a strict schedule) ensured that they got to their goal unscathed. There Amundsen and his companions grasped a pole topped by the Norwegian flag 'with five weather-beaten, frost-bitten fists' and collectively planted it at the South Pole.

They returned to their base on a straightforward trip 'all hale and hearty' with five men and 11 dogs. Nobody lost their lives, went hungry, contracted scurvy or suffered from frostbite, though a few got toothache. The last of earth's symbolic geographical goals had been bagged.

The English, however, didn't like Amundsen one bit. The widely expressed opinion was that because he had treated the journey as a race and had failed to die, he had somehow cheated. Furthermore, killing his dogs offended English sensibilities. 'The British', he later grumbled, 'are a nation of bad losers.'

::

For Scott, on his second expedition, it was to be terribly, tragically different. Since his return from Antarctica he had been promoted to captain and returned to his military career. News of Shackleton's attempt at the Pole had alarmed him, and his former colleague's failure perhaps stiffened his resolve to head south once more. In 1909 he announced he would lead a new expedition to Antarctica and he began a lecture tour to raise the necessary funds. It took him a year, but he eventually managed to secure a government grant.

Together with an attempt at the Pole, Scott proposed a wide-ranging scientific programme to justify the considerable costs. He purchased a 700-ton, coal-burning whaler, *Terra Nova*, and set about gathering ponies, motor sledges and men. Although he was to take dogs, he placed no faith in them and was to choose man-hauling for the final assault. One man whose services Scott wanted above all others, and secured, was Edward Wilson. Another was the photographer Herbert Ponting, who joined the party in New Zealand.

The ship sailed from Britain in June 1910, leaving Scott to tie up last-minute financial arrangements. He joined his ship in Simon's Town, South Africa, and the polar party then sailed for Melbourne. There he received a shock: a telegram from Amundsen which read:

'Beg leave to inform you, *Fram* proceeding to Antarctica. Amundsen.' His team were incensed by what they considered unfair competition, a sentiment derived from the unwarranted conviction that Antarctica was spiritually, if not physically, British territory.

Scott's diaries became handbooks on how a 'true Englishman' should conduct himself in the face of danger.

After a gruelling trip, the *Terra Nova* reached the Ross Ice Shelf in December 1910 and set up base at a place they named Cape Evans. The hut, in which 24 men over-wintered, was built strictly along class lines: private cubicles for the officers, a bunkhouse for the rest of the men, a stable for the horses. The dogs lived outside. From there, Scott sent out scientific parties – one west to investigate the glaciers beyond McMurdo Sound, another east to explore King Edward VII Land, and a third to begin laying depots for the trip south. After that, they settled down for the long winter night.

Meals included seal consommé and breast of penguin. Three nights a week Scott convened 'Universitas Antarctica'. They discussed topics such as art, aviation, biology and ichthyology. At other times they wrote poetry, painted or read uplifting literature. They studied the Napoleonic campaigns in Iberia, parasitology and Japanese painting. In the words of Anne Fadiman, 'these men may have been incompetent bunglers but, by God, they were gentlemen'.

In the confinement of the hut the different temperaments began to show. Scott proved rather aloof and formal, though the men respected him; Apsley Cherry-Garrard, the youngest member, amused the team with the production of a newspaper, the *South Polar Times*; and Ponting's slide-shows relieved the boredom. But the man everyone found most approachable and came to love was the zoologist and artist 'Uncle Bill' Wilson and it was he, together with Titus Oates, 'Birdie' Bowers and Edgar Evans, that Scott chose for the final push to the Pole.

The southern party set out the following November with 10 people, 10 ponies and 23 dogs hauling two sledges. The motor vehicles had proved unreliable and the ponies tired easily in the tough conditions. Scott was delighted to see how well the dog teams managed, but was committed to man-hauling beyond the Beardmore Glacier and didn't change his plans. In doing so, he forsook the one means of transport that ensured Amundsen's success.

At the top of the glacier Scott sent the rest of the party back and pressed on with his chosen team for the final push. They passed Shackleton's southern record, but that made Scott press on even harder, plagued by the possibility that Amundsen was ahead of them. He wrote of 'the appalling possibility … of the sight of the Norwegian flag forestalling

ours'. On 16 January they knew the worst. At the Pole they found the Norwegian flag and a tent with a message in it from Amundsen to Scott.

'The worst has happened,' Scott wrote. 'The Norwegians are first at the Pole … all dreams must go.' The next day he added: 'The Pole. Yes, but under very different circumstances from those expected … Great God! This is an awful place and terrible enough for us to have laboured to it without reward of priority … Now for the run home …'

It was to be a nightmare of starvation rations, the first effects of scurvy, frostbite and appalling weather. In the midst of all this, they went geologising at the top of the Beardmore Glacier, adding to their sledges heavy rocks containing late-Palaeozoic fossil leaves and stems of the genus *Glossopteris*. On 17 February Evans became delirious and died. Oates's feet were black with frostbite and gangrene, and each step for him was agony. By mid-March he could take it no longer and walked out of the tent to die in the blizzard. The three remaining men pushed on until 18 kilometres from a supply depot which could have saved them, but cruel weather tied them down in their tent. Their food ran out and they knew it was the end. Scott penned a letter to Wilson's wife:

> My dear Mrs Wilson,
>
> If this letter reaches you Bill and I will have gone out together. We are very near it now and I should like you to know how splendid he was at the end – everlastingly cheerful and ready to sacrifice himself for others, never a word of blame to me for leading him into this mess … My whole heart goes out to you in pity.
>
> *R Scott*

The last entry which would conclude his extraordinary journal – and which would secure him the sympathy and adulation of a nation – read simply:

> We shall stick it out to the end, but we are getting weaker, of course, and the end cannot be far. It seems a pity, but I do not think I can write more. For God's sake look after our people.

Their frozen bodies were found eight months later by a search party. What they also found was that Scott, who had measured every item of food on the trip to cut down on weight, hadn't dumped the 35-pound bag of rocks. If he had, they might have made it to the depot. Had he valued the quest for knowledge above his own life? Was he a lousy explorer or a hero? Maybe he was simply a victim of bad weather. The scientist Susan Solomon, who spent 13 years ploughing through meteorological data and eye-witness accounts, has concluded that it was freak weather and therefore bad luck that killed the polar party. 'Only once,' she writes, 'in 1988, have comparable temperatures been found in March.'[8]

A MAN OF MANY PARTS

The first man to study the orders of life in Antarctica with scientific rigour was Edward Wilson, who joined Scott on both his expeditions as surgeon, zoologist and artist. He was, from the many accounts of his colleagues, both a talented and lovable man with an exceptionally sharp eye for colour, form and detail.

When he was four years old his mother wrote: 'Edward is never so happy as when lying full-length on the floor drawing little figures in every conceivable attitude.' Ten years later, in 1886, he was secretary of the ornithological section of his college's natural history society and had won the school prize for drawing four years in succession.

Then, when he was 17, he read Darwin's notes on the voyage of HMS *Beagle*. It prompted him to keep a journal – which he maintained for the rest of his life – and nurtured a yearning which was fulfilled when Scott invited him to join the 1901 British Antarctic Expedition.

Wilson's dedication to ornithology and his skill as an artist were to reveal to the world, for the first time, the diversity and grandeur of Antarctica's birds. He sketched on deck in storms, chased birds across ice floes, and sledged and man-hauled for hundreds of kilometres, all the time keeping a meticulous diary and working up his sketches into watercolours in the evenings.

While over-wintering on Scott's final expedition Wilson, Cherry-Garrard and Bowers undertook an expedition to collect emperor penguin eggs. In darkness and with temperatures around –70°F they struggled to Cape Crozier, a harrowing trip of three months which was described at the time as the most hazardous journey ever voluntarily undertaken for a scientific purpose.

Wilson accompanied Scott to the South Pole. On their return, in an appalling blizzard and with no supplies left, the entire party died – only 18 kilometres from the next depot of food. Wilson's sketch books were found next to his body, recording the entire, painful journey in his usual meticulous detail.

His sketches, which were published posthumously in *Birds of the Antarctica*, were to form the basis of Antarctic ornithology.

Of him Scott wrote: 'Words must always fail me when I talk of Bill Wilson. I believe he really is the finest character I ever met – the closer one gets to him, the more there is to admire.'

::

Although the Pole had been reached, Shackleton wasn't about to give up. He began raising money to undertake 'the greatest Polar journey ever attempted'. He would, he said, walk 2900 kilometres across Antarctica from the Weddell Sea over the Pole to the Ross Sea. It would be across areas never before explored. His advertisement in a London newspaper was droll: 'Men wanted for hazardous journey. Small wages, bitter cold, long months of complete darkness, constant danger, safe return doubtful. Honour and recognition in case of success.' He received around five thousand applications.

Shackleton secured two ships, the *Endurance* and *Aurora*, one to enter the Weddell Sea and the other to lay depots from the Ross Sea side. While he was preparing to sail in 1914 war broke out. He offered his ships for war service but was told by the Admiralty to proceed south.

From the moment the *Endurance* entered the Weddell Sea pack ice, she was in trouble, and by mid-January was solidly frozen in. The crew survived the austral winter well enough, but when the pack began to break up the following summer, pressure from the shifting ice posed a terrible danger to the ship. By then she had drifted around 2400 kilometres with the pack. The *Endurance* was leaking badly and Shackleton ordered the crew to set up camp on the ice in case she went down. On 21 November the vessel dipped her nose sharply into the sea and slipped out of sight. 'She's gone, boys,' said Shackleton, who was watching, and ordered an extra half-sausage for the crew. As the ice floes thinned and broke beneath them, Shackleton decided to head for Paulet Island, dragging two of the ship's lifeboats. Eventually they went back for a third.

The trip across the floes was terrifying, made worse by the fact that all the while they were drifting northwest, away from Paulet. Shackleton later changed his plans and set a course for Elephant Island. With the floes around them crumbling, they took to the boats and, in wild seas, managed to make landfall on the island, a dreary, inhospitable place where nobody would think to look for them. The beach they'd landed on was in danger of being inundated in high tides, so the weary men set off again in a raging sea and landed on an only slightly less inhospitable spit of land near a penguin colony. At least, Shackleton must have thought, eyeing the penguins, they'd have food to eat.

They built crude shelters while Shackleton plotted his next move. The nearest inhabited island was South Georgia, 1300 kilometres away across huge seas. There was little choice. If everyone stayed where they were, or the boat crew drowned on the journey, the men on the island would probably die. South Georgia was their only hope. The carpenter covered the largest boat, the *James Caird*, with canvas decking and on Easter Monday, 1915, Shackleton and five crewmen shoved off from the beach, leaving the men under the charge of Frank Wild. They were soon hit by a blizzard, which continued for weeks. In the troughs the little boat would wallow, windless, only to be lifted to the wave tops into a howling

gale that ripped at the sails. At one point Shackleton thought he saw a break in the weather, but it was the white foam of a monstrous wave. 'For God's sake, hold on! It's got us!' he yelled and the wave hit, flinging the boat upwards until she crashed over the crest. They baled for their lives.

After two weeks they spotted the dark rocks of South Georgia. With only a handful of sightings, their navigator, Frank Worsley, had steered them true. In danger of being smashed on the rocks, they stood off for two nights, then headed for a gap in the reef and grounded on the beach of King Haakon Bay. From there, Shackleton and a crewman, Tom Crean – the only men strong enough to hike – began a 27-kilometre trek over South Georgia's mountains and glaciers towards the Stromness whaling station. Nobody had ever penetrated the island's inhospitable spine before. Eventually they heard a steam whistle and finally – shivering, filthy and unrecognisable – they staggered into the whaling station.

Shackleton organised the rescue of the four men huddled on the other side of South Georgia. Then he begged and borrowed four ships, one after another – three of them thwarted by pack ice – to save the rest of his men on Elephant Island. On the fourth attempt the Chilean steamer *Yelcho* got through. Shackleton stood on the bridge, tense, staring through his binoculars, counting the soot-blackened figures. Finally he shouted: 'They're all there, skipper!' The men had been on the island for 105 days and had never believed that their leader, 'the Boss' as they called him, would fail them. Each day Frank Wild had bolstered the despondent men, telling them 'the Boss might be coming today'. Eventually he did. It was one of the most dramatic rescues in naval history.

::

Tales of high adventure and the often inhuman suffering of the men who first penetrated Antarctica held, for a while, the fascination of Europe. Looking back, though, it's not the white continent that commands attention, but the divergent characters of those who led the expeditions. If you were seeking adventure and wanted to reach the Pole and return with the least fuss, your best bet as a leader would undoubtedly have been Amundsen; if you were in Antarctica and found yourself in great peril, the choice would be Shackleton; and if you were prepared to die but required a brilliant epitaph, Scott would have been your man.

After them there were to be several less spectacular journeys into Antarctica, but the age of explorers seeking records was effectively over. Following the horrors of the First World War, governments and the public had little taste for high adventure or even for scientific exploration of such a remote region. What was its value, anyway? The blinding white polar plateau was a vast, imperfect mirror that simply reflected back the character of the person and the civilisation that gazed upon it. What explorers brought back was the discovery of *themselves*. The object of Shackleton's journey, as with Amundsen, Scott and other Antarctic

explorers, was not the struggle to advance a goal, but to discover a goal that would justify their struggle. All they could offer by way of inducement was honour and recognition.

By 1911, when the Pole was reached, a new age was dawning, which would show little interest in fur-clad heroes trudging over an ice desert. While Scott was struggling to his death, Niels Bohr was outlining a new theory of the atom. As Shackleton fought to save

A FORGOTTEN HERO

One of the photographs that survived the Shackleton expedition is of the tangled remains of the *Endurance*. She's down at the stern, her funnel is at a crazy angle and her masts are broken. Standing calmly viewing the disaster, pipe in hand, is a small figure in snow goggles. You can almost feel the resigned shrug of his shoulders. The man is Frank Wild, one of the great unsung heroes of Antarctic exploration's heroic age.

In 1901 the powerfully-built young sailor with deep-set eyes was selected to join Scott's *Discovery* expedition (Antarctic expeditions tended to be named after the ships that bore them south). During the three years of hardship, Wild's cheerful, unflappable nature made an impression on Shackleton, who accompanied Scott and Wilson on their attempt at the Pole.

Six years later Shackleton invited Wild to join his *Nimrod* expedition. Wild accompanied him to within 160 kilometres of the Pole, when cold and hunger forced them to turn back. At the top of the Beardmore Glacier, Wild and his pony, Socks, plunged into a crevasse. Wild managed to haul himself out but Socks disappeared.

By now a confirmed Antarctican, Wild joined Mawson's *Aurora* expedition in 1911, living under extreme conditions until the expedition returned three years later. In 1914 he was back on the ice with Shackleton. When the *Endurance* was crushed by the pack, the men made for Elephant Island, sailing in perilous waters. Wild took command of the *James Caid*. Shackleton later wrote: 'All the time I was attending to the boats and watching the condition of the men, Wild sat calmly steering the *Caid*. He never batted an eyelid, always the same confident, blue-eyed little man, unmoved by cold and fatigue.'

his crew, Albert Einstein was elaborating the theory of relativity. The Antarctic had briefly renewed public interest in exploration among the adventure-hungry in the first half of the 20th century. But this collapsed in the trenches of the First World War and was buried with Shackleton, who died in 1922. In the aftermath of that war, the Antarctic was relegated, again, to a white smudge at the bottom of a map.

On the island, Wild was put in charge of the 22 men while Shackleton sailed to look for help. For four awful months the men lived under upturned boats through blizzards, boredom and the fear of never been rescued. Each day they had to bale around 300 litres of water which flooded their makeshift home. Wild kept the desperate men from falling apart. Each morning he'd wake them cheerfully and say: 'Lash up and stow, roll up your bags, boys, the Boss may come today.'

The Boss did return, in one of the greatest examples of leadership in history. Afterwards Wild served in the First World War on the Russian front, and then tried his hand at tobacco farming in Malawi. When Shackleton asked him to join yet another expedition, Wild could not refuse his leader. It was to be Shackleton's last – he died of a heart attack on South Georgia. Wild was heartbroken. He called the crew of the *Quest* together and told them: 'Boys, I've got some bad news for you. The Boss died suddenly at three o'clock this morning. The expedition will carry on.'

Wild took command and sailed south, but the heart had gone out of the trip and he set sail for England. It is said that Wild was a changed man after that. He married Vera Altman, the daughter of a tea planter, took his savings and bought a cotton farm in Zululand, which he called *Quest Estate*.

Floods and then drought ruined the venture and, despite financial assistance from South Africa's Prime Minister, General Smuts, the farm folded, as did his marriage to Vera, who divorced him in 1928. For a while he worked in a hotel bar until a newspaper broke the story with a cruel headline: 'Broke Antarctic hero found working as barman.' 'It's a job,' Wild retorted, hurt. 'I am not a loafer.'

He tried his hand as a battery manager on a gold mine in Zimbabwe, then on the Witwatersrand. He married a Capetonian, Trixie Rowbotham, twenty years his junior. They bought a house and a car and went travelling round the country together. But a drinking habit and the strain of Antarctic exploration took their toll on Wild's heart. He ended up as a storekeeper on the Babrosco mine in Klerksdorp and, in 1939, died of pneumonia aged 65. He was cremated and a service was held in Braamfontein Cemetery. 'Even on the last day,' Trixie remembered, 'he was relating an episode of the Antarctic.' His ashes were 'taken' by the undertakers for safekeeping and have not been seen since.

In 2002 a researcher, Angie Butler, found Wild's letters, papers and journals with one of Trixie's relatives and acquired them for the Scott Polar Research Institute in Cambridge. The spirit of Shackleton's blue-eyed little man had returned home at last.

Footnote: Details of Wild's life in Africa are from Day-to-day living defeated Antarctic hero *by Angie Butler (Sunday Independent, 24 April 2005).*

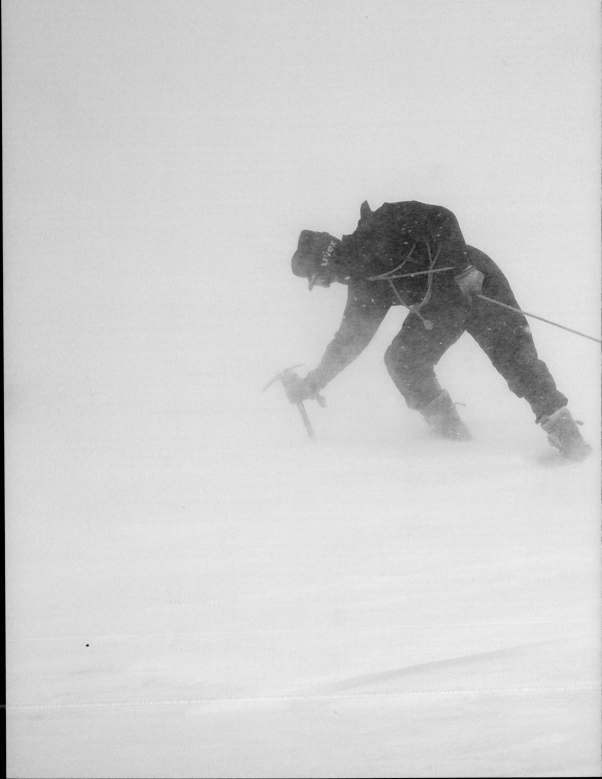

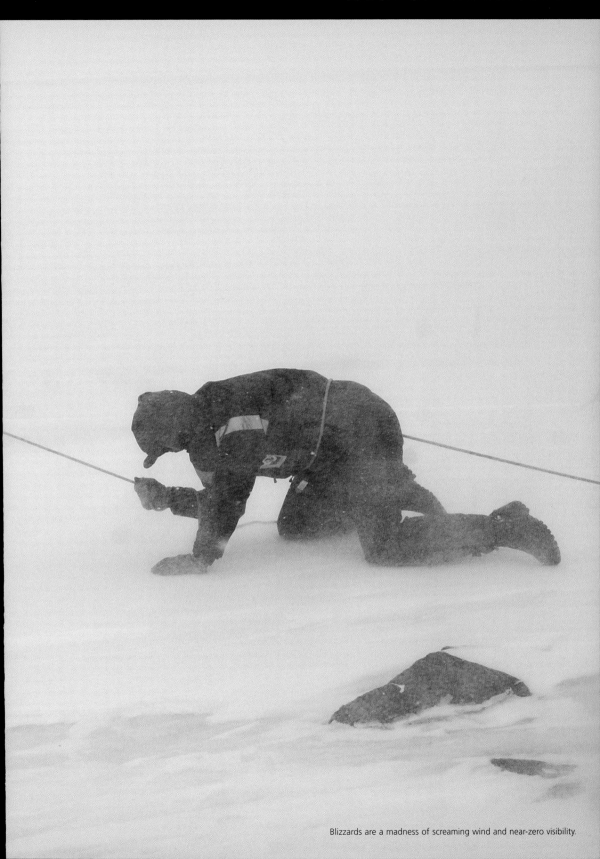

Blizzards are a madness of screaming wind and near-zero visibility.

Land of the blizzard

Even now the Antarctic is to the rest of the earth as the Abode of the Gods was to the ancient Chaldees, a precipitous and mammoth land lying far beyond the seas which encircle man's habitation …

Apsley Cherry-Garrard, *The Worst Journey in the World*

The blizzard begins with a stiff breeze, which builds up over a few hours into a blow that's causing the masts on the base to whistle. But it doesn't stop where normal winds on other continents usually do. Soon there's another, more sinister sound: a booming like the endless roll of a base drum threaded through with the shriek of tortured air ripped by pylons and aerials. I finish a cup of tea, and when I put it in a saucer on the table it shivers as though it's alive. In the dining room, glasses are tinkling and have to be saved from crashing off the shelf.

I head for the weather service office seeking an explanation. The wind-speed indicator is practically spinning off its bearings. 'It's a blizzard coming out of the south,' Met officer Solly Shaku explains. 'Cyclonic storms that move inland act as barriers to gravity-driven katabatic winds building up on the high central plateau. When the storms move on or dissipate, the barrier is removed and a violent avalanche of wind swoops down out of the south across the ice surface. The result is a show of power and violence you don't get in many other places on earth.'

The gale blows all day and it blows all night. When I look out of my window in the morning, it's as though a light has been placed behind frosted glass: I'm seeing outside but there's nothing to see. It is a total white-out.

To go out in such weather runs counter to my survival instincts but there's the problem of the 'smelly'. All bases, whether high-tech or simple, require water, and the way to get it is to melt snow. The process is simple: you heave snow into a container, warm it until it melts, then pump the water into the base. Because you want clean snow, the smelter is generally some way from the base, and in Sanae's case this distance is about half a kilometre.

I'm on 'smelly' duty and, blizzard or not, the base needs water. Several of us kit up and open the base door on the lee side of the building. The sound that hits us is somewhere between a scream, a howl and a growl. Great gobs of snow are being driven at incredible speeds and, as we descend the stairs and turn towards the storm, the wind pummels my chest and it's difficult to breathe. The light is radiant but I can see nothing. I walk on crisp snow but no shadow shows in my footprint. No sun, no sky, no ground, no horizon. I appear to hang in a void. We make our way unsteadily along the length of the base, before turning downhill towards the smelter.

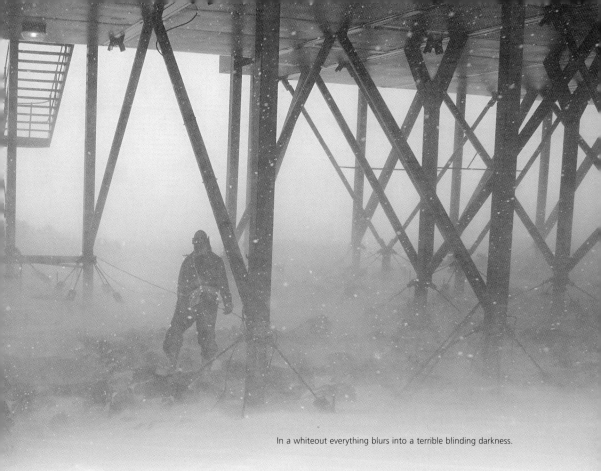
In a whiteout everything blurs into a terrible blinding darkness.

I find I have trouble keeping my balance. The coils in my inner ears are used to confirmation from my eyes about how to stand, but here they get none. I might as well be blind. At times I can't even see my feet, so each step is stressful: what if I step onto super-slippery blue ice, or against a rock? I stumble along in a weird white darkness. The person just ahead of me disappears, and then suddenly reappears as a grey shape not more than an arm's length ahead. The noise of the wind is incredible: you could shout your head off and nobody would hear you.

While Sanae was being built in the 1990s, the construction crew and over-wintering team lived in converted containers set side by side with a cable fence for guidance. A team member heard the dinner bell during a blizzard and left his hut. A particularly strong gust blew him slightly off course and he missed the guide cable and walked past the huts into the snowfield. A search party was mounted and, though he was eventually found, one of his rescuers, a young medical orderly named Pierre Venter, also lost his way. They found Pierre, dead from hypothermia, after several days when the storm had abated. There's a cross near the smelter that marks his act of bravery.

A year later a member of the Public Works team, Eric Williams, wandered off course in a blizzard and lost his bearings. 'I had been one of those who found Pierre the year before,' he said. 'I started running on the spot to get warm, then I scraped together a ridge of snow and lay behind it all curled up so the wind went over me. After a while a cowl of ice formed over my face but that kept me warm. I lay there and made a promise to God. I said "Lord,

if you get me out of this, I will do whatever you ask of me."
You need to be careful what you promise God. They found
me after a long time and I was alive. Now I'm a lay preacher
and I care for everyone in my community who needs me.
People knock on my door at all hours of the night and I have
to answer. A promise is a promise.'

As I plod, sightless, towards the distant smelter I'm thinking:
This is a place where you can die on the way to dinner.

What is particularly disturbing about a white-out – apart from
not seeing anything – is that it tends to confound rational
thought. I find space, time and definition dissolving. How
long have I been walking? Have I missed the smelly? Is the
base upwind or downwind? Where are the other people?
Sight is designed to distinguish contrast. Without it you're just left with the creatures of
your imagination. Steven Pyne calls it 'an unpleasant mysticism that illuminates everything
and enlightens nothing'. Just as panic begins to get the better of me, I bump into someone
who's stopped by the smelter trapdoor. I feel like hugging him.

We dig the snow on our knees, grey forms in the swirling fog under a spotlight. It seems
to take forever. The temperature is a manageable –8°C but the buffeting is exhausting.
Eventually we stumble up to the base with the wind at our backs, propelling us over
obstructions faster than we'd like. Back inside I look around. The others are unrecog-
nisable, their goggles and gear frozen and with snow packed into every chink. Those with
beards have faces ringed with ice. I'd left a pocket open and it's full of snow.

There is a photograph entitled *Pushing Against the Gale* by Frank Hurley, a member of
Douglas Mawson's *Aurora* expedition to Cape Denison in 1911, an area which Mawson
called 'Home of the Blizzard'. It's of two men, one crawling, the other bent almost double,
pushing into an obviously blistering Antarctic gale with snow flying at them horizontally. I
had always thought the photo was posed. I now know otherwise.

A day later the wind stops suddenly. It snows gently for a few hours and then the sun
comes out. The flat areas which the bulldozers had spent a week creating around the base
are once again snow mountains. Challengers and skidoos are half covered, and if you walk
anywhere there's a chance you'll sink up to your waist. But in the sun the snow glistens
like diamonds and, high above, snow-petrels are playing tag.

My experience sends me searching through the pages of *The Worst Journey in the World*
for Cherry-Garrard's description of the terrifying midwinter trek undertaken during Scott's
Terra Nova expedition to find emperor penguin eggs at Cape Crozier. It's one of the most
gripping pieces of travel writing I've ever read and describes the journey that provided the
name for his book.

Penguins were an enigma to the science of the time. Were they primitive birds, a missing link to dinosaurs? It was thought that a study of their embryos would give a clue, but because emperors inconveniently lay their eggs in the middle of the polar winter, nobody had ever studied one. The quest for an emperor's egg was therefore a noble one and deemed to be of inestimable value to science.

Cherry-Garrard was an unlikely candidate for the hazardous trip. He was a rather frail classics scholar who was short-sighted and wore glasses which constantly fogged up. He, scientific officer Bill Wilson and 'Birdie' Bowers set out in the depths of an Antarctic night, man-hauling two heavy sleds across more than 63 miles of sastrugi, pressure ridges and dangerous crevasses to Crozier, struggling against bitter temperatures. On the way back a blizzard blew their tent away, an almost certain death sentence. Cherry-Garrard describes the moment:

> I do not know what time it was when I woke up. It was calm, with that absolute silence which can be so soothing or so terrible as circumstances dictate. Then there came a sob of wind, and all was still again. Ten minutes and it was blowing as though the world was having a fit of hysterics. The earth was torn in pieces: the indescribable fury and roar of it all cannot be imagined.
>
> 'Bill, Bill, the tent has gone,' was the next I remember – from Bowers shouting at us again and again.

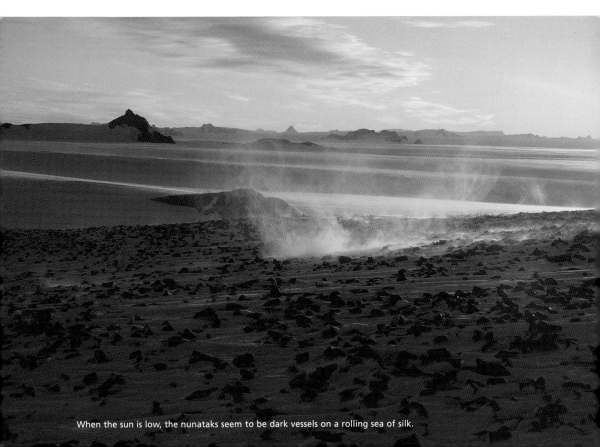

When the sun is low, the nunataks seem to be dark vessels on a rolling sea of silk.

Then it blew away the roof of the igloo they'd built and they huddled in their sleeping bags, half frozen, for three days until the storm abated. Miraculously they found their tent and arrived back five weeks after leaving Cape Evans, half dead, with only three of the five eggs they'd collected (Cherry-Garrard had dropped two).

The whole mad exercise turned out to be rather pointless and of little scientific value. Back in London more than a year later Cherry-Garrard carried his precious charges to the Natural History Museum for analysis. His meeting with the First Custodian was brief:

'Who are you? What do you want? This ain't an egg shop.'

Having side-stepped that reception, Cherry-Garrard finally got to the Chief Custodian, who was in deep conversation with some other Person of Importance and didn't want to be bothered. He took the eggs without thanks. Cherry-Garrard asked for a receipt.

'It's not necessary; it's all right. You needn't wait,' he was told.

Cherry-Garrard insisted. He was asked to wait. Several hours later and after much insistence he got his receipt, and left the building imagining what he would like to do to the Chief Custodian, mostly with his boots. The eggs were eventually analysed by a Professor Cossar Ewart, who concluded that emperor penguins were descended from birds and not dinosaurs, though 'it is admitted that the birds descended from bipedal reptiles ... in build not unlike the kangaroo'.

'It's extraordinary how often angels and fools do the same thing in life,' Cherry-Garrard wrote of the winter trek, 'and I have never been able to settle which we were on this journey.' What he gained, however, was a deep love and respect for his two travelling companions. When he and other members of the southern party found their bodies with Scott, it was a shock which stayed with Cherry-Garrard for the rest of his life and probably led to his nervous breakdown while writing his book ten years later. But he finished it and concluded with a paragraph that must have left every *Boy's Own* reader cheering:

> And I tell you, if you have the desire for knowledge and the power to give it physical expression, go out and explore. If you are a brave man you will do nothing: if you are fearful you may do much, for none but cowards have need to prove their bravery. Some will tell you that you are mad, and nearly all will say, 'What is the use?' For we are a nation of shopkeepers, and no shopkeeper will look at research which does not promise him a financial return within a year. And so you will sledge nearly alone, but those men with whom you sledge will not be shopkeepers: that is worth a good deal. If you march your Winter Journeys you will have your reward, so long as all you want is a penguin egg.'

After a blizzard you have to dig your way out of your clothes – and your beard.

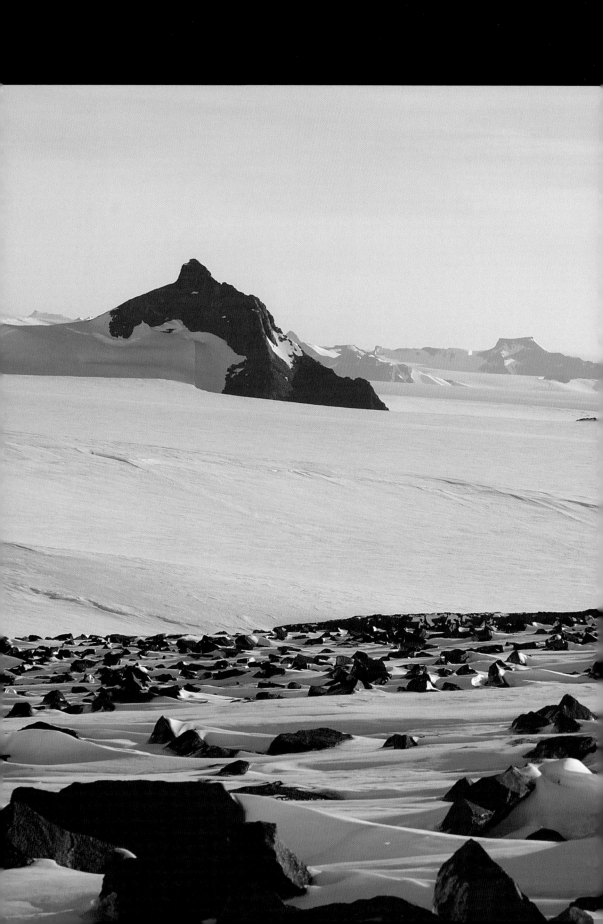

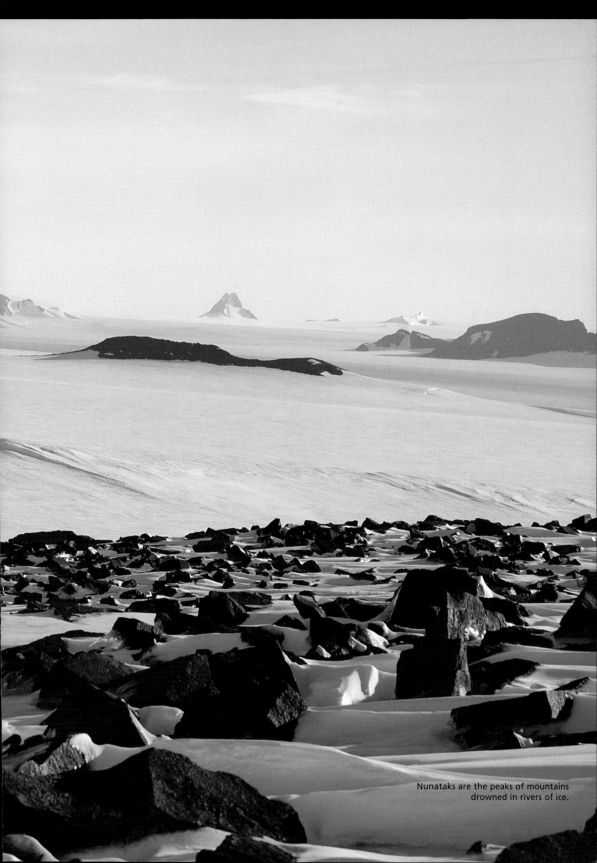

Nunataks are the peaks of mountains
drowned in rivers of ice.

Antarctica rediscovered

The land retains an identity of its own, still deeper and more subtle than we can know. Our obligation towards it becomes simple: to approach with an uncalculating mind, with an attitude of regard.

Barry Lopez, *Arctic Dreams*

If Antarctica had been like any other continent, exploration – in the grand tradition of Cortez, Livingstone or Lewis and Clarke – might have been followed by the conquest of its local inhabitants, the establishment of colonies and the appropriation of its natural resources. The only inhabitants of the white continent, however, were penguins and seals and the only raw material was ice. Its colonisation required logistics more applicable to deep oceans or interplanetary space than to Africa or America. By comparison, dealing with a rebellious colony was far less troublesome.

There have been many who had planted a flag, fired off some muskets and proclaimed ownership of a piece of Antarctica in the name of some king or country, but they were mere gestures often bordering on farce. In the late 1930s German aircraft sought to claim their slice by dropping aluminium arrows topped with swastikas onto the ice and a German U-boat captured the entire Norwegian fishing fleet off the disputed coast of Queen Maud Land.[9] Argentina flew a pregnant woman to their Antarctic base so her baby could be born on its 'domestic' territory. Both Argentina and Chile claimed the continent in terms of a 15th-century papal decree which divided the world between Spain and Portugal.

These were small gestures in the face of a general indifference about Antarctica and what it had to offer: the time of heroes was over. But the indifference was about to change, and three things were to intersect to make it happen: mountains of surplus hardware left from the Second World War, the growing awareness of the value of aircraft in aerial mapping, and a resulting recognition of the interconnectedness of the earth's geography.

The new explorers were from a different tradition: science. In the absence of human cultures or accessible biology, Antarctica had always been seen in terms of geography. An interest in polar science had begun in the late 19th century when twelve Western nations held the first International Polar Year in 1882 and established 14 high-latitude bases, mainly in the North Pole. The south, though, was soon to have its day. Between 1895 and 1904 the Sixth, Seventh and Eighth International Geographical Congresses were held in London, Berlin and New York, and at the first of these three it was resolved that 'the exploration of the Antarctic regions is the greatest piece of geographical exploration still to be undertaken'.[10]

The second congress, in Berlin (1899), declared 1901 to be 'Antarctic Year'. This was to lead to a flurry of expeditions which included those of Shackleton, Scott and Amundsen.

Countries which sent parties south were Belgium, Britain, Norway, Germany, Sweden, Scotland, France, Japan and Australasia. There were also a number of independent explorers. It was a brief heroic age of polar travel, which drifted away with the smoke of the First World War.

After that war, four expeditions attempted to revive interest in the white south with varying success. Shackleton mounted an expedition to Wilkes Land in 1921 funded by a private sponsor, but he died before reaching Antarctica. In 1928 Sir Hubert Wilkins, who had travelled with Shackleton, secured sponsorship from the American Geographical Society and William Randolph Hearst's American News Service to survey the Antarctic Peninsula by aircraft. Flying at 1800 metres over an area of Graham Land where he had previously hauled sledges, Wilkins was heralding a new era in polar exploration.

'The contrast was most striking between the speed and ease of flying in by plane and the slow, blind struggles of our work along that coast a few years before,' he wrote in his autobiography. 'It had taken us three months, on foot to map forty miles; now we were covering forty miles in twenty minutes.'

Sir Douglas Mawson, an Australian who had travelled with Shackleton's 1907 *Nimrod* expedition and had trekked to the Magnetic South Pole, obtained Australian sponsorship and built a base at Cape Denison in Adelie Land, an area he was to name Home of the Blizzard. On a sledging expedition he lost two of his colleagues and was forced to spend two winters on the ice with winds gusting over 160 kilometres an hour. In 1929, older and wiser, he returned as leader of the British-Australian-New Zealand Antarctic Research Expedition (BANZARE) to eastern Antarctica. They used aircraft to survey large tracts of coast, collected a mass of scientific information and raised flags claiming areas for Britain and Australia.

But the expeditions which were going to change the nature of Antarctic exploration for ever were those pioneered by the American pilot Richard Byrd. With encouragement from Amundsen, he decided to attempt a flight to the South Pole. He made his first attempt from his base on the Ross Ice Shelf, Little America, in January 1929. After over-wintering, Byrd and two others reached the Pole on a flight lasting 15 hours and 51 minutes, a journey that had taken Amundsen three months and had killed Scott and his men.

In 1934 Byrd was back again with a much bigger expedition, during which he over-wintered alone in a weather station hut and nearly died, first when the trapdoor into his hut jammed while he was outside in a temperature of −71°C, then when he was poisoned by carbon monoxide from the generator. He was saved just in time by colleagues from the main station who forced their way through the darkness to reach him. He survived to become a champion of Antarctic exploration.

::

Hannes le Grange

South Africa's presence in Antarctica began after World War Two and had its roots in a madcap scheme dreamed up in 1949 by the explorer Sir Vivian 'Bunny' Fuchs and a South African, Ray Adie, while they were confined to their sleeping bags in the mountains of Alexander Island off the Antarctic Peninsula during a blizzard. Why not undertake the journey clear across Antarctica which Shackleton failed to make in 1914?

'With time on my hands [in the tent],' wrote Fuchs, 'I began to list the various requirements and even the possible cost of such a plan. If one could go as far as the Pole, why not continue to the far side of the continent rather than return along the same route?' Such a route would pass through British, Australian and New Zealand territories, so these countries could be invited to participate. Maybe South Africa would be interested, suggested Adie, considering that the Weddell Sea area closely affected weather conditions in the southern hemisphere. Back at their base on Stonington Island, Fuchs mentioned the idea to the rest of his team but nobody took the matter seriously. There were even bets made against it ever taking place.

Fuchs, however, was a man of determination and with influence. By 1955 his dream had become the Commonwealth Trans-Antarctic Expedition, with Queen Elizabeth II as its patron and financial support from Britain, New Zealand, South Africa and Australia. On his team was no less a hero than the man who'd conquered Mount Everest, Sir Edmund Hillary. The expedition was cast in the heroic mould of Scott and Shackleton, though this time there would be mechanised SnoCats, aircraft and radio communication. Uncharitable commentators, contending that the post-war world had no place for gung-ho heroes, would dub it an anachronism. But Fuchs ignored them.

South Africa was invited to provide a meteorologist. The man chosen for the task was a remarkable character named Hannes le Grange, a 28-year-old employee of the Weather Bureau who'd grown up in the Little Karoo town of Ladismith. According to Fuchs, he was 'something of a blind date', but got the explorer's approval because 'he was tall and heavy in build'.

The plan was for Fuchs to set up Shackleton Base in the Weddell Sea, and for Hillary to establish Scott Base on the other side of the continent near McMurdo Sound on the Ross Sea. From there Hillary would lay supply depots for the trans-continental party to use on its run from the Pole to Scott Base.

In November 1955 Le Grange, together with Fuchs, Hillary and other members of the party, set sail for the Weddell Sea in a Canadian sealer, *Theron*. Aboard her were stores and

equipment plus a SnoCat, two aircraft, some track-adapted Ferguson farm tractors and 24 huskies. They had a tough time getting through the pack. The great scoop of Antarctica which forms the Weddell Sea creates a clockwise gyre into which pours ever-westward-moving bergs and pack ice, often forming long, dangerous pressure ridges or forcing huge floes to raft onto each other like gigantic stacks of playing cards. The *Theron*, probing her way south along channels between the packs, was often clamped in an icy embrace.

'Day after day, time after time, for hours on end,' Fuchs wrote, 'everyone was over the side with axes, shovels, boards and boat hooks to clear the ice from the side of the ship. Some would hack at the huge piled-up floes and prise them free with crowbars, others poled the loosened pieces back into the wash of the propeller, thus clearing them into a small pool of water which always lay astern. Sometimes electrically fired explosive charges were used…'

The vessel finally drew alongside some bay ice connected to the shelf and the team began scouting for a position to set up base. It would be named Shackleton, Fuchs said, 'in memory of Sir Ernest Shackleton who had set out in 1914 with the same object of crossing the continent and who had intended to establish his base near to the very spot where the *Theron* was now lying.' The site was chosen and offloading of the stores began. Before they could complete this task, a blizzard swept down from the north, flooding the stores on the bay ice. The ship parted its cables and was forced to stand off while the men tried frantically to retrieve drowned or floating boxes. Later that day the *Theron* returned but the storm was closing the pack around her and, after hastily picking up those who were not over-wintering, she sailed northwards. Eight men, including Le Grange, watched her disappear from sight. All attempts to reach the ship by radio failed. 'Many of those who were going home,' Fuchs later wrote in understatement, 'must have felt that in some way they were leaving their companions in the lurch.'

They had 300 tons of stores to shift from the bay ice to the base up on the shelf before winter set in and, at that point, they had nothing to live in but a large SnoCat packing case which was being used as a tea-break shelter. It was to be their home for eight months. Before they'd completed the hauling, they were hit by what Le Grange called 'the Great March Blizzard'. For seven days they were confined to their packing case, going out only to relieve themselves and to dig away snow that was threatening to bury them. Ventilation was a constant problem and they suffered from sore eyes and headaches caused by the stove's fumes. One of the party was praised for his skill in producing delicious, mint-flavoured tinned peas on his kitchen shift until it was discovered that his recipe included some of his mint-flavoured toothpaste. As Le Grange would put it, 'time passed slowly.'

 When the storm abated, they emerged to discover that the bay ice had disintegrated and most of their stores were missing. Lost was a tractor, all the heating coal, the timber for a workshop, a boat, engineering stores, seals to feed the huskies and 300 drums of fuel. After they'd carried what was left to the base, another storm with winds of up to 140

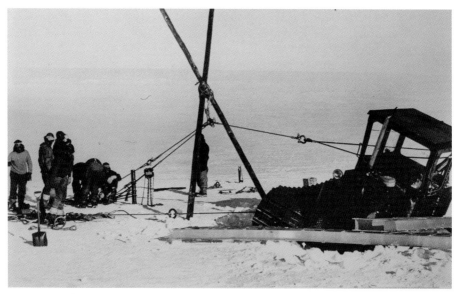

An ever-present danger to people and equipment are unseen crevasses. Some can be hundreds of metres deep.

km/h confined them to the spot for ten more days. In August the lowest temperature was recorded at –53°C. It's a miracle they survived the winter.

Next summer Fuchs returned with equipment and aircraft and, together with the Shackleton Base refugees, began to lay inland depots before the onset of the second winter at Shackleton. Laying depots was a nightmare. The tractors kept breaking down and, with tracks added, were difficult to steer. Dog teams fared much better and were used to negotiate routes through the heavily crevassed terrain. A welcome addition was the construction of a large, warm hut, a workshop and an ice cave for the dogs. While work at the Weddell Sea base was taking place, Hillary began laying depots from McMurdo. Then everyone settled down for the long, dark winter, Le Grange's second on the ice.

The following spring, further depots were laid and the team prepared equipment and vehicles for the crossing. Le Grange, as meteorologist, was chosen to undertake the entire journey. At first, extreme weather conditions delayed them. When the weather cleared, they found the only way inland was across huge crevasse fields and then over the forbidding ice wall of the Shackleton Range. 'I had always expected to find difficulty in climbing from Shackleton to the inland ice sheet,' Fuchs wrote, 'but the actual problems we had to overcome were far greater than we could have possibly envisaged.'

At times there were crevasses on all sides and vehicles had to be roped together. The snow bridges would often break and the vehicles would hang, sickeningly, over dark abysses. One of the party, David Pratt, said it reminded him of driving a tank over a minefield, except that in this case you were waiting for something to go down and not up. Racing

against time and the weather, nobody got much sleep. Three vehicles were eventually abandoned, but Fuchs pressed on, finally reaching the Scott–Amundsen Base at the South Pole on 19 January 1958. There Le Grange erected a flag he'd made with a springbok on one side and a protea on the other. They were greeted by an exuberant Hillary, who'd made it with only 90 litres of fuel left.

In late January, Fuchs's party started out again in a race against winter. At one point they crossed fifty crevasses in the space of seven kilometres and were tied down by katabatic winds howling down the Skelton Glacier as they descended onto the Ross Ice Shelf. On 2 March they reached Scott Base, having travelled 3472 kilometres in 99 days. From there they were ferried to New Zealand aboard the *Endeavour*. Le Grange made his way to Britain where he was awarded the British Polar Medal by the Queen, as well as a Royal Society medal. After that he sailed home to resume his duties at the South African Weather Office.

::

The Commonwealth Trans-Antarctic Expedition was to be the last of the 'heroic' adventures of exploration. As the Soviet Union and the United States eyed each other across the Iron Curtain, matters far greater than exploration and heroic travel were seen to be at stake. In 1946 Byrd – now a Rear-Admiral – returned to Antarctica at the head of a minor military invasion. It consisted of a fleet of 13 ships (including an icebreaker, an aircraft carrier and a submarine), 23 aircraft and 4700 men to establish an indelible American presence in Antarctica. Known as Operation Highjump, it established a base at Little America where an ice runway was built. Over the next four weeks the aircraft spent 220 hours in the air and mapped and photographed nearly 4 million square kilometres of the continent.

The operation may have been couched in the terminology of science but, like the establishment of all national bases which were to follow, there was an underlying political motive. With the escalation of the Cold War, both the Soviet Union and United States believed that Antarctica had strategic value. The Soviet Union, which had formerly expressed no interest in Antarctica, suddenly dusted off Von Bellingshausen's forgotten reports and asserted Russian priority to discovery, declaring its 'indisputable right … to participate in the solution of problems of the Antarctic'.[11] Both Britain and Argentina claimed ownership of the Falkland Islands and the Antarctic Peninsula, and busied themselves dismantling each other's huts and putting up plaques declaring ownership.

There were those watching this flurry of national aggression for whom the notion of a partitioned continent was ridiculous. Byrd, despite his direction of Operation Highjump, insisted that 'men cannot fight each other in the Antarctic because the one universal enemy is cold'.[12] The United Nations Secretary General, Dag Hammarskjöld, pleaded for a 'balance of prudence'.

It was in this climate that preparations for an International Geophysical Year (IGY) took place. The idea was initially championed by a scientist named Dr Lloyd Berkner, who had spent time in Antarctica at McMurdo. He argued that techniques for exploring the earth's surface and upper atmosphere had made considerable advances and that new technologies were available for renewed exploration of the southern continent. There was also a huge surplus of military hardware available.

Berkner's initial idea was for an International Polar Year. He took his plans to the International Council of Scientific Unions, where they were well received. At the suggestion of the World Meteorological Organisation, however, they were expanded to encompass the entire globe, and became an International Geophysical Year. The proposed 'year' was to be 18 months, beginning from June 1957.

It is remarkable how readily the superpowers cooperated in these developments. After Stalin's death, the Soviet Union had shifted to a far less bellicose foreign policy. It was also obvious to all nations interested in Antarctica that the only valuable raw material which could be extracted from it was scientific information, the production of which was increased through cooperation. For this reason – at the preliminary Antarctic Conference leading up to the IGY held in Paris in July 1955 – the emphasis was on science and not politics or national boundaries. The nations attending included Argentina, Australia, Belgium, Chile, France, Japan, New Zealand, Norway, South Africa, the United Kingdom, the USA and the USSR, all of which would become the first signatories to the Antarctic Treaty. Following much heated debate it was agreed that scientific parties should have free access to all parts of the continent and that a nation's measure of seriousness would be defined by the size of its investment in the continent. The IGY would usher in the third great age of Antarctic discovery.

After the conference, twelve nations submitted proposals for the establishment of 40 Antarctic field stations, with a further 20 on the southern islands. A Scientific Committee for Antarctic Research (SCAR) was established to assist with the coordination of national programmes and the IGY was extended by an extra year. At a conference held at Dartmouth in 1958 to evaluate the IGY, delegates began negotiations towards a treaty by which Antarctica could be governed. The following year the Antarctic Treaty was signed and came into force in 1961.

::

These developments were not going to leave Hannes le Grange in peace predicting rain or shine back in South Africa. In signing the treaty, South Africa was obliged to establish a presence on the ice. Conveniently, the Norwegians were planning to vacate a base in Queen Maud Land and offered it to South Africa. They also agreed to transport a party down on

THE ANTARCTIC TREATY

The treaty's success is more a feature of what it does not do. It confirms Antarctica's status under the IGY, but resolves the most pressing issues by deferring them – probably indefinitely. Territorial claims are neither agreed upon nor rejected but are, in the end, seen to be meaningless in the face of cooperation.

The continent was declared open for scientific research; it would be a non-military zone; weapons testing and waste dumping was forbidden; all bases were open to inspection by any treaty nation; and the continent was to be administered in the interests of all humanity.

There is no permanent secretariat (this being supplied by the country in which meetings are held) and all decisions are arrived at by consensus. No party has special rights, and pressure to conform is simply the realisation that territorial and organisational chaos will aid nobody.

It is widely considered the most successful treaty of its kind ever drafted and formed the basis of accords later worked out for space, the moon and planetary exploration.

their vessel, the *Polarbjørn*, which would be passing through Cape Town in November 1959. In a flurry of activity the South African National Antarctic Programme (SANAP) was established and a national expedition, Sanae 1, given top priority. The obvious man to lead it was Le Grange, the only South African who had ever set foot on the South Pole.

He accepted, but with only three months to find a team and purchase supplies he became like a man demented. He flew to London and, with the help of Vivian Fuchs, bought clothing, sleeping bags, instruments and both man and dog rations. Next stop was Oslo, where he got the run-down on the Norwegian base and also ordered fuel. Then it was off to Berlin for meteorological equipment, and to Denmark to negotiate the purchase of a Polar vessel (but without success). After that it was back home to choose his team, none of whom had any ice experience.

The *Polarbjørn* sailed in early December, only months before the British Prime Minister, Harold Macmillan, would tell the South African parliament that the winds of change were sweeping through Africa and that they had better adapt. South Africa's response was to declare itself a Republic and later to withdraw from the Commonwealth. For the ten South Africans aboard the Norwegian ship this might have clouded their future, but right then they had their own problems. In heavy seas a steward, emptying bins, slipped and fell overboard. He was never found. Soon afterwards the vessel's engines broke down and had to be repaired at sea. Then one of the officers accidentally blew himself up with dynamite brought along to break up ice floes.

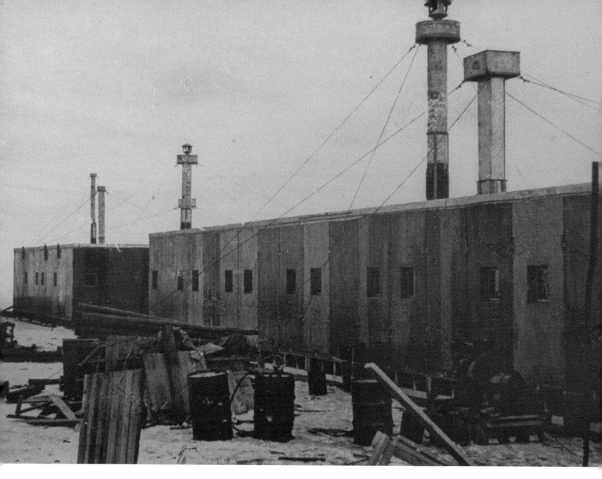

Above: South Africa's Sanae 2 – now buried far beneath the ice.
Opposite below: Members of the Commonwealth Trans-Antarctic Expedition. The South African Hannes le Grange is on the right.

Within the Antarctic Circle they were saved from being frozen in by the chance appearance of an Argentinean icebreaker, *San Martin*. Five weeks after leaving Cape Town they finally reached the shelf. The Norwegians hastily departed, fearing they'd be iced in, leaving the first South African Polar expedition to manage as best they could on their own.

Norway Station was showing signs of ice damage. By then it had been buried by seven metres of ice and some roof beams were bending and cracking under the pressure. There was a generator, but the South Africans had not brought replacement bearings and had to improvise with leather. The labels on the many tins left by the Norwegians were unreadable, so they never knew what they'd find when they opened them. They had similar problems with instructions on equipment. Still, they managed, even organising a month-long dog-sled journey inland to survey the inland nunataks in the region where Sanae 4 is now situated.

The team arrived back in Cape Town in January 1961. There was a welcoming party at the Castle and they received the country's first Antarctic Medals. Their winter occupation of Norway Hut laid the foundation for South Africa's presence in Antarctica and kicked off the country's Antarctic programme, SANAP. There has been an over-wintering team in Queen Maud Land ever since.

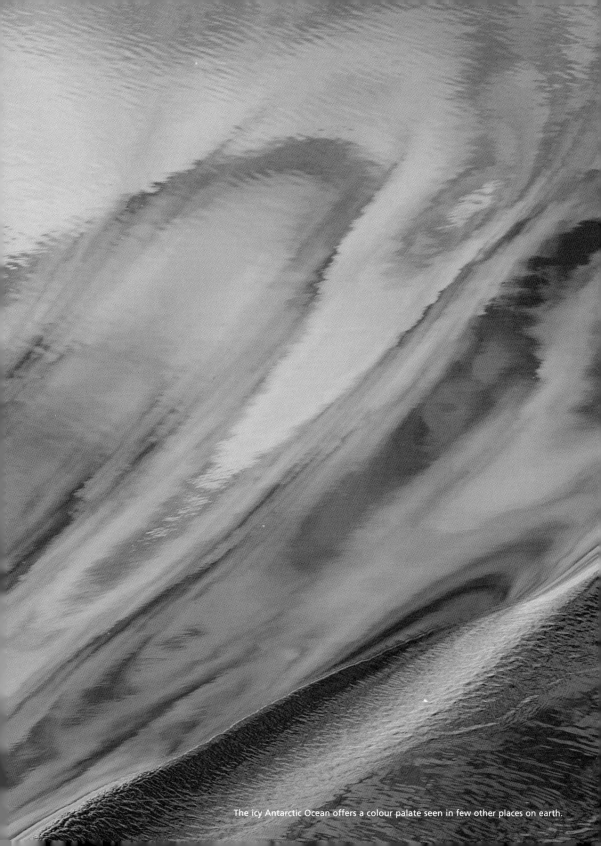

The icy Antarctic Ocean offers a colour palate seen in few other places on earth.

A matter of light

Ponting would have been a great asset to our party if only on account of his lectures, but his value as pictorial recorder of events becomes daily more apparent. No expedition has ever been illustrated so extensively.

Robert Falcon Scott, *Diaries*

Antarctica is blindingly white. I knew this before going, but am still shocked by the eye-frazzling glare each time I peep over the top of my snow goggles. If it can scrunch your eyes like that, what will it do to film? I had browsed through coffee-table books on Antarctica and stared in wonder at the beautiful photographs. What did they know about below-zero photography that I didn't? Apparently, just about everything. So before heading south I'd trawled for advice around Cape Town's photographic fraternity.

'Take lots of film and bracket widely,' someone offered.

'Shoot everything one stop wider than the meter tells you to,' another said, 'because the meter will close down the camera's aperture in all that light and you'll get blue snow.'

'Your shutter will freeze.'

'At low temperatures your film will get brittle and snap in the camera.'

'The colours of slide film go funny at −30°C.'

'When you go inside, put your cameras in the fridge or else water condenses inside them.'

'Take a digital and check first, then set your slide camera to those settings,' was perhaps the most useful.

On my first foray I shoot a spool at +1. Much later, when it's developed, it proves to be all glare and little definition. I bracket, but how far should I go? And taking three shots at different settings to get a good one will consume my film stock at a terrifying rate (it's not as though I can head for a camera shop to buy more spools).

I zip two cameras into my down jacket, causing much discomfort and problems with zips and thick gloves, but hope for the best. Eventually, though, I put away the slide camera and go about with the digital, figuring that errors will cost nothing and I can take thousands of shots until I get the hang of the light. Back inside the base, I take out a book I'd tossed in my trunk at the last minute: *The Great White South* by Scott's expedition photographer, Herbert Ponting. When packing it, I wondered if a book about photography published in 1921 would be worth taking. It turns out to contain the best advice on polar photography I find, and is also an introduction to an exceptional photographic artist.

Ponting crackled with nervous energy and never let weariness or impossible terrain interfere with a good shot. After landing in Antarctica he became so enthralled with what

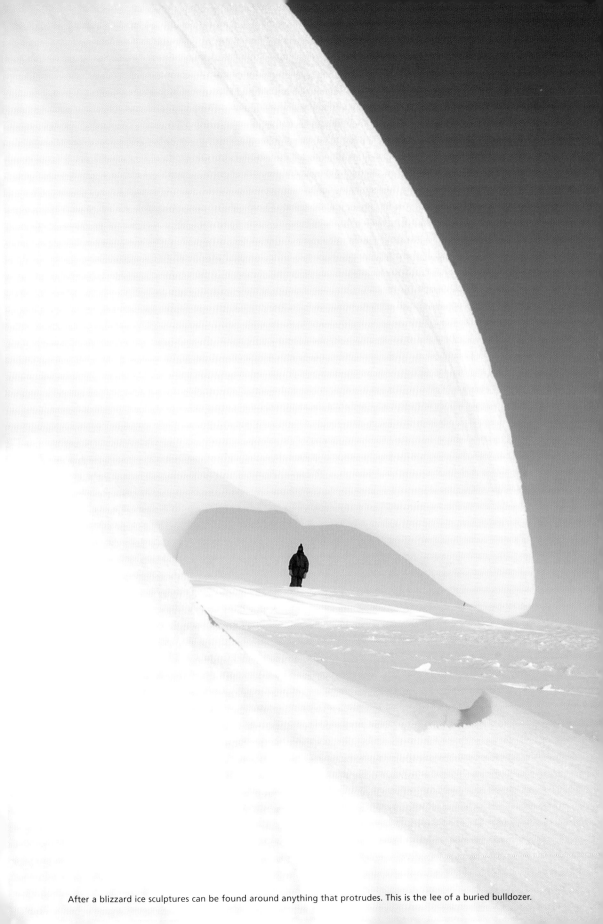

After a blizzard ice sculptures can be found around anything that protrudes. This is the lee of a buried bulldozer.

he saw that he forgot to sleep for four days. He was an inveterate traveller, but he'd never seen the likes of Antarctica. 'Before going to the Far South with Captain Scott's South Pole Expedition,' he wrote, 'my life – save for six years' ranching and mining in Western Australia; a couple of voyages round the world; three years of travel in Japan; some months as war correspondent with the First Japanese Army during the war with Russia; and in the Philippines during the American war with Spain; and save, too, for several years of travel in a score of lands – had been comparatively uneventful.'

Ponting had become absorbed by Scott's book, *The Voyage of the Discovery*, while travelling on the Trans-Siberian Railway from Vladivostok to Moscow, so when Scott invited him to join the *Terra Nova* expedition he jumped at the offer. Adventurer he may have been, but sailing the Southern Ocean was another matter entirely. 'I soon found that life on the *Terra Nova* was a very different matter from travelling on comfortable ocean liners. She seemed to me not only to know and practise every movement known to every ship in which I had previously sailed, but frequently to vary these with movements of her own, which I felt convinced that no other respectable ship knew anything whatever about.' He spent much of the voyage miserably sick.

On the occasions when Ponting emerged from below, he became fascinated by birds which were following the ship. He remembered asking a crewman the name of such birds on a previous voyage. 'The old Irishman shaded his shaggy brows with his palm for a few seconds, closely scrutinising the birds, then he replied: "Why, yess, sorr. Them's what we call seaburrds, sorr!' Remembering the encounter, he asked zoologist Bill Wilson, instead of a sailor, and got an answer that lasted several days. It was to begin a working friendship that would result in some of the finest wildlife photographic studies yet taken in Antarctica.

Pack ice delighted Ponting, and he had a boom made so he could hang off the side of the ship and film the boat slicing through the pack. Icebergs amazed him. When one first loomed out of the mist he gaped in wonder: 'The grandest and most beautiful monuments raised by human hands had not inspired me with such a feeling of awe as I experienced on meeting with this first Antarctic iceberg.' When the expedition landed at McMurdo Sound, he loaded 400 pounds of photographic equipment on a sled and man-hauled it across the ice to capture grounded bergs on film.

One such expedition was nearly his last. Noticing eight killer whales at the edge of some bay ice, he grabbed his camera and headed in their direction. When he was a few metres from the edge, the whales all dived and, to his horror, heaved the ice up under him and split it into fragments. He barely kept his balance, and nearly lost it when all eight ragged-tooth creatures suddenly burst from under the ice and spouted. He leapt from floe to floe with the orcas following, tipping the floes he had just leapt from. 'I recollect distinctly thinking, if they did get me, how very unpleasant the first bite would feel, but that it would not matter much about the second.' As he leapt clear onto firmer ice, an orca heaved out of the water and rested on the ice, 'looking round with its little pig-like eyes to see what had become of me.'

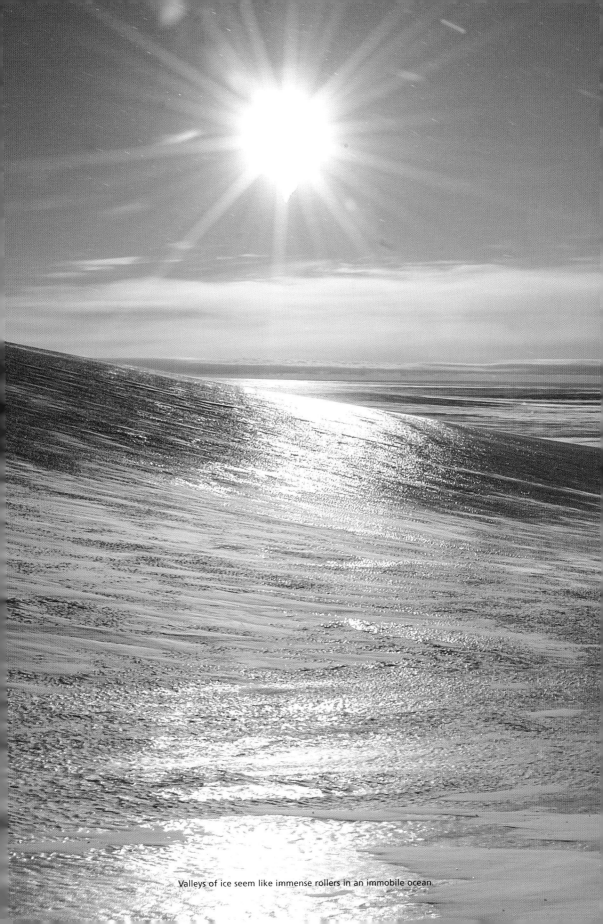

Valleys of ice seem like immense rollers in an immobile ocean.

There's no record of an orca ever having eaten a human, and Ponting speculated that they might have been after two huskies that were tethered nearby. Or perhaps they thought him to be a seal. One of the party, Victor Campbell, who witnessed the event, wrote in his diary: 'What an irony to be eaten for a seal and spat out because one was only a photographer.'

On one occasion thin ice began sinking beneath Ponting and his sledge. He thought of uncoupling from his harness in case the heavy sledge went through and dragged him under, but then decided that without his cameras his presence in Antarctica would be meaningless, so he hauled harder and hoped for the best. Luck was on his side.

When the sun dipped below the horizon, it temporarily stalled Ponting's photography, though he managed to get an atmospheric shot of a berg by leaving his camera shutter open and letting off three carefully placed flares. When the winter cold became too extreme for his equipment, he entertained expedition members with lectures and lantern slides of his travels.

When the Cape Crozier party returned from their terrible journey collecting penguin eggs – their clothing and caps frozen round them like armour – their faces bore evidence of the terrible hardships they had endured. Ponting photographed them. 'Their looks haunted me for days,' he wrote. 'Once before I have seen similar expressions on men's faces – when some half-starved Russian prisoners, after the Battle of Mukden, were being taken to Japan.' To many it would seem incredible, he reflected, that men should forgo the comforts of civilisation and suffer inconceivable hardships in order to study the breeding habits of a bird.

Gradually, Ponting's experience grew. One needed to work half against the light to get the correct effects of shadow, he found. Photography was too important and difficult to be done in haste, and he slowed down and spent more time looking. Cameras, he discovered, needed to be left in their cases outside the hut or they would be subject to condensation and become dripping wet in the warm air. In Antarctica he became fascinated with clouds, cirrus being the most spectacular. Many of his finest pictures were taken into the sun, a technique that works well in Antarctica because of the bright, ambient light bouncing off the ice. There were negative lessons as well. Once, while focusing, he licked his lips and his tongue touched his camera's metal body and stuck fast. He had to jerk his tongue away, causing it to bleed profusely.

The creatures he encountered added new lessons. He was bitten on the shin by an irate Weddell seal and added 'extreme caution of seals' to his store of knowledge. Not long afterwards he had to add skuas to his caution list. While photographing a chick hatching from its egg, the parents dive-bombed him from behind, gouging the back of his head and landing a blow on his right eye, bowling him over. The gentle penguins, however, enthralled him. Emperors were proud, stately aristocrats with no fear of humans. Adelies, he said, were the lovable bourgeoisie and born comedians.

Prowling for pictures with two lightweight Nikon single-lens reflex cameras inside my jacket, I often used to think of Ponting with his cumbersome bellows instruments and

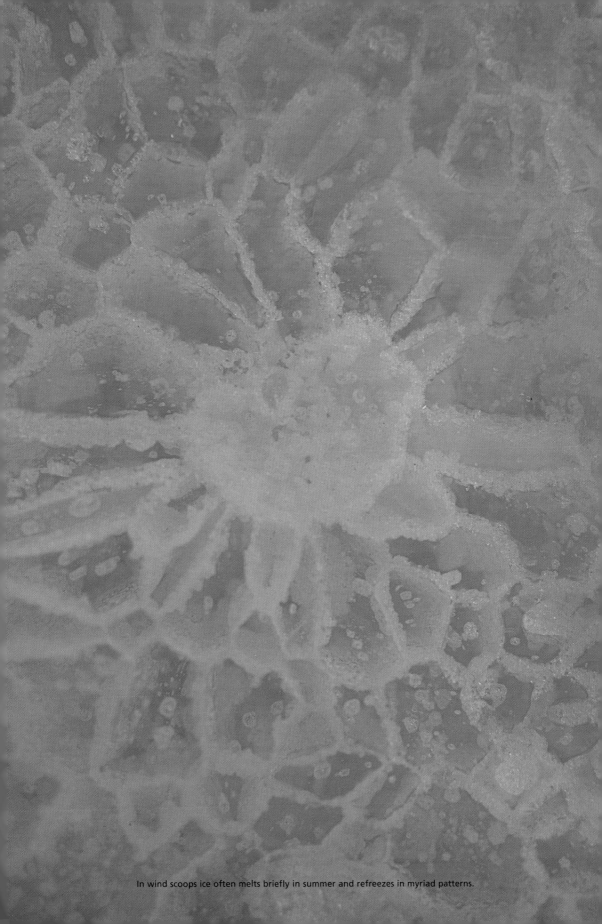

In wind scoops ice often melts briefly in summer and refreezes in myriad patterns.

heavy bronze lenses. His 'lightweight' camera was the size of a shoebox and his primitive movie camera was nearly a metre tall and had to be manually wound while filming. For his 'medium-sized' plate camera – a monster by today's standards – he had to dive under a black cloth to focus.

Making the necessary fine adjustments required gloveless hands which, after a few minutes, he had to plunge his hands into large fur mittens which he wore to prevent frostbite. The slow speed on his film necessitated the use of heavy tripods which had to be dragged around with all the other heavy equipment on his sledge. Soon after shooting, because the emulsion of his plates deteriorated in the harsh temperatures, he was forced to develop his negatives in a tiny darkroom in which water froze when he closed the door because it had no heater. No doubt photography at the turn of the last century was a gruelling undertaking.

Not being part of the Pole party, Ponting gave photography lessons to those who would undertake the historic trek. When their bodies were found, their cameras contained photographs which would become iconic images of the tragic journey. Once Ponting developed them, he knew he had history in his hands.

Given his equipment and the harsh conditions, his black and white pictures are today memorable photographic landmarks of polar exploration. On his return to England, audiences at his lectures and exhibitions could, for the first time, get a sense of both the beauty and the horror of the frozen south. It was in great part due to Ponting's work that Scott and the southern party became the heroes of a nation.

In the end, though, he confessed that there were things about Antarctica that no camera could depict. How could one capture the glory of a calm, moonlit day in the depths of the polar night? Or the utter desolation and indescribable loneliness beneath shivering stars when there was nothing to hear but the beating of your heart? Then, when the sun returned, there was the thrill of movement through the icy wastelands.

> To drive by dog team over the frozen sea in the crisp polar air is one of the most exhilarating experiences imaginable. The yelping of the excited creatures as they are harnessed up; the whining and howling in pleasurable anticipation as they strain at the traces, impatient to be off; the mad stampede with which they get away when the driver gives the word to go; the rush of the keen air into one's face; the swish of the sledge runners and the sound of forty paws pat-a-pat-a-patting on the crackling snow, is something that cannot be described. It must be experienced.

I spend a long time analysing Ponting's photographs, working out his exposures, and checking the position of the sun beyond his frame. I study one of his pictures, then go outside and try to emulate it. Afterwards I swap the digital for the slide camera, get my sun angles right, take chances and trust the meter. It works.

Ponting, after all these years, still proves to be an inspiring teacher.

GETTING THE SHOT

Antarctica is a beautiful place, so, on advice, I took lots of film. I used several single-lens reflex Nikon cameras and was thankful for a wide-angle lens – most scenes tended to be vast. Long-range lenses were worth taking, but on the ice shelf creatures were so tame I often had to shoo them away to get the shot.

Because of the reflectiveness of the ice, light seems to be coming from everywhere in Antarctica. The camera meters do a fair job of dealing with the glare in matrix mode (taking an average light reading across the whole scene) but I found it best to intervene when there were high contrasts. This is because the camera's meter wants to turn everything into what's called '18% grey', which is like photographically mixing black and white in equal quantities. A good idea was to spot meter on the object essential to the photo and let the rest of the frame sort itself out.

Scenes often had too much white, threatening to produce a greyer or deeper blue than I was seeing unless I 'opened up' at least one stop. The way I did this was to set the meter on +1 in aperture priority mode (and remind myself to set it back to zero afterwards). If there were a lot of dark areas, the meter reduced it to grey unless I 'stopped down' by setting at -1. This way, what was dark stayed dark. There were times when I pushed film to +2 or -2, but had to be sure of the camera to get reasonable shots. With the digital I was sometimes shooting at +5 or -5, something I wouldn't think of doing with film. So I didn't miss that once-in-a-lifetime photo I bracketed widely.

Slower film speeds work best in Antarctica because there's so much light, and I used a tripod to ensure pin-sharp photos. The cold also shortens the life of batteries, so a good supply was essential. I also took rechargeables. Polarising filters cut the glare on ice and water and darkened skies. A UV filter reduced the blue cast of the snow a bit. But filters were hard to handle while wearing thick gloves, so I mostly left them off.

When composing, I tended to position subjects a third over to left, right, top or bottom. And I tried not to forget about the messy or blurred backgrounds. I'd been warned by someone who'd been south not to be deterred by bad weather. How right they were. Dark, threatening skies, iced-up faces, blizzards and white-outs produced some of the moodiest photos.

My Nikons were an F100 and a D70. Sticking my neck out, I'd say the digital D70 did best because of the extreme light conditions. I could see my errors immediately, readjust and shoot. If necessary I could fiddle with the images in Adobe Photoshop afterwards. I was taking thousands of digital shots, downloading them onto my laptop and burning them to CD. I was like a kid in a toy shop until I had to start selecting the best. It took days.

And finally, I kept a reasonable distance from animals I was photographing. They seemed tame by virtue of being unafraid, but they're wild, they peck and they bite. I was also aware that scaring birds from their nests could leave the chicks to die without their parents' warmth.

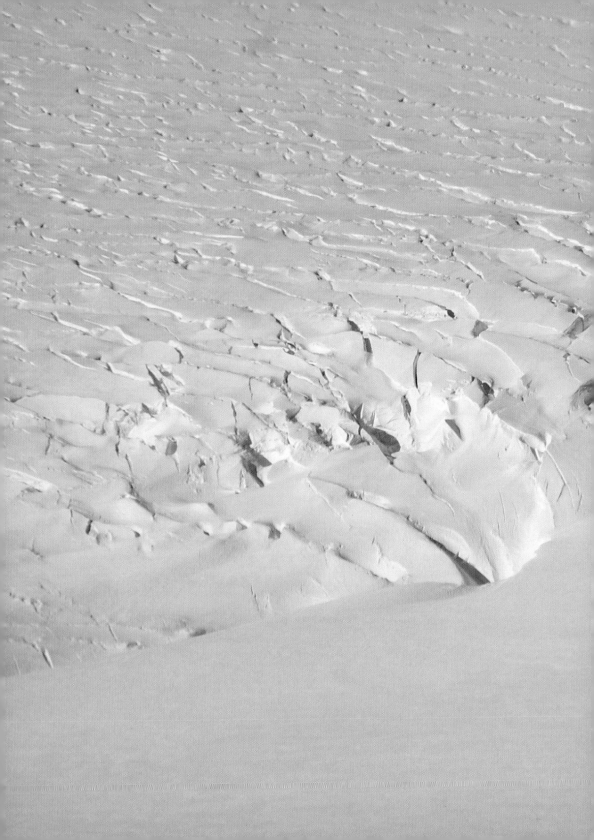

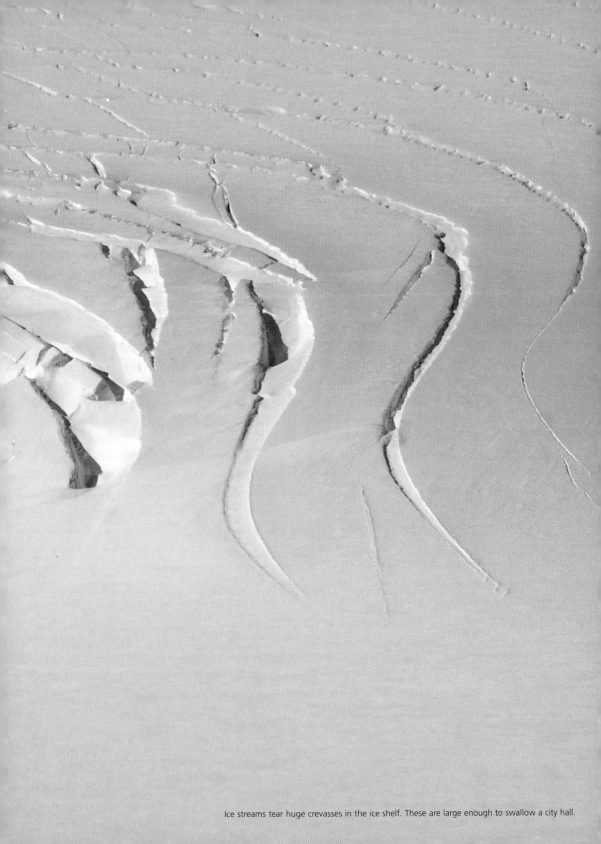

Ice streams tear huge crevasses in the ice shelf. These are large enough to swallow a city hall.

Rivers of ice

In contrast to the exquisite balance that exists between the Antarctic environment and its living organisms, Antarctica is as alien to humans as humans are to it.

Mark Jones, *Wild Ice*

The thing about the few bases I managed to poke my nose into and those I'd read about is that there always seems to be a prodigious amount of food around. Three full meals a day are standard, plus tea-times with scones or biscuits and, quite often, wicked-looking cakes. You can't exactly go jogging in snow boots, so working off all this inevitable consumption takes discipline, of which I do not have much. But desperation eventually drives me to seek out the base gym. Around 7.30 each morning I dutifully plod up the stairs, get on one of the exercise bikes and spin away under the sultry gaze of Buffy the Vampire Slayer whose poster had been stuck to the wall. There is another poster of a large-breasted lady named Carmen Electra showing half her bottom, but Buffy holds my gaze.

The place is deserted at that time of morning, so I have it to myself. After a few minutes on the cycle I do some lengths on the rowing machine staring up at an energy-saving light in the roof. Then one day I go round at four in the afternoon to find the gym much changed. It's full of all the computer-gazing scientists who have metamorphosed into grunting, sweating jocks pumping iron. They are quite unrecognisable. I commune silently with Buffy for a moment and flee. On the way back through the base, Frans Hoffman taps a finger on his ever-changing schedule upon the wall and announces that I'm on a flight to Troll, the Norwegian base, the next morning. Sorry, Buffy, I'm heading out …

I arrive after breakfast clothed in outers, middles, inners, boots, hoods and gloves and carrying my camera bag to find the pilot, Big André Vandrie, in nothing much more than snow boots and a flying overall. He's a tall, lean Canadian who, when he's not in the air, stalks the passages and offices clutching a large, brown, insulated coffee mug. Once I heard in it the tinkle of ice cubes, but mostly it really is coffee. He has a craggy face, a shock of hair lightly dusted with silver, and is movie-star perfect for the part. Big André has logged thousands of flying hours crop-dusting, fighting forest fires, plucking injured climbers from mountain peaks, dropping geologists into inaccessible places, running crates of gemstones from isolated mines, laying oil pipes in Alaska, and is now sky-taxiing in Antarctica. We take off from Sanae and set a course east along the Queen Maud Land Mountains. Gazing down, I can see how ice, sliding down from the high plateau, has torn itself into cat-scratch-like crevasses around the southern edge of our home nunatak, Vesleskarvet, on its inexorable way to the sea. I find a headset hooked over the back of my seat and put it on. André's singing.

'What's that you're singing?' I ask into the headset's microphone.

'Oh, you can hear me, can you? Well, man, it's a beautiful day in Antarctica, and will you just look at that amazing scenery. We're so lucky, you now, seeing this stuff. I mean, how many people get to check out this kind of thing? Shit, man, I'm singing because I'm here! I dunno what the tune is.'

As the Huey thunders along, its double engines making normal conversation impossible, the tips of black, ice-jacketed mountains unspool dramatically to our right, while under us the snow seems as smooth as a new tablecloth. After about half an hour a blue slash appears ahead, looking out of place in the monochrome landscape.

'What's that?' I ask André.

'It's a glacier, they call them ice streams here. The Jutulstraumen. Big, hey?'

Before we get over it, crevasses begin to appear. First there are longitudinal cracks, bent in the direction of the stream's flow. Nearer the blue ice are chevron-patterned crevasse fields, then shattered ice, then yawning holes in which you could lose an aircraft hangar. The glacier itself is rippled by transverse crevasses which, way north at its snout on the shelf, are curved like the way kids draw rainbows. The Jutulstraumen is clearly torturing the ice it slices through.

We land at Troll on the ice runway and slither precariously across to the snowline, where we're met by the base's doctor, who has a broad American accent. Troll is still in its construction phase, and accommodation for the crew is in little pointy tents perched in neat rows along several bulldozed terraces.

'Don't you get cold living in those tents?' I ask the doctor.

'No,' she answers. 'It's summer.'

The Norwegians have been in Antarctica for nearly a hundred years and their favoured son, Amundsen, won the respect of the non-British world by bagging the Pole. Most of Queen Maud Land falls within their area of influence – a cake-wedge slice of Antarctica from near the Pole to around 60° South. They've done much of the surveying in this area and have had plenty of time to choose a good position for their base. The mountains around Troll are spectacular and dominated by a huge, flat-topped peak named Stabben. Right behind the base is a saw-tooth berg with the quaint name Sophiespiggen. We don't stay long – it's a taxi run delivering a Norwegian who's spent time at Sanae – and we're soon on our way back. By then, high cirrus clouds are mottling the icescape and the sun, being lower, has widened the jaws of the Jutulstraumen's crevasses.

::

SLITHERING MONSTERS

The Jutulstraumen Glacier has its genesis on the high polar plateau, which sublimates every-thing in Antarctica by its vastness and brutal simplicity. This plateau dictates the continent's weather, glaciers pour from its edges and ferocious katabatic winds, drawn from its great height by gravity, shape the entire continent and the Antarctic Ocean. It's one of the largest and yet simplest landforms on the planet.

The plateau has more in common with the moons of Jupiter than the lands to the north. It's shaped like an inverted dish, but fattens at the edges where it builds up against the polar mountains which rim the continent. At its highest point the ice is nearly five kilometres deep and so heavy that it forces the land below it downwards into the earth's magma. Antarctica, therefore, has the lowest continental landmass above sea level yet is the highest continent. At its edges the plateau literally moves mountains and extrudes ice through scoured valleys towards its edge.

The Jutulstraumen is, quite simply, a frozen river which collects, transports and dissipates ice, ramming it clean through the massive Fimbul Ice Shelf. No other ice mass is subjected to such hideous pressures as an Antarctic glacier. Along its flanks – the shear zone – stress builds up, crevasses form and the rate of flow is slowed. Movement at its base may be speeded by melt-water or slowed by rocks. The centre of the stream moves more rapidly than the edges, the top more rapidly than the bottom. As it travels it erodes, scrapes, realigns, grooves, cracks, potholes and gouges the surrounding surfaces, not moving evenly but often in jerks which give rise to icequakes.

In 2002 several stations recording seismic signals in Queen Maud Land picked up two midwinter quakes followed by a far larger one. The two preceding events were found to be caused by a huge glacier, listed simply as B9a, colliding with the continental shelf near the snout of the Jutulstraumen, and the main quake was thought to be flow-induced vibrations in crevasses and tunnel systems inside the iceberg triggered by the collision.

::

My brief exploration into glaciology should have warned me off crevasses, but instead it exerted a strong pull in their direction. The next day, while gazing down at them from Sanae, I think of Struan Cockcroft. There are certain people who reliably rise to a challenge, and he's one of them.

'Do you think you could get me down a crevasse for some photographs?' I ask him a bit later, knowing full well he can.

'Yep. When do you want to go?' he replies.

'How's now sound?'

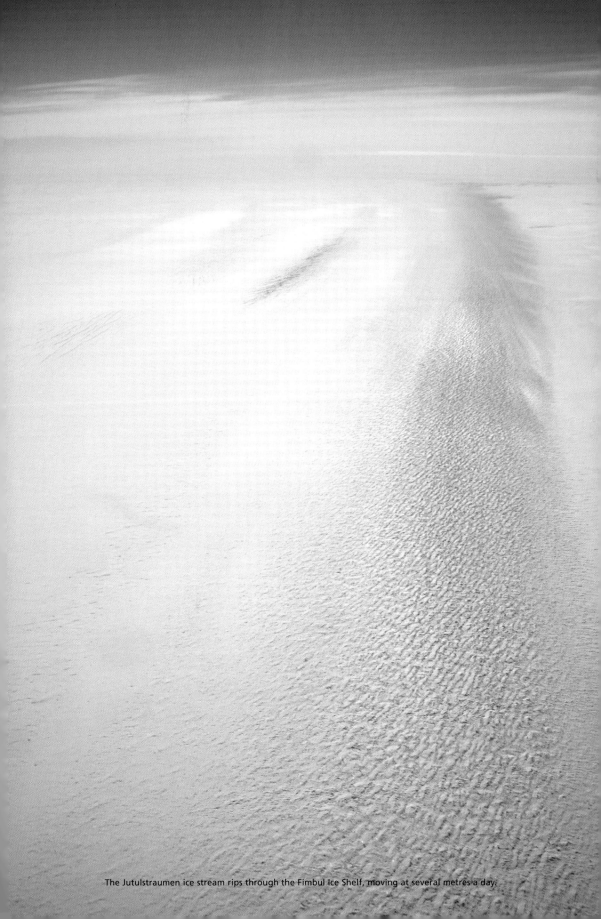

The Jutulstraumen ice stream rips through the Fimbul Ice Shelf, moving at several metres a day.

So not long afterwards we skid to a halt next to a running indentation in the ice about four metres wide. Struan clips on some crampons, buckles a harness, ropes himself to the skidoo and attacks the edge of the crevasse with a spade. It goes through the snow bridge with disturbing ease, indicating just how easily you'd disappear if you tried crossing it. This one fails to meet his approval: 'Too wide and not deep enough.' The next is perfect. He digs a hole, buckles up again and goes down to investigate, popping out a bit later like a Weddell seal at a blowhole with a grin of approval. I harness up and lower myself gingerly into the hole, hoping the short ice screws to which I'm tethered will hold.

As I look down, the walls are tinkling ice crystals and there are stalactites of the profoundest blue. Light is filtered and soft, from white to a deep, serene indigo. I abseil down and land knee-deep in crystals. The 'floor' (you never know if it's the bottom or just another snow bridge) slopes down to a larger turquoise chamber with fluted, crystalline walls. After the icy blast above, it's warm down here. I tie off and ready my cameras. Then Struan – the perfect model – drops in and hangs just where I want him for the photo shoot.

Getting up is another matter. I've never come across a jumar system before, but it's the only way I can get out. It consists of two separate handles that slide up but not down. Attached to them are loops of cord, one round my foot, the other tied to my harness. It requires a steep learning curve spurred by the anxiety of being stranded down a crevasse.

'What happens if I can't do this?' I yell up at Struan.

'Ah, don't worry,' he calls down. 'We'll just bring your sleeping bag and throw down some food occasionally until you do.'

I slide up the foot jumar, heave myself upwards, then slide up the harness jumar. The result is a sort of one-footed walk up the rope. Finally my head pops up, met by an icy blast that freezes my eyelashes.

That night at supper, the scientists are on top form. We're talking about who did what during the day and someone mentions they've just been killing time.

'You can't kill time without injuring eternity,' Struan announces. Everyone looks at him, waiting for details, but he just sits there and grins.

The chaplain, Sybrand, takes the bait. 'According to the Bible, God created time on the third day. You can't kill time at all.'

'So how did He get to the third day?' space weatherman Lindsay wants to know. Everyone hoots with laughter.

'Woah! Smart parry there,' says Jurgen Olivier.

Sybrand looks puzzled: 'Well …'

Joe Starke interrupts: 'If time is the process of our expanding universe, what happens outside that universe?'

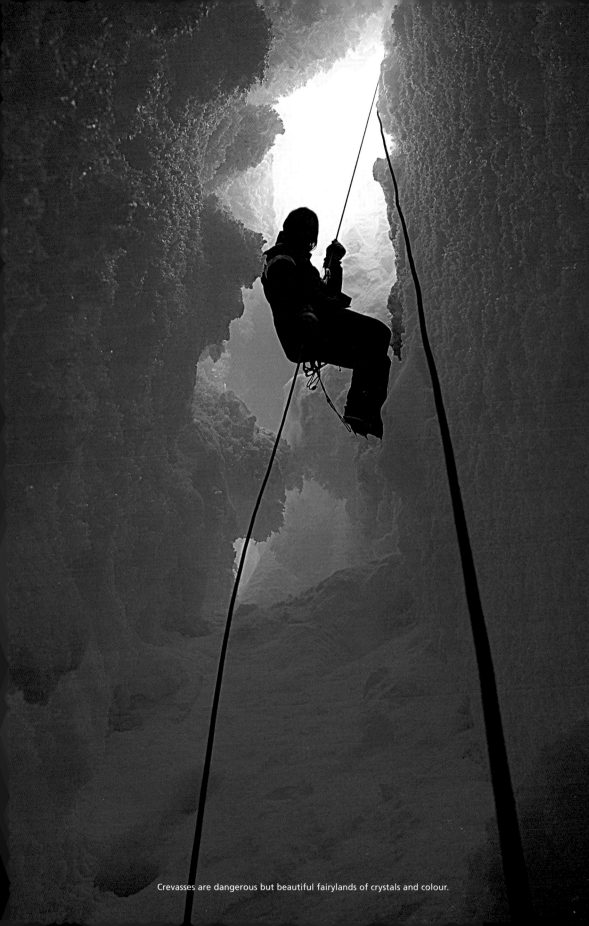

Crevasses are dangerous but beautiful fairylands of crystals and colour.

'Think of it like this,' explains John Sample, an American space researcher. 'If you were at the boundary of the universe and could walk faster than it was expanding, it would be like walking up a steeper and steeper incline until you walked right back over your head. There's no Outside. If there was, it wouldn't be a universe.'

'Yeah, but that's only in this dimension,' Struan challenges, unable to resist. 'You can't say six-dimensional space acts like three-dimensional space.'

'So what about God?' Joe wants to know. 'Is He the sixth dimension?'

Sybrand looks pleased with that explanation, but space plasma researcher Mike Kokorowski sighs loudly and makes his bid. 'God is, and always has been, the next unknown thing. God'll continue to be the name we give to that which we do not know until we know everything. Then we will be God.'

'But if we are the thing that knows, we can never get outside ourselves, so we can't ever know everything objectively,' Dr Joe tries, but there's a silent agreement that Mike has clinched the argument, so the conversation shifts to the toughness of the Brazilian chicken we were just eating.

'They must be all roosters in Brazil,' comments Struan. Do you think you can tell a rooster from a hen by eating it?'

Everyone groans.

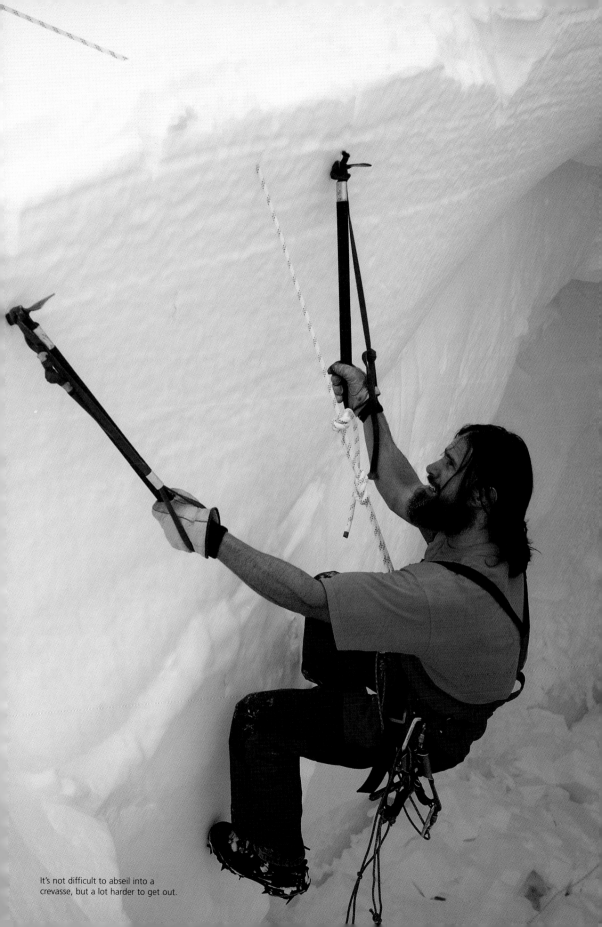

It's not difficult to abseil into a
crevasse, but a lot harder to get out.

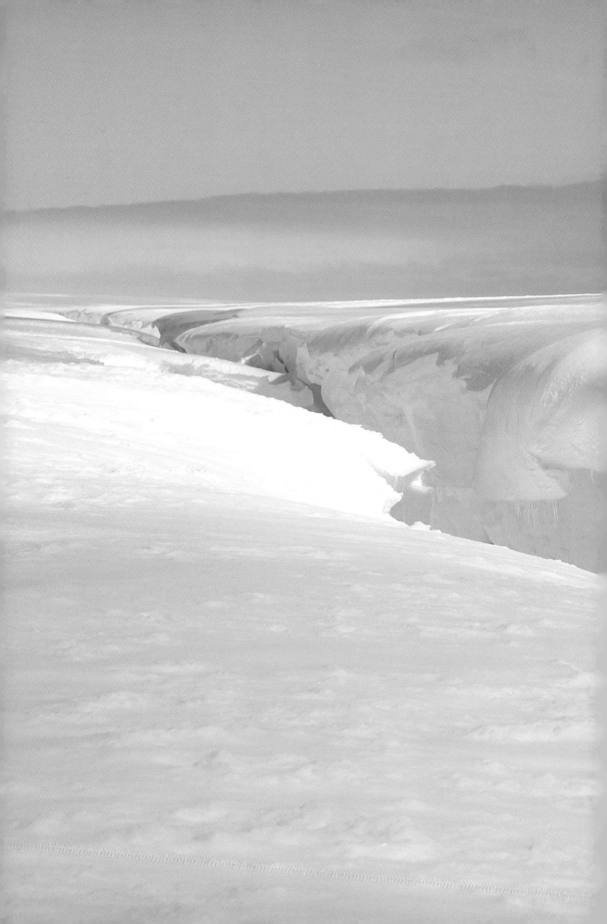

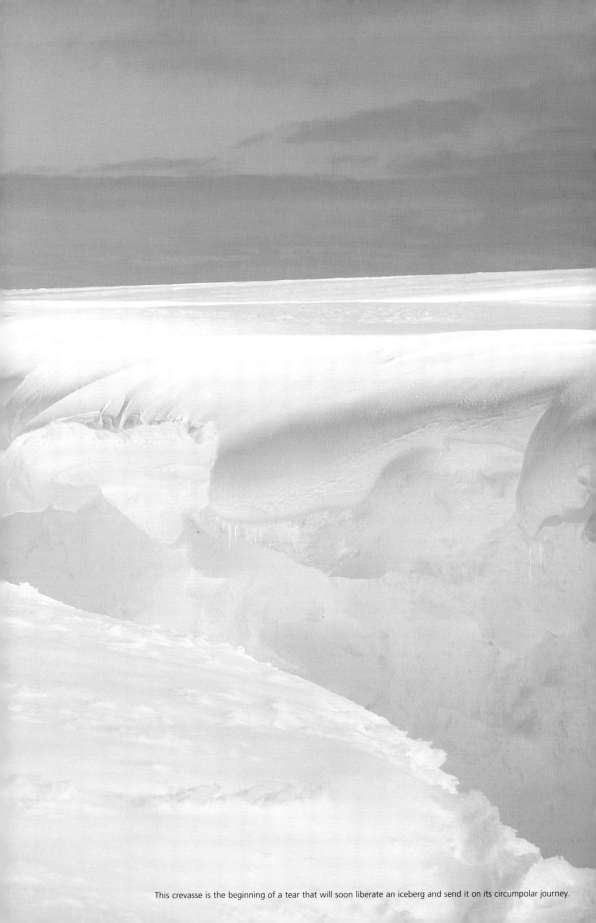

This crevasse is the beginning of a tear that will soon liberate an iceberg and send it on its circumpolar journey.

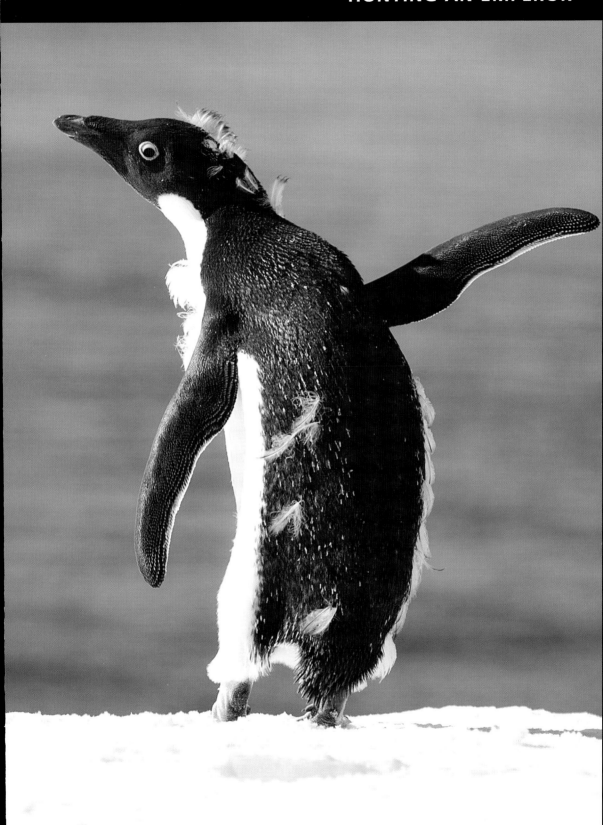

Adelie penguins are the darlings of Antarctica and never shy of a comic turn.

Hunting an emperor

I have often had the impression that, to penguins, man is just another penguin – different, less predictable, occasionally violent, but tolerable company when he sits still and minds his own business.

Bernard Stonehouse

There is what seems to be a penguin egg in the display cupboard at Sanae, so someone had repeated Cherry-Garrard's worst journey in the world. But up among the nunataks there are no penguins. Not even an emperor would consider waddling nearly 200 kilometres inland to lay an egg. I sit looking over the ice fields and realise that, more than anything, I want to meet an emperor. If they won't come to me, I'll have to go to them.

Down at E-Base the shelf is too high for penguins, but several hundred kilometres away the German base, Neumayer, is near bay ice and perfect for penguins. Each year the South Africans organise a courtesy visit, ferrying mainly over-wintering types down to Neumayer and bringing their German equivalents to Sanae. There's a place on the chopper, I discover, so early one morning I kit up and head for the heli-deck. Thus begins my quest for the perfect penguin.

We fly over nunataks and then the ice sheet until the coast comes into view. Being summer, the shelf is calving and the sea is sprinkled with icebergs. Neumayer isn't in evidence when we land; it's buried deep in the ice. Yes, confirms a member of the welcoming party after I escape the blast of the rotor blades and am able to ask, there are emperors here. Actually, he says, pointing, there are some right over there. Three large black forms seem to be in deep conversation about fifty metres away. I get my camera ready and stalk them, but they don't need stalking. The three view me with supreme indifference, however close I come. But they look awful! Grumpy, scruffy and moulting. The perfect penguins they are not.

The Germans are sympathetic. So we go hunting, bounding over sastrugi in skidoos. Throughout my stay in Antarctica I harbour an ambivalent attitude to skidoos. They're the best way to travel fast over ice, but they bump hideously. Everyone uses them and they're as convenient as a Vespa scooter, but afterwards you feel as though you've been in a wrestling match.

::

Emperors have impossibly high-risk breeding routines – it's a wonder they've survived so long as a species. The females lay a single egg in winter and pass it to the male, who incubates it on his feet through winter blizzards while the female is off feeding. When the chick hatches, the male dutifully nourishes it on secretions from his stomach. He doesn't eat – for months – and at the right time he shuffles, as only a penguin can shuffle, towards

the sea. This can be more than a hundred kilometres away. When he gets there, he's nearly dead from hunger, having fasted for up to 120 days. He finds his mate (it's hard to know how), gives her the chick and heads to sea for a well-earned meal.

A fully grown emperor can weigh up to 40 kilograms, stand over a metre tall and have the same attitude towards humans that we have towards an irritating fly. We are, by comparison, youngsters on the evolutionary scale, having been around in our present, upright form for maybe three million years. Penguins probably descended from auks or petrels, and took off on their own specialised trajectory some time in the Cretaceous Period, between 140 and 65 million years ago. Their fossil record is limited, but what we have shows that there were many more species than at present. One, named *Pachydyptes ponderosus*, stood over a metre and a half tall and weighed around 80 kilograms.

Modern penguins, like albatrosses, are long-lived. Emperors only begin breeding at the age of 9 and are still sexually active at 20. They're largely monogamous and pair-bonds have been recorded as lasting more than ten years. On land they waddle, but in the water they're extraordinarily fast. Emperors have been clocked at depths of up to 450 metres during dives lasting around 11 minutes.

Emperor penguins treat humans as minor irritations, if they regard them at all.

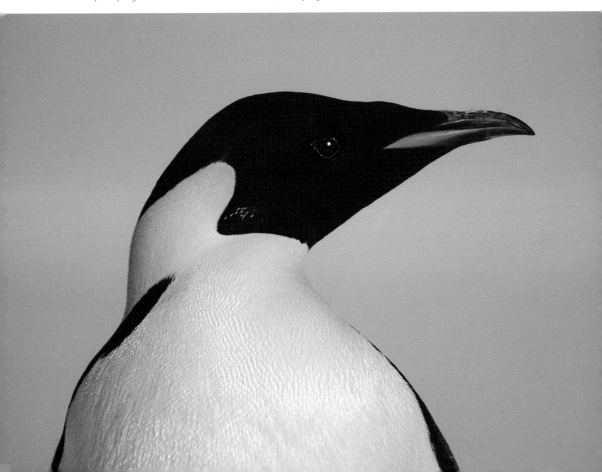

The earliest historical record of penguins can be found in an account by the Portuguese mariner Vasco da Gama on a voyage to India. He described the strange creatures he sighted (African penguins) as being 'as large as ganders and with a cry resembling the braying of asses'. Towards the end of the sixteenth century a Dutch explorer, Oliver van Noort, visited an island in the Straits of Magellan and noted that his crew 'furnished themselves with a store of penguins [which] of these fowles they took fifty thousand, being large as geese, with eggs innumerable'.

The German naturalist John Forster who accompanied James Cook on his 1772 expedition, set the tone for future human treatment of penguins. 'They are said to be very tenacious of life,' wrote expedition artist William Daniell, observing Forster's collection methods. 'Forster knocked down many of them, which he left as lifeless as he went in pursuit of others; but they all afterwards got up and walked off with great gravity.' By the late nineteenth century the plunder of penguins for their oil was in full spate. At one point up to 150 000 were taken each year from Macquarie Island and their numbers were greatly reduced throughout the Southern Ocean.

The first man to study the penguins of Antarctica with any scientific rigour was Scott's colleague Edward Wilson. He found, above all else, that Antarctica was a land of penguins. Most of the world's 17 species occur in the Southern Ocean region, and on the continent they constitute up to 80 per cent of the biomass. His book, *Birds of the Antarctic*, contains sketches of no less than 103 penguins, many of them quickly executed line drawings and others finely detailed and coloured. Emperors, Wilson wrote,

> have no fear, but an abundance of inquisitiveness, and a party … will walk up to one with dignity and stand in a ring all round, with an occasional remark from one to the other, discussing, no doubt, the nature of this new and upright neighbour. That the new beast is a friendly one they appear to have no doubt, and one can only regret that from time to time necessity compelled us to disillusion them.[13]

His delight, however, was with adelie penguins. On 2 January 1902, as the *Discovery* nosed its way through the pack ice, Wilson saw them for the first time. The presence of the ship, he diarised,

> afforded an excellent opportunity for the inquisitive little birds to run long distances towards us, and with many halts to gaze and cry in wonder to their companions; now walking along the edge of a floe in search of a narrow spot to jump and so avoid the water, now with head down and much hesitation judging the width of the narrow gap, to give a little standing jump across as would a child, and running the faster to make up the delay.

Later, observing an adelie rookery bursting with young chicks, he noticed that any adult that entered the area was badgered by hungry youngsters urging it to disgorge its meal,

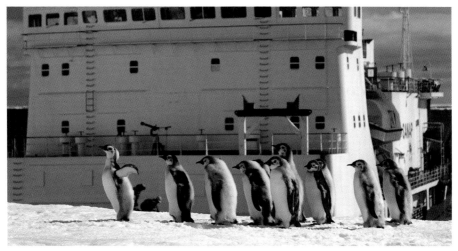

Emperor chicks can't yet swim, so a ship is a good distraction from the long wait to moult.

while the adult hunted frantically for its own chick. In this way the stronger got fed, but for the less robust a more pathetic ending was the rule.

> A chick that had fallen behind in this literal race for life, starving and weak and getting daily weaker because it could not run fast enough to insist on being fed, again and again ran off pursuing with the rest. Again and again it stumbled and fell, persistently whining out its hunger in a shrill and melancholy pipe, till at last the race was given up … Sleepily it stands there with half-shut eyes in a torpor resulting from exhaustion, cold and hunger, wondering perhaps what all the bustle around it means, a little dirty dishevelled dot, in the race of life a failure, deserted by its parents who have hunted vainly for their offspring … And so it stands, lost to everything around, till a skua in its beat drops down beside it and with a few strong vicious pecks puts an end to the failing life.[14]

::

It's a beautiful, sunny day. We picnic at the edge of the shelf, watch the icebergs rock gently in the swell, photograph crab-eater seals lounging on a floe and listen to minke whales sounding among the bergs. But no penguins. So we drive along the ice for half an hour. Finally, standing imperially on the shelf edge, is an emperor. I don't bother to stalk this time, and she (I suspect it's a she) looks down her beak at me with the greatest disdain. She's glowing with a post-moult sheen and looks glorious. She poses, she preens, she stretches her considerable flippers comfortably and simply ignores me. Naturally she becomes a most photographed penguin: I zoom in on her proud head with a red flash

under her beak and a yellow scarf, her elegant black flippers, her shining breast and her reptilian feet. The Germans have to drag me away and we hurtle back to their base over sastrugi in great discomfort. I nearly miss the chopper home. Even if I did, I decided, it would have been worth it: I've met an imperial emperor.

::

The next evening I have a radio interview arranged and booked for a certain time. But at the appointed hour Franz is on the external phone. I drop a polite note beside him telling him there will be a call coming through for me. For some reason this irritates him and afterwards he gets really angry about being disturbed on the phone. He tells me I'm wasting my time just looking at the pretty side of Antarctica and sitting around writing. I should be out working in the Depot like a real man, digging out oil drums until I need muscle relaxant drugs for the pain in my shoulders.

I figure he's under a lot of pressure to blow like that, but maybe he has a point. I take it as a licence to purloin a skidoo and get off base. So next morning I kit up and whiz down to the Depot where containers are being loaded onto sledges. It's not exactly hard work – the crane does all the lifting – but it's certainly freezing out there. We spend the morning loading and sliding round on the frozen sledges. I'm not sure it makes a man of me but I end up with damn cold fingers.

On the way back to the base I come across Leon du Plessis all alone on a crane hoisting containers from sledges up onto the heli-deck. He positions the hook over the container, jumps out of the crane, clambers onto the container, passes two cables through the tie slots, loops the end over the hook, jumps off, clambers up into the crane and hoists the load up onto the deck.

'This is nuts,' I call up to him. 'Why are you working all alone?'

'Nobody likes this work,' he says, 'and it has to be done.'

So I do the hooking while he works the crane. We load containers companionably for several hours and get to know each other as we do. Leon loves Antarctica. He has no complaint about colleagues who fail to help him, absolute dedication to the job at hand, a twinkling sense of humour and a deep thoughtfulness that seems to contextualise everything he does. Being outside working on the ice fulfils him. When I fail to hook up a cable or send the boom in the wrong direction, he shows no irritation. He just waits patiently with the −30° wind whipping over him and, when I'm obviously out of my depth, he offers advice without judgement.

Another Antarctic hero, I think. This continent seems to attract them.

At supper that evening the science table is discussing why Struan the Irrepressible is like Darth Vader.

'Why me?' he questions.

'Do you know why the sky is blue?' Lindsay asks him.

'Yeah. Rayleigh scattering; it deflects the sun's rays at the blue end of the spectrum.'

'That's why you're like Darth Vader,' Lindsay concludes, while the table erupts.

I figure it will take me a while to work out space-science humour and defect to join Leon and the Cat drivers who are discussing the backloading trip to Neumayer. It makes more sense.

ANTARCTIC SCIENCE

Doing science in Antarctica is expensive. It requires complicated transport, high-tech bases and, generally, government funding. The question is: why do it at all?

The reason is that the seventh continent provides a platform for science that is directly relevant to the more populated regions of the world. It is also one of the few areas where open scientific cooperation takes place. This is organised through a non-governmental body, the Scientific Committee for Antarctic Research (SCAR) and the Convention for the Conservation of Antarctic Marine Living Resources (CCAMLR).

Southern Ocean research includes attempts to understand the nature of global ocean currents and weather patterns; bird life on the sub-Antarctic islands and ice shelf; the six species of Antarctic seals, fish, algae and seabed communities.

On the continent the extreme conditions force fascinating adaptations by plants, invertebrates and microbes, the study of which is deepening our understanding of possible life on other planets. Antarctica forms one of the seven major rock shields that cover the surface of the globe, and though mainly covered by ice, it possibly contains valuable minerals and fossils. Because of its hard white surface, Antarctica is a perfect place to find meteorites which contain information about deep space.

The ice sheet both drives the world's weather and responds to long-term climate changes. Ice cores drilled out of the continent's vast plateau are indicators of weather and pollution patterns going back thousands of years.

It is in Antarctica that the ozone hole was discovered by British scientists and key research is being done on the rate of ozone depletion. The continent is also a sensitive barometer of global warming.

Because of the clear air and long, dark winter nights, the continent is a good site for astronomy, but at all times it is one of the best places to study the impact of solar wind on our planet and even the global impact of lightning strikes.

In the close confines of Antarctic bases through the eerie polar nights, it's also an excellent opportunity to study the psychology of small groups

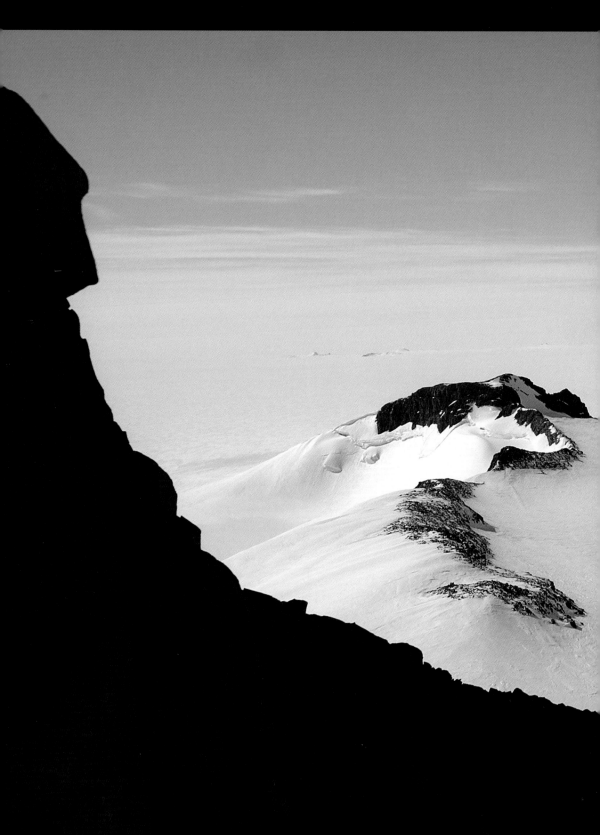

From Lorenzenpiggen Peak you seem to be able to see to the end of the world.

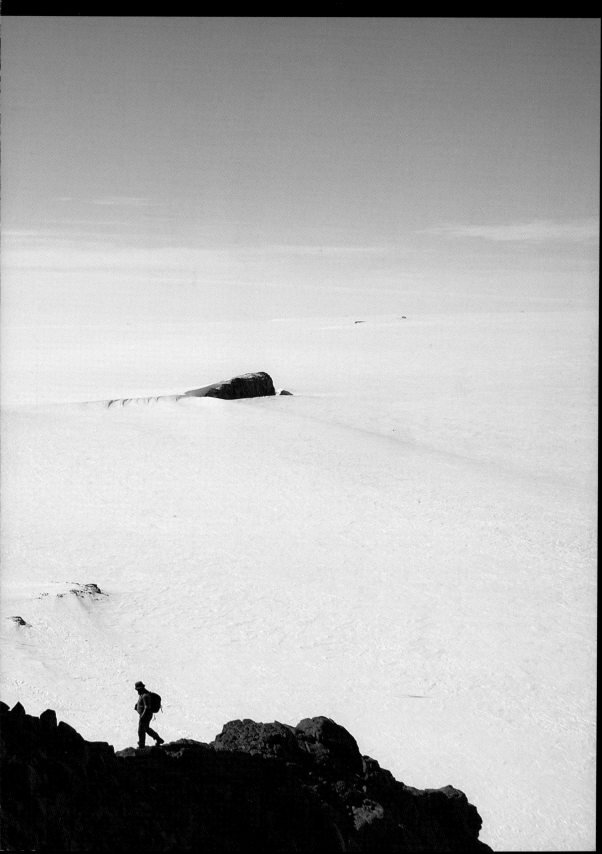

Challenging a nunatak

Beauty and grace are performed whether or not we will or sense them. The least we can do is try to be there.

Annie Dillard, Pilgrims at *Tinker Creek*

One morning, as I walk along a corridor to breakfast, an insect shoots off under a door. That may be a matter of little significance anywhere else, but in Antarctica there are no insects apart from a species of spider that inhabits the guano heaps of nesting penguins on the Antarctic Peninsula. I'm amazed. So I open the door and sneak after it as it tries to get behind a cupboard. What I end up with in my hand is a creature which, after some study, I name 'scuttle fluff'. And from my subsequent studies of it a new theory emerges – for me, anyhow.

That life fills all vacant niches is well known. Without mammals in Australia, marsupials filled the niche. In Madagascar, lemurs occupied the primate gap and in New Zealand the kiwi does a creditable job as a rodent. Penguins are to Antarctica what barracuda and tuna are to more tropical waters, and seals are excellent stand-in hunters for sharks. So what fills the insect gap on the Antarctic plateau?

In the base the air is extremely dry and loaded with static electricity. Everyone soon learns to touch things with the backs of their hands which are less sensitive than fingers to the inevitable spark accompanied by a snap and a small flash. Most people wear synthetic, fluffy, warm garments that shed like a moulting penguin. In this atmosphere the stray pieces gather static and cling together, growing voraciously, and use the breeze of our movement through the base to travel. The more it scuttles, the bigger it grows. A niche is filled. I christen it *Antarcticus polartechii*. In the absence of any life forms other than humans, scuttle fluff is somehow a reassuring presence. There is, I later find out, another life form nearby. It nestles beneath the dark, rocky tooth called Lorentzenpiggen – known as Piggen Peak – a spectacular nunatak about eight kilometres from Sanae across a crevasse-creased snowfield. To meet it requires an expedition and quite fortuitously, with nothing to do with stray life forms, one is arranged.

Several weeks into my stay a rather arbitrary public holiday is declared, a Tuesday when nobody wants to do any work. A group of us make climbing Piggen our objective. We kit up after breakfast and bounce across the sastrugi on sleds towed by skidoos, looking like red penguins in a row, all hanging on for dear life.

From the angle we approach Piggen, it looks like a woman's dressy high-heeled shoe with an over-stated ankle support, but as we drive round the back, which seems the easier ascent, it appears more like the Matterhorn. Before us is a scree slope which is the most dangerous bit of mountain I have ever seen. Millennia of freeze and thaw action have turned the slope into what looks like a giant's breakfast granola. Each step of the crumbly

45-degree slope causes rocks to shift or stones to slither downhill. Occasionally a boulder dislodges with the awful crunching sound of quick death. We make sure nobody is above us as we ascend. On the permanently shadowed side of the naked, toast-brown rocks, ice still clings, dripping gently on warm days and feeding water into small crevasses which are the perfect habitat for minute beds of brightly coloured lichen.

I sit for a moment and contemplate the yellow blob clinging to a rock beside me. In these wild surroundings it looks impossibly fragile. I guess it's a *Buellia*, though which one of the 32 species I can't say. Lichen is to Antarctica what trees are to the rest of the world, though this hardly conveys its continental dominance. If you're prepared to include the ice shelf as surface, then it's the dominant life form in an area of about 28 million square kilometres – an expanse as large as Africa. The other plants – some mosses and two species of grass: a hairgrass and a pearlwort – live mainly on the warmer Antarctic Peninsula. Out here in the Queen Maud nunataks, lichens rule.

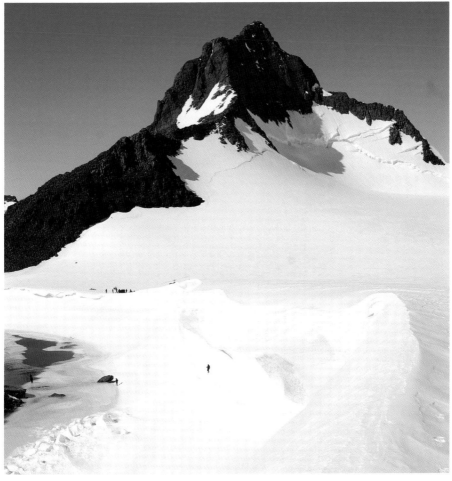

If the Matterhorn has a little brother, it's Piggen Peak in the Queen Maud Mountains.

::

Our party makes it up onto a high shoulder. From there the nunataks around us look magnificent, all laid about with crevasse traps. The rock above us goes up almost vertically. I elect to be the base camp; I know my limitations. Four young bloods rope up and take on the wall. After about half an hour, two return. They have also discovered their limitations. Two, Martin Slabber and Pieter Wolmarans, continue. An un-bolted, unknown route with loose rocks is tricky at the best of times. In Antarctica the temperature is always below zero and you need gloves, but this gives your fingers less grip. Progress is slow for the climbers. I hunch up against a boulder and stare across the ice fields to the Queen Maud nunataks stepping away into the distance.

Sanae 4 is positioned inland of the huge Fimbul Ice Shelf just east of the Jutulstraumen Glacier. All around are nunataks with names difficult to pronounce unless you speak Norwegian. South of Piggen is Nils Jørgennutane and Schumacherfjellet and to the east, beyond the glacier, are the HU Sverdrupf and Gjelsvik mountains with icy peaks topping around 3000 metres.

Satellites, aircraft and sophisticated radar imagery have mapped the last of the planet's unexplored areas, but a few places are remote and rugged enough to remain free of human footprints: pockets of African rain forest, remote escarpments in Sichuan and Tibet, bits of Canada's Arctic regions. Nowhere, however, is as remote as Antarctica and its mountains are mostly still *terra incognita*. The highest peak on the continent – the 16 067-foot Vinson Massif in the Trans-Antarctic Range – was scaled only in 1966. Though it's not a very technical climb, most mountaineers have been content with that experience. The Queen Maud Mountains are way off that beaten track: dark, vertical shafts of rock thrusting through the ice at the bottom of the world. They're among the most unclimbed peaks on earth. In books about Antarctica they're generally treated to little more than a passing mention.

Time passes. My feet freeze. Dr Joe sits under a boulder with his knees up and hands against his heart, hoping, no doubt, that his services won't be required to repair broken limbs. My fingers freeze, so I curl them up inside my gloves. That helps. The world feels Precambrian, the air interstellar. This is not just another place, it's another time: the time of ice. No student of physical geography can fully understand the history of the earth, or how it spins, breathes, freezes and thaws, until they understand Antarctica and its turbulent, ever-circling sea. When India tore away from eastern Antarctica midway through the Jurassic Period, around 150 million years ago, it caused massive, volcanic pyrotechnics. White-hot magma ripped through the sedimentary layers, cooling as granite peaks and valleys. While it was heading north, to collide eventually with Asia and push up the Himalayas, Antarctica was heading south, cooling by 2°C every million years. New species formed to cope with the changing conditions: sub-tropical trees, beautiful reptiles, fish,

marsupials and ferns. Returning from the Pole, Scott and his party explored some peaks at the head of the Beardmore Glacier and were amazed to find coal which contained impressions of leaves.

As the continent slid to the bottom of the world, the Queen Maud Mountains – the scars of separation from India – were gradually captured by ice. Life became tenuous, then almost impossible and finally was banished. But for some nesting snow petrels and hardy lichen, they stood, unknown, unseen and seemingly lifeless for millions of years.

Eventually I decide I'm freezing to death and need to move, so I descend to get a better view of the peak but can't see the pair of climbers. A few of us take the skidoo further down the ice rise. On the top of the peak a figure emerges, its arms raised. Then another. They've made it.

Needless to say, they take even longer to come down. By then, most of us are at the bottom enjoying a braai. You can't spend too much time in Antarctica waiting around or the cold will get you. And eating helps. When Martin and Pieter arrive, they are weary but happy, the way conquering warriors tend to be. Lorentzenpiggen is in their bag. Later Pieter tells me there was a moment when his left hand wasn't gripping properly and his right hand found no purchase. He looked down and knew one wrong move and it would be a very long way to fall. He held himself against the rock as best he could and calmed down. Then he found his grip. In Antarctica there's no room for mistakes.

ANCIENT SURVIVORS

Lichens may seem insubstantial scraps of life, but they are among the most enduring organisms on earth. They grow at a steady rate, so from their size it's possible to work out their age.

Some grow fast and die young, surviving but a single year. *Usnea antarctica*, which thrives on the Keller Peninsula, is not one of those. By measuring its growth rate (0.45 millimetres a year), many plants were found to be more than 500 years old.

Rhizocarpon geographicum beats that by a long way. Some plants have been radio-carbon-dated at more than 5500 years – older than Egypt's pyramids. How lichens got to Antarctica is anybody's guess. The most likely theory is that they were living on the continent before it broke away from Gondwanaland and slipped south.

On some nunataks, particularly in the vicinity of snow-petrel nests, lichens cover large areas. In more extreme habitats they're barely visible, living in micro-fissures in rock up to two centimetres below the surface or around the edge of large crystals. They have been collected at elevations of up to 2500 metres in areas where the winter temperatures plunge to minus 70°C. If we're searching for life on Mars, lichen is what we'll be looking for.

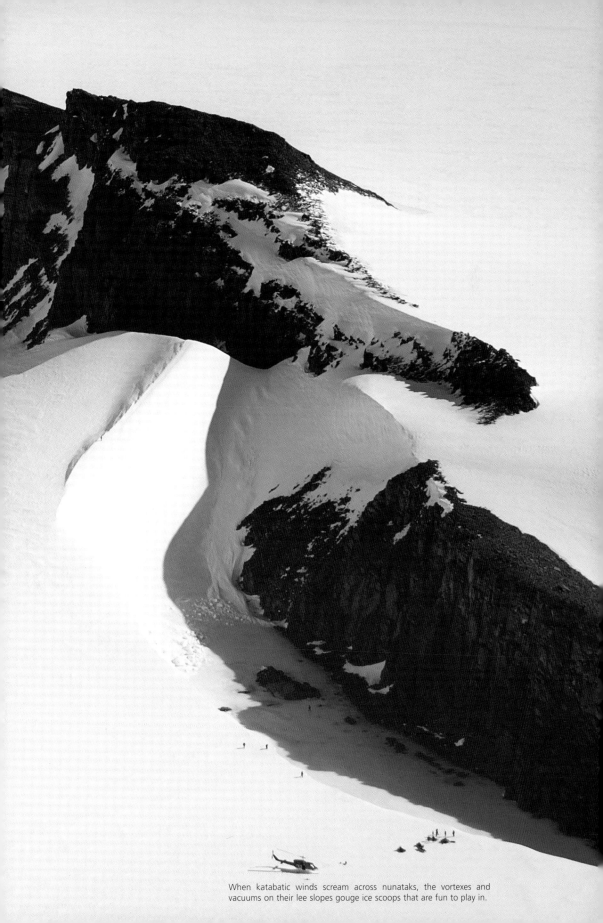

When katabatic winds scream across nunataks, the vortexes and vacuums on their lee slopes gouge ice scoops that are fun to play in.

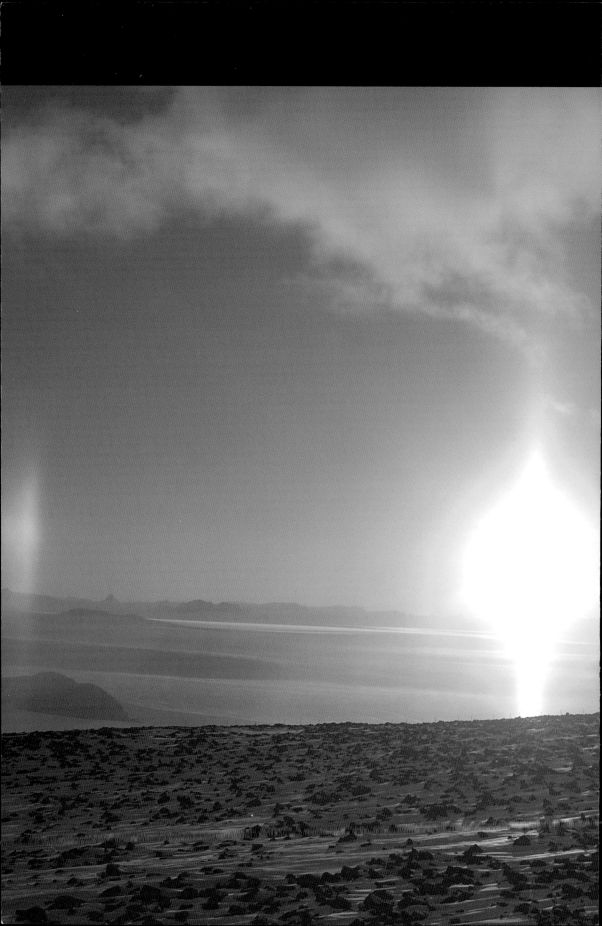

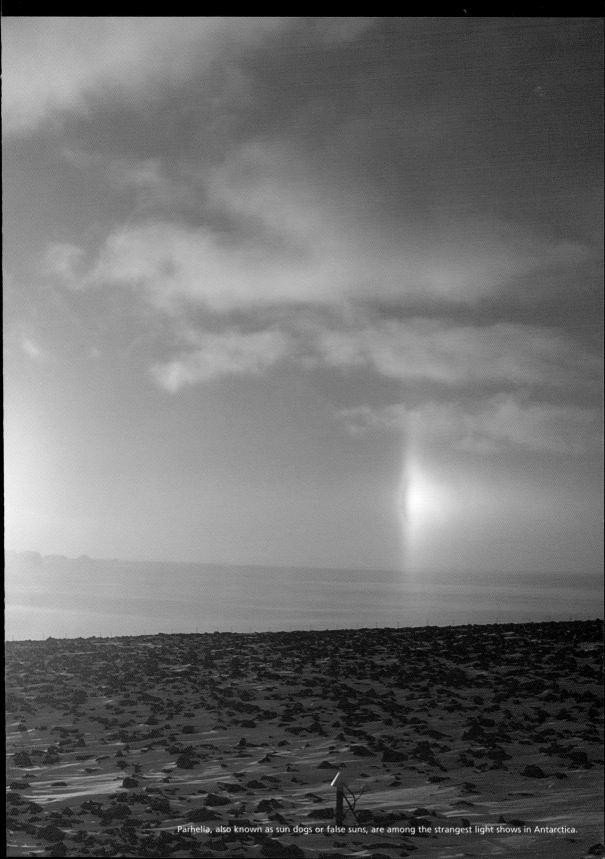

Parhelia, also known as sun dogs or false suns, are among the strangest light shows in Antarctica.

Memories of winter

Beyond this flood a frozen continent
Lies dark and wilde, beat with perpetual storms
Of whirlwind and dire hail, which on firm land
Thaws not, but gathers heap, and ruin seems
Of ancient pile, all else deep snow and ice.

John Milton, *Paradise Lost*

In late January the sun dips briefly below the horizon, reminding us that the season is changing. Autumn comes fast in these high latitudes of eternal ice. A century ago men would be packing sleds, stowing specimens, and watching the horizon anxiously for ships that might or might not get through the pack ice to bear them home. The horror of killing temperatures and darkness would quicken their steps and add urgency to their arrangements.

Today it is different. E-mail and satellite phone contact, secure, well-provisioned bases and high-tech clothing comfort us because of the authority with which they keep danger at bay. We retreat to comfortable quarters and wait, appraising the landscape very differently. The nights grow longer, the subtlety of light increases, colours change and deepen: vivid reds, glowing oranges, startling yellows, washes of rose and salmon, pale cyan, deep blues, mysterious purples. Day by day the thermometer drops. In January the still-air minimum is −13°C, February −15, March −22, April −30, May −33. By August it will be around −36 before beginning to rise slowly in September.

In February Sanae is a bustle of activity as the summer teams prepare to leave. From around eighty people, the base complement will soon drop to nine: the over-wintering team. Soon the population of a continent nearly the size of Africa will drop to that of a village. It is then that the full mystery of Antarctica will envelop the base in its delicate, icy grasp. Winter, with its iron indifference, its terrible weight, explains the ecstasy of summer. Darkness shuts off the view of distance, drives you deep into your polar fleece, pushes you back inside the base, and even your mind retreats into itself, sometimes leading to anomie and depression. Most creatures flee northwards, while only humans and lichen remain (what does lichen murmur in its winter dreams?) It is then, writes Barry Lopez in *Arctic Dreams*, that you can hear the breathing of something with ice for a heart.[15]

Each year the over-wintering team at Sanae produces a monthly newsletter as a way of staying in touch with the warmer world. It makes interesting reading. February's letter is practical, all about arrangements and activities with an occasional thoughtful comment:

'This is a strange land we have chosen to come to, and the truth of it is stranger than anything I could have imagined.'

In March when the first *aurora australis* rippling across the night sky the awe deepens.

Beneke de Wet, the team leader, had been waiting for these strange solar lights: 'Auroras at last! What a wonderful sight. Huge sheets of colour flowing in a gentle outer-atmosphere breeze, dancing and gliding across the sky, effortlessly. Sometimes they look like coloured, translucent wax flowing down a glass dome, others pulsate like wave action on the surface of water. An investment for the soul.'

'This must be some kind of fairyland – wonderland,' writes engineer Leon Engelbrecht.

In the long darkness of April – with only about four hours of daylight – diurnal rhythms begin to slip. 'Sleep is a thing of whim,' writes radar scientist Pieter Wolmarans. 'Many nights I find fellow team members awake, unable to sleep, a condition that seems to be affecting us all. But I also have the problem that when I do go to sleep it's really hard to get up. I wear no watch. I hope I can remember where I put my wallet before I get back to South Africa.'

'By the time we ended up with 22 hours of darkness, our body clocks decided that was enough,' comments Leon. 'Some of us ended up with two or three sessions of three hours' sleep a day, other walked around like zombies, not being able to sleep for 48 hours, then eventually falling asleep out of sheer exhaustion. If I can just get my hands on that damn body clock, I'll make it pay for this! But the moon cycle is awesome. Nowhere else will you be able to see the moon like that, huge and floating along the horizon.'

When winter approaches, icy arms gather up the continent in preparation for darkness.

On 18 May that year Antarctica experienced its last sunset, and Sanae entered a strange, twilight world. Having read tales of long, dark polar nights, the team is surprised to see how the reflective ice is lit up by the moon and stars. 'Living in the dark is not what I had expected it to be,' writes Pieter. 'But it's cold! Just walking around outside for five minutes turns any exposed hair snow-white with frost. A slight breeze causes a dull throb behind an uncovered eye and speaking becomes difficult.'

There are celebrations on midwinter's day, 21 June, but tinged with a sense of unease about the depths of the team's isolation within a minuscule artificial world. 'The base is our universe of existence on the Antarctic continent,' Leon reflects. 'Treasure it, nurse it and we'll all go home, safely and in one piece.'

In July temperatures plunge even further and katabatic winds of up to 140 km/h hammer the base. A calculation by engineer Mark Loubser indicates that daily diesel use is too high and they may run out before being re-supplied the following summer. Base heating will have to be drastically reduced. On 24 July the sun reappears briefly, raising everyone's spirits. 'How nice it would it be to just walk through the veld, savouring the smell of all it has to offer, hearing and seeing the birds and insects go about their daily routine,' writes Leon. 'There can be no substitute for the smell of the earth after a shower of rain, or a forest with its lush vegetation. It's what we miss in Antarctica.'

The doctor, Rupert Niemand, is missing other things. Asked what woman he thought was the most beautiful, he answers: 'Right now I can't think of a woman who is not beautiful.'

In October the temperature rises briefly to a 'sweaty' −10°C, making everyone listless. Halfway through the month a snow-petrel appears. 'We are not alone,' writes Beneke enthusiastically.

'The air is different,' Pieter comments. 'Dull patches of lichen are now brilliantly coloured. There seems to be a change in us too. Subtle but definite. Every now and again someone remarks on something suddenly noticed again. It's an awareness deep inside us of some great natural force coursing through the entire continent. Even the onions in the fridge seem to be growing a bit stronger and greener.'

The good weather seems to be holding, so it's decided to fire up a Challenger and do an inspection run to E-Base. Four of the team leave, dragging a rudimentary caravan on a sled. Someone, with memories of the days when steam trains dragged guard's vans across the veld, dubbed it the Caboose. After the winter freeze the terrain has altered and anything seems possible. They pass the ice hinge zone, then encounter cracks. 'We contemplated the possibility of the whole lot breaking off with us on it,' writes Struan, 'but continued.'

They eventually arrive at where the GPS says E-Base should be, but the weather closes in. Winds of around 80 km/h reduce visibility to almost zero. Hunting for the base will be dangerous and they decide to wait out the storm. The weather gets worse. They leave the Challenger running (shutting it down will make it difficult to re-start at those temperatures) and power up the Caboose's generator, giving them light and heating. A day later

they are still waiting, and decide to shut down the Challenger, having discovered that its batteries have frozen. The generator begins acting strangely, its revs going up and down. It's found that the heaters are causing the problem, but when they are switched off, the generator speeds up so fast that the radio begins to smoke and has to be unplugged. Then the light bulb blows, so they agree to shut down the faulty generator before it cracks up. They push outside against the howling wind and find the engine is covered in ice and have to hack with a pocket knife to find the cut-out switch.

What saves their lives is the propane gas cooker which they leave on to heat the Caboose. Without radio contact they begin to worry that those back at Sanae will fear the worst and come looking for them, landing in the same predicament but without the Caboose to sustain them. If their batteries ice, the cab heaters will stop and they'll freeze to death. For three days there's no change in the weather. Then a glow appears above, presumably the sun. This means the storm is abating. They link together all the rope they have, tie one end to the Caboose and the other to Struan and Beneke, who go looking for E-Base. They finally see a dark shape at the very limits of their vision and stumble towards it. It's the corner of the base.

The E-base's generators start and they replace the Challenger's batteries. The snow is at roof height and they figure that without a lot of digging, the base will be lost the following year. After that they head back. With the temperature at −33°C, they don't sleep until they reach Sanae.

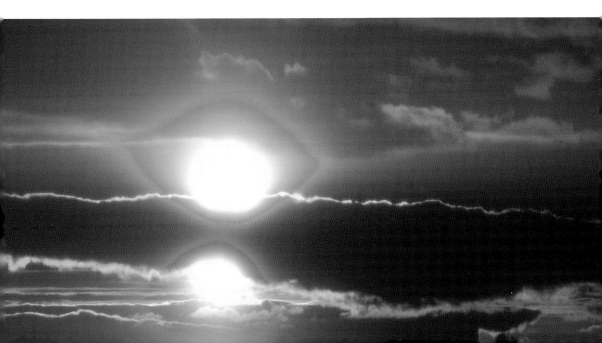

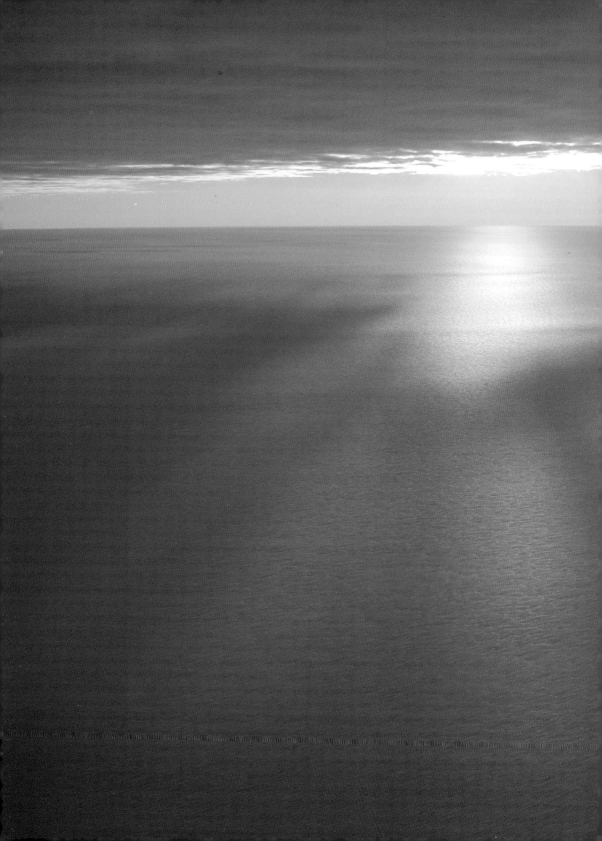

With no free water, Antarctica is the largest desert on earth.

The great nothing

With winter in the air, I sailed away from Antarctica late one February, like most others, after a few short months blessed by her purity.

Tui de Roy, *Wild Ice*

Not being part of the over-wintering team, I begin preparations for departure. My mind reaches towards Africa – home, friends and family. And warmth. But there's still something missing, some essential experience. I brood over it for a few days, then realise what it is. Being surrounded by bases, machines and people, I haven't yet felt the brooding, ancient rhythms of Antarctica. I need to be alone, surrounded by nothing but ice and sky. I need to go walkabout. Maybe find a hut somewhere. But where?

Discussion around the science dinner table has deteriorated into a seemingly endless ramble about films I've never seen, or the more arcane aspects of space plasma. Everyone is busy completing experiments or loading containers in preparation for departure. Busy people are the worst news for a writer in residence. I have two choices: play patience on my laptop or get off base.

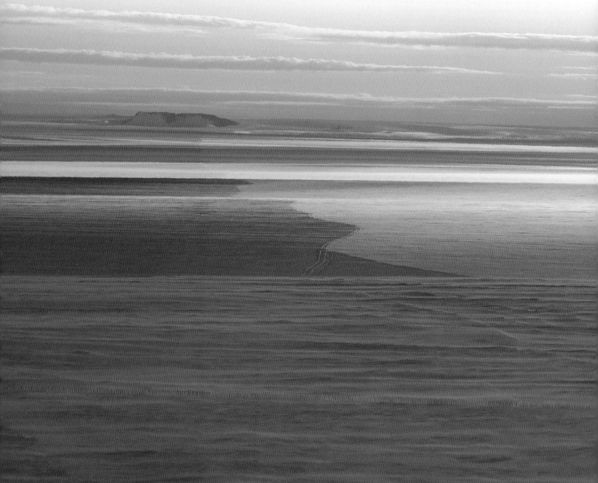

'Is there a hut anywhere around?' I ask.

No. Sarie Marais was dismantled.

'Could I borrow a tent?'

Sorry, no tents on the base.

'Maybe an ice cave somewhere?'

Not permitted.

At this point, somebody mentions the Caboose. If there is anything in the middle of nowhere, this is it. With loaded SnoCats averaging around 15 km/h, a journey to the German base, Neumayer, from where we will soon be loading containers onto the *Agulhas*, takes about 40 hours. To break the journey, the drivers have dragged the Caboose to about halfway, around 150 kilometres from Sanae in the middle of a vast ice plain. It had beds, a gas stove, a generator, a toilet and a stash of emergency food.

My request is mulled over and a decision is arrived at. I can hitch a ride with a Cat train and stay in the Caboose, but not alone. Too dangerous. Maybe I'll go mad or blow myself up with the gas ring. So, it seems, I need a sitter. Beneke, the over-wintering team leader, agrees to do service.

We're supposed to leave around midday but pull out an hour after midnight the following morning. If you're hitching a lift, you take what comes. There are four Challengers, some with three sleds each, and we speed away at a steady 15 km/h. As the Vesleskarvet

The Antarctic atmosphere has no pollution or water vapour – you seem to be able to see for ever.

nunataks fall behind, all there is to see are the snow-filled tracks of a previous trip and flat, twilight-blue ice.

At about 01h30 the sun rises magnificently under fire-kissed clouds. A wind is blowing and freeze-dried surface snow is on the move. The surface is relatively smooth and the pace soporific. John, who'd been with me on the E-Base trip, climbs into the bunk to sleep and I chat to Doepie, a tough army vehicle-recovery specialist who's come south to earn a bit of extra income.

'What do you recover?' I ask.

'Well, there's small, medium, large and extra large,' he says.

'So how would you rate SnoCat?'

'It weighs 19 tons, so it's medium.'

'Medium? So there are bigger vehicles than this?'

'Oh, way bigger.'

After three and a half hours we nose into a depression, then up an ice rise. One after the other the Challengers churn to a stop, their tracks flailing and spewing snow. They back up, then angle across the slope, though some became so bogged down they have to uncouple the sleds and drag them up singly. From the top of the ice rise Vesleskarvet is still plainly in view, 50 kilometres away. Our passage has disturbed the wind-polished snow, so, in the angled dawn light, the surface to the lee of our tracks is dull grey and to the windward side still gleaming white. We can plainly see our route all the way back to the nunataks, splitting the world to the east between light and dark. What a surreal landscape this is. When we get going again, I wedge myself alongside the luggage in the second bunk and sleep fitfully.

::

Ten hours after leaving the base we slide to a halt at the Caboose. Beneke and I climb down with the drivers, who fill their vehicles from the polar diesel bowsers, then come in to make coffee, eat some sandwiches and go to the toilet. The hut is pretty rough and ready – a box perched on an orange sled with small windows and a door. There are no beds, just mattresses piled on the floor, no table or chairs, a sink with a shelf on one side and two gas rings on the other. Tucked awkwardly beside the exit door is what passes for a toilet: a seat over which you place a plastic packet which, when you're finished, has to be tied and dropped into a drum outside for later collection. There is also a large yellow oil drum with a funnel jammed into it for peeing. Outside is a small diesel generator, some emergency drums of chopper fuel, two diesel tanks and ice to the horizon.

The drivers say their farewells and pull away in a line. I stand on the roof of the hut and watch the SnoCats depart – their growl growing fainter and fainter – until they are dots on the smudged horizon. When they disappear I swing round in a circle to survey my new home. In every direction the flat ice plain stretches to a slightly blued horizon where it merges with similar-coloured clouds. It's like being at the bottom of a giant fishbowl of milky light – the greatest nothing I've ever been in, several hundred kilometres from any form of life. Even lone yachtsmen have birds and fish. The silence is absolute.

PLACES OF REFUGE

Antarctica is not short of isolated accommodation, the problem is getting to it.

In 1899 an eccentric Norwegian, Carsten Borchgrevink, who'd worked in Australia and sailed south under a British flag, built two huts at Cape Adare near the Ross Ice Shelf where he and his crew over-wintered. He was blunt and not well liked – he was described by a member of the Royal Geographical Society as incompetent and his ship, *Southern Cross*, as rotten – but he made it to Antarctica all the same and did some useful science. He and nine other men are best remembered, however, for being the first humans ever to over-winter on the Antarctic continent.

Borchgrevink's hut still stands, though the elements are slowly reducing it to rubble, as do both Scott's huts, the first one built at Hut Point at McMurdo Sound beside the Ross Sea and the one at Cape Evans from where he left on his tragic journey to the Pole. The Scott huts, as well as those of Shackleton and Byrd, have been cleared of the ice which had accumulated round and inside them, and look much as when their occupants left them around a hundred years ago.

When Richard Byrd entered Scott's Cape Evans hut in 1947 he recorded that it 'appeared somewhat disorderly after the buffeting of thirty-five winters. The frozen carcass of a dog stood on four legs as if it were alive. Seal carcasses from which fresh steaks might have been cut lay about. Scattered around the cabin were cartons of provisions still good to eat. A box of matches ignited easily.'

That remained true fifty years later when a New Zealand team restored the huts. In the Antarctic's sub-zero temperatures there is almost no decay and these huts are frozen in time: windows into the heroic age of polar exploration.

It is in such places that the Antarctic tradition was born: camaraderie, fortitude and endurance, the marks of a polar explorer. These days, and out of necessity, bases are very different in style from the first polar huts. Some are buried under the ice like goblin halls; others have expanding legs that keep them above it; still others, like Sanae, are virtual spaceships seemingly perched for takeoff.

The few huts that have been preserved are thousands of kilometres on the other side of Antarctica from Sanae, one of the last in Queen Maud Land being a South African geological base named Sarie Marais in the Borgmassivet Mountains about a hundred kilometres from the base.

We have no form of communication and are entirely dependent on the Challenger drivers finding us by GPS on their return journey. What if there's a blizzard? They could pass five metres from the hut without seeing it. Sitting up there on the roof, half my mind is demanding how I've got myself in such a crazy, dangerous situation. The other half is singing with exhilaration. I have a strong sense of being on another planet. So much of only one substance, only one colour – it's completely alien to my temperate-zone sensibilities. In the spaceship beneath me life is possible; without it I would surely die. If a wind came up or, worse, a blizzard, I'd die quickly. There's no human-scale interface between out and in, a micro-climate bubble in the snowfields of eternity.

When I finally climb down and go inside, I'm hit by an extraordinary animal sound. Beneke is asleep and snoring in two-part harmony with side bars and base drum. I hadn't realised people could make that sort of noise in their sleep and not wake up. Over-wintering has clearly taught him how to hibernate.

If I can't sleep with that racket, it's going to be difficult, I think. Inside the hut it's –3 degrees and outside I'll freeze to death. The smell of the supper I cook up eventually wakes him and we eat, sitting on the mattresses and chatting companionably. We explore our families, our dreams and life in general, getting the measure of each other. Beneke is a computer expert with a taste for remote places. He grew up on a farm in South Africa and had spent 13 months on Marion Island in the Southern Ocean and then another 15 months in Antarctica. He has wild, curly red hair from the top of his head to the bottom of his chin and farm-steady Hobbit feet. While I hunch and shiver he walks round barefoot, making coffee with large squirts of condensed milk. Afterwards he snuggles into his sleeping bag and is snoring within seconds of closing his eyes. It must have been a hard year; and babysitting clearly doesn't require him to be awake – merely to be here.

With earplugs I sleep wonderfully, though it would have been nice to lie listening to a silence greater than the inside of my head. In the morning, when I awake, the sun is high in the sky and the air is utterly still. The temperature in the hut is a cosy zero degrees. I dress, push the door open and walk some way from the hut. The further I go, the more anxious I become. Where do I think I'm walking to? If I fall in a crevasse, Beneke, who is still sleeping, might never see the hole in the snow. If a blizzard blows up, I'll never find my way back. They're only vaguely reasonable fears but are reinforced by the massive, still solitude of the ice. I decide snoring is preferable to anxiety and head back to the hut, climb on the roof and write in my diary:

> Time passes here in no-time space. I can measure it on my watch but it seems to make no sense. Daylight lasts so long – 21 hours – and there is nothing to indicate its passing. No lengthening of shadows from trees or buildings. So much of one colour. The only things that cast shadows are little ridges of snow and this hut. Somehow they tell me nothing. Maybe Beneke's reaction is the correct one: sleep until something changes.

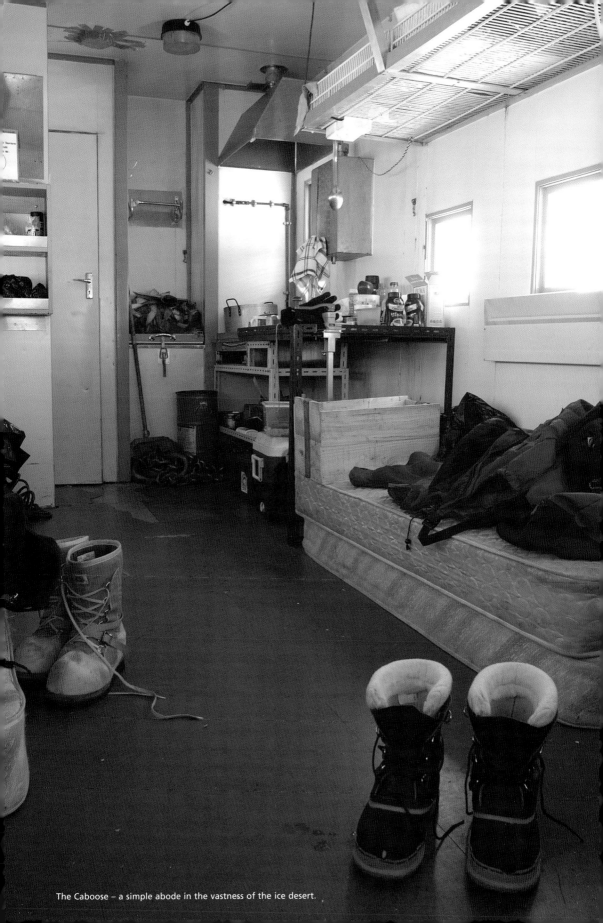

The Caboose – a simple abode in the vastness of the ice desert.

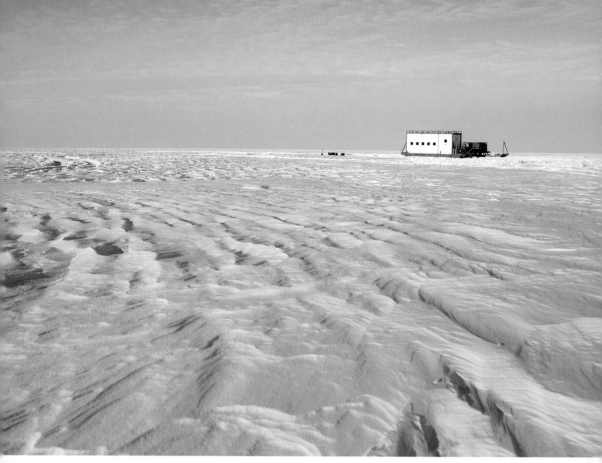

In the Caboose we were probably the most remote people on earth.

Deep, almost beneath hearing, something rumbles. I start. What was that? I drop off the roof and go inside to find Beneke awake.

'Did you hear the rumbling?' he asks.

'Yeah. What was it?'

'Oh, maybe it's the ice deep below us tearing at the land. Perhaps it's a big berg calving a hundred kilometres away. This hut acts as an echo chamber. It amplifies sound.'

This said, he returns to bed and is soon snoring again. Tea and chocolate refuse to warm up my fingers and toes, so I climb into my sleeping bag to read. A few pages into my book I feel a strong presence outside, but I refuse to be stupid enough to act on it. But a few pages later the sense is unbearable, I get up and peer out the windows. Both to my relief and, I realise, disappointment, nothing is out there. Even some apparition would do, though a bird or insect would have been better. I return to my diary.

> In Antarctica descriptive language is stripped of its complexity: ice … white … sun … cold … blue … endless … emptiness. Surprise is dulled by repetition. Perspective vanishes. The subtle brushstrokes of sastrugi rendered again and again to the horizon. White glitter that penetrates everything. The iceblink-saturated sky. Endless ice plains coloured platinum by a low sun.

Myself: insignificant. I'm either in the hut or in infinity. I remember Mawson's comment about being in the midst of infinities. I couldn't imagine it when I read it. I can now.

In *The White Silence* Jack London wrote:

Nature has many tricks wherewith she convinces man of his finity … but the most tremendous, the most stupefying of all, is the passive phase of the White Silence. All movement ceases, the sky clears, the heavens are as brass … [man] trembles at his audacity, realises that his is a maggot's life, nothing more. Strange thoughts arise unsummoned, and the mystery of all things strives for utterance. And the fear of death, of God, of the universe, comes over him … it is then, if ever, man walks alone with God.

Beneke gets up for lunch, sleeps through the afternoon, rises for supper and turns in for the night. It's weird, all this sleeping. Is he ill or am I that boring? I scratch around the shelves for something to do and find the first-aid box. One of the packets has Milde Payne written on the label. Beneke sounds as though he could use them. Next morning, though, he stays awake after breakfast and begins unpacking large coloured cloths from the bag I thought contained his clothing.

'What are those?' I want to know.

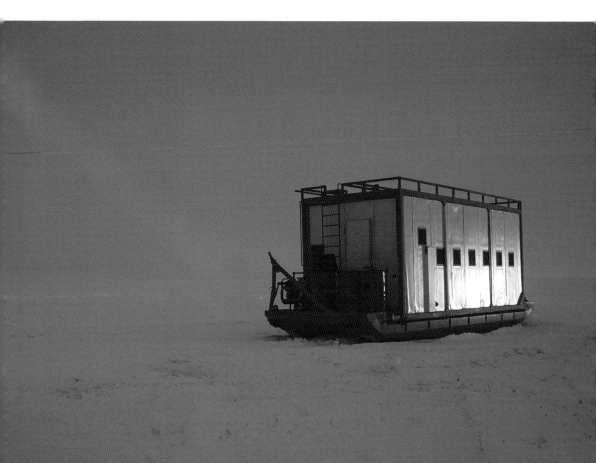

'Flags. We need to brighten up this place.'

He's serious. We hunt around for some poles and he ties what looks like a red tablecloth to one and lopes across the ice with it fluttering behind him. To our colour-starved eyes it's magnificent. I take photos of him flying bright red, green and blue flags. We then swap roles and I bound up and down with flags fluttering. After that, he digs out a long piece of green glitter cloth and does a *Priscilla, Queen of the Desert* from the top of the Caboose. Finally we plant all the flags in a row and photograph them.

Eventually, though, the Nothing wins. We untie the flags and come inside to warmth and something to eat. All this activity has tired Beneke, so he tucks in for 'a quick afternoon nap'.

'Why do you sleep so much?' I ask.

'I'm waiting for something to listen to,' he replies.

'If you could hear yourself snoring you'd never need to sleep.'

'Ja, but I can't. Just a quick snooze, that's all.'

The sun disappears and I'm back in the white goldfish bowl. The wind picks up and all definition disappears. I hope a blizzard isn't on the way. I put my diary on my knees and begin writing:

> Despite the snoring there is a wonderful peace all about. I have no duties, nothing to do, nowhere to go and am warm in my sleeping bag. With no company except a comatose companion, you realise how much head space people take up when they're around. Here my inner person expands to whatever limits it pleases; uncontested, comfortably. The dangers may be considerable but right now they seem far away. I think I will sleep deeply tonight – as long as I use ear plugs.

I do sleep, deeply, nine unbroken hours, but it's bitterly cold when I awake and I'm reluctant to get out of the bag. I eventually wiggle out, grab a book, snuggle back and begin reading. But soon my hand holding the book is numb with cold, so I put it down and try to thaw my hand between my thighs. The temperature difference between the inside and the outside of my bag must be around 40 degrees. Eventually necessity prises me out of my cocoon. I eat breakfast and begin tidying the hut. The Challenger drivers are due later that day and, as it's their hut, it seems right to hand it back in good shape. After a while I sit down with a cup of tea and listen to the growls and gulps emanating from the next bed and the plunk of water dripping from the roof. Water? If there's a leak it means the day is warming up. It crosses my mind to toss a mug of ice water at Beneke but there doesn't seem much point, so I put on my cap, gloves and jacket and open the door. It's like stepping out of a freezer into a summer's day. The Caboose is trapping the cold inside its steel cocoon.

Feeling much braver now, I walk along the Cat tracks for maybe 200 metres. Then I step out of them and squeak over new ice, hoping I'm not stepping on the thin bridges of lurker crevasses. In the hut I'm a large creature in a small space. The further from the hut I walk, the smaller I become, and when I stop it's a tiny box, startling in its difference from the ice but minuscule in the vast scenery. It's difficult to imagine that anyone could live in such a tiny thing. The hall-of-mirrors effect is muddling my brain, so I lie down. The ice isn't uncomfortable or cold through my thick wadding. The places where the sun touches my dark clothing are soon comfortably warm.

I can feel Antarctica below my spine. Everything about it is unearthly. Around me is nothing but blue sky, white ice and sunshine. I'm the furthest I've ever been from any form of life. Unless someone is man-hauling across the continent right then – and I haven't heard of anyone – Beneke and I are also probably the most remote people on the planet. Yet, lying there, I feel as though I'm in the palm of all life.

Ever since stepping onto the ice, so long ago it seems, I've been puzzling about the incon-gruity of my comfort in this utter alienness. Then I realise, with absolute certainty, it's because I've been here before. It doesn't make sense and I don't try to work it out. Instead I open my arms wide to embrace Antarctica's great icy presence. My mind empties of thoughts. I'm a tiny point of awareness in the limitlessness of space, just atoms and energy, nowhere and everywhere. The point dissolves and I'm nothing. An eternity later, the ice beneath me begins to rumble. For a moment I think it's Beneke's snoring, but it gets louder and louder. The SnoCats. It's time to go.

In the unrelenting whiteness, you'll do anything for a bit of colour.

Glossary

ablation. The loss of snow or ice by melting or evaporation

Antarctic Convergence. The region where the colder Antarctic seas meet the warmer waters of the more northern oceans

austral. Of the southern hemisphere.

bergy bit. A piece of floating ice rising one to five metres out of the water

brash ice. Fragments of other forms of ice

calve. The breaking off of an iceberg from an ice shelf or glacier

circumpolar current. The cold ocean current circulating Antarctica

Coriolis effect. The westward deflection of wind and ocean currents caused by the spinning of the earth

fast ice. Unbroken sea ice remaining attached to the coast or between stable bergs

frazil ice. Needle-like ice crystals forming a surface slush on the water

gneiss. Coarse-grained metamorphic rock layered by mineral strata. Also used to describe hard, stratified ice.

GPS. Global Positioning Systems based on satellite tracking

grease ice. A more advanced stage of freezing than frazil ice. Named because it causes the sea to appear greasy

growler. A small and hard-to-detect piece of ice, smaller than a bergy bit, which is a hazard to shipping

gyre. A circulating movement of any substance. Generally referred to in relation to movements of sea or air caused by the Coriolis effect of the spinning earth

ice blink. A brighter section on the underside of clouds caused by light reflected from ice below

ice sheet. A continuous mass of ice and snow of considerable thickness covering many hundreds of square kilometres

ice shelf. The skirt of ice encircling Antarctica beyond the edge of the continent. In winter it can double the surface area of Antarctica.

IGY. International Geophysical Year, which ran from July 1957 to December 1958

katabatic. Gravity-driven wind caused by colder, heavier air rushing down from the high polar plateau

nunatak. A mountain or rock mass protruding through an ice sheet. Usually the tops of buried mountains

old ice. Sea ice that is several years old and up to three metres thick

pack ice. Any area of sea ice other than fast ice

pancake ice. Discs of young ice formed when waves bump them against each other, rounding them and causing ridges along their edges

parhelion (pl. parhelia). One or more 'false' suns, commonly known as sun dogs, caused by the refraction of sunlight by airborne ice dust

rime. Dirty, granulated ice.

rotten ice. Older, weakened ice in the last stages before melting

sastrugi. Frozen waves or irregularities formed on a snow surface by wind.

SCAR. Scientific Committee on Antarctic Research operated jointly by many participating countries

skidoo. A small, tracked vehicle – rather like the cross between a jetski and a motor bike – used as transport on ice

SnoCat. A large, rubber-tracked Caterpillar vehicle generally used to tow ice sledges

snow bridge. A crust-like bridge over a crevasse which is formed when windblown snow builds up from the leeward wall of the crevasse

sun dog. One or more 'false' suns, more correctly known as a parhelion (pl. parhelia), caused by the refraction of sunlight by airborne ice dust

tabular berg. A recently calved iceberg with a flat top and vertical sides

whiteout. A condition of diffuse light when an overcast sky descends to the horizon, causing a blurring between ground and sky and eliminating all points of perspective. No surface irregularities of the snow are visible

Wind. Wind forces are logged according to the Beaufort Scale:

No.	Description	Mean velocity in km/h
0	Calm	0
1	Light Air	1.6
2	Light breeze	6.4
3	Gentle breeze	14.5
4	Moderate breeze	22.5
5	Fresh breeze	32
6	Strong breeze	42
7	Moderate gale	53
8	Fresh gale	67
9	Strong gale	83
10	Whole Gale	100
11	Storm	120
12	Hurricane	147

Antarctic chronology

Date	Expedition leader/ significant person	Expedition/vessel/ event	Route/discovery/ outcome
1519	Ferdinand Magellan	To find sea route to east	Discovers Straits of Magellan to Pacific Ocean
1578	Francis Drake	Exploration & plunder	Discovers Drake Passage round South America
1616	WM Schouten & Jacob la Maire	Exploration & plunder	Discover Cape Horn and sail into Pacific.
1739	Jena-Baptiste Bouvet	Search for the South Continent	Discovers Bouvet Island
1773	James Cook	To find southern land	Becomes first crew to cross Antarctic Circle. Reaches 71°S
1775	James Cook	To find southern land	Possibly sighted ice fields of Antarctica.
1801	Edmund Fanning	Sealing	Kills thousands of seals in S. Georgia. Makes huge profit in China
1819	William Smith	*Williams*	Discovers South Shetland Islands south of Cape Horn
1820	F G Thaddeus von Bellingshausen	To find southern land	First confirmed sighting of Antarctica
1820	Smith & Edward Bransfield	*Williams*	Sight Antarctic Peninsula.
1821	John Davis	*Celia*	First landing on Antarctica
1823	James Weddell	Exploration	First to penetrate Weddell Sea
1831	John Biscoe	Sealing	Circumnavigates Antarctica
1840	Jules-Sebastian d'Urville	Exploration	Raises French flag in Adile Land, Antarctica
1841	James Clark Ross	*Erebus* and *Terror*	First to penetrate ice pack Discovers Ross Ice Shelf & Mt Erebus
1899	Carsten Borchgrevink	*Southern Cross*	First team to over-winter in Antarctica
1903	Robert Falcon Scott	*Discovery*	First attempt to reach South Pole
1904	Carl Larson	Whaling	First southern shore-based whaling station: South Georgia
1908	Ernest Shackleton	*Nimrod*	Reaches point only 180 km from Pole but has to turn back
1909	TW Edgeworth David & Douglas Mawson	Search for Magnetic Pole	Reach Magnetic South Pole
1911	Scott	*Terra Nova*	Scott's party over-winter at Cape Evans
1911	Wilson, Bowers & Cherry-Garrard	To collect penguin eggs	Described as 'worst journey in the world' by Cherry-Garrard
Dec. 1911	Roald Amundsen	*Fram*	Plants Norwegian flag at South Pole
Jan. 1912	Scott	*Terra Nova*	Reaches South Pole but dies on return journey
Oct. 1915	Ernest Shackleton	*Endurance*	Ship crushed by ice and party stranded in Antarctica
April 1916	Shackleton	*Endurance*	Leave in James Caid for S. Georgia to seek rescue of crew
Aug. 1916	Shackleton	*Endurance*	All crew rescued by Shackleton
1929	Richard Byrd	Polar flight	First flight to South Pole
1934	Richard Byrd	Solo over-winter	First person to over-winter in Antarctica alone but almost dies
1935	Lincoln Ellsworth	Polar flight	First trans-Antarctic flight
1947	Richard Byrd	Operation Highjump	US base established with 4700 men; huge areas mapped
1950	John Giaever	Queen Maud Land Expedition	First base set up in QM Land
1957	International cooperation	Scientific exploration	International Geophysical Year begins; 67 countries combine forces
1958	Vivian Fuchs	Commonwealth Trans-Antarctic Expedition	Party successfully crosses Antarctica
1959		International cooperation	Antarctic Treaty signed
1965			Last southern whaling station closes
1976	Emilio de Palma	First baby born in Antarctica, at Argentinian base	
1979		First tourists killed in Antarctica	Air New Zealand aircraft crashes into Mt Erebus
1982		International cooperation	All whaling ends in southern oceans but Norway & Japan defy ban

Photographic credits

All black and white photographs were taken from displays at Sanae 4 and permission to use them has been granted by the Department of Environmental Affairs and Tourism. They were originally supplied by individual team members but no record of their names has been kept. Should they contact us, we will acknowledge them in future editions. All colour photographs are © Don Pinnock.

Bibliography

Allen, Benedict: *The Faber Book of Exploration* (Faber & Faber, London, 2002)

Amundsen, Roald: *The South Pole* (John Murray, London, 1912)

Anderson, John: *Antarctic Marine Geology* (Cambridge University Press, Cambridge, 1999)

Byrd, Richard: *Alone* (Putnam and Sons, New York, 1938)

Byrd, Richard: *Discovery* (Putnam and Sons, New York, 1935)

Campbell, David: *The Crystal Desert: Summers in Antarctica* (Minerva, London, 1992)

Cherry-Garrard, Apsley: *The Worst Journey in the World* (Pimlico, London, 1922 & 2003)

Debenham, Frank: *Antarctica* (Herbert Jenkins, London, 1959)

Debenham, Frank: *Voyage of Captain Bellingshausen to the Antarctic Seas 1819–1821* (Hakluyt Society, London, 1945)

Fadiman, Anne: *Ex Libris: Confessions of a Common Reader* (Farrar, Straus & Giroux, New York, 1999)

Fuchs, Vivian, and Edmund Hillary: *The Crossing* (Cassell, London 1958)

Gurney, Alan: *Below the Convergence: Voyages towards Antarctica, 1699–1839* (Pimlico, London, 1997)

Harris, Jean: *An Introduction to the Geology, Biology and Conservation of Nunataks in Dronning Maud Land, Antarctica* (FitzPatrick Institute of African Ornithology, University of Cape Town, n.d.)

Heacox, Kim: *Antarctica: The Last Continent* (National Geographic Society, Washington, 1998)

Headland, Robert: *Chronological List of Antarctic Expeditions* (Cambridge University Press, Cambridge, 1989)

Hough, Richard: *Captain Cook: A Biography* (Hodder & Stoughton, London 1994)

Lopez, Barry: *Arctic Dreams* (Vintage, New York, 1986)

Mawson, Douglas: *Home of the Blizzard* (Heinemann, London, 1915)

Naveen, Ron, Colin Monteath, Tui de Roy and Mark Jones: *Wild Ice: Antarctic Journeys* (Smithsonian Institution, Library of Congress, 1990)

Ovstedal, DO and RI Lewis Smith: *Lichens of Antarctica and South Georgia: A Guide to their Identification and Ecology* (Cambridge University Press, Cambridge, 2001)

Ponting, Herbert: *The Great White South* (Duckworth, London, 1921)

Pound, Reginald: *Scott of the Antarctic* (Cassell, London, 1966)

Press, Frank, and Raymons Siever: *Understanding Earth* (WH Freeman, New York, 2001)

Pyne, Stephen: *The Ice: A Journey to Antarctica* (University of Washington Press, Seattle, 1986)

Quigg, Philip W: *A Pole Apart: The Emerging Issue of Antarctica* (New Press, New York, 1983)

Reader's Digest: *Antarctica: Great Stories from the Frozen Continent* (Reader's Digest, New South Wales, 1985)

Rubin, Jeff: *Antarctica* (Lonely Planet Publications, Hawthorn, 1996)

Scott, Robert Falcon: *Scott's Last Expedition*, 2 vols. (Macmillan, London, 1913)

Scott, Robert Falcon: *The Voyage of the Discovery* (Macmillan, London, 1905)

Seaver, George: *Edward Wilson: Nature-lover* (John Murray, London, 1937)

Shackleton, Ernest: *South* (Carrol & Graf Publishers, New York, 1998)

Simpson-Housley, Paul: *Antarctica: Exploration, Perception and Metaphor* (Routledge, London, 1992)

Thompson, David: *Scott's Men* (Allen Lane, London, 1977)

Wheeler, Sarah: *Terra Incognita: Travels in Antarctica* (Vintage, London, 1996)

Wilson, Edward: *Diary of the Discovery Expedition* (Humanities Press, New York, 1967)

Wilson, Edward: *Diary of the* Terra Nova *Expedition* (Blanford Press, London, 1972)

Notes

1. D. Campbell, *The Crystal Desert*.
2. A. Gurney, *Below the Convergence*, p. 148.
3. Reported in Campbell, *Crystal Desert*, p. 175.
4. R. Headland, *Chronological List of Antarctic Expeditions*.
5. F. Debenham (ed.), *Voyage of Captain Bellingshausen to the Antarctic Seas 1819—1821*, Vol. 1, pp. 127—8.
6. Sastrugi are frozen waves caused by wind, rather like rippling sand dunes.
7. A. Fadiman, 'My Odd Shelf' in *Ex Libris*.
8. B. Allen, *The Faber Book of Exploration*, p. 444.
9. S. Pyne, *The Ice*, p. 339.
10. L.P. Kirwan, *A History of Polar Exploration*, p. 224.
11. Ibid., p. 344.
12. P.W. Quigg, *A Pole Apart*, p. 134.
13. G. Seaver, *Edward Wilson*, p. 128.
14. Ibid., p. 135.
15. B. Lopez, *Arctic Dreams*, p. 241.
16. Jack London, *The White Silence*, quoted in Pyne, *The Ice*, p. 381.